INDIANAPOLIS
THEN & NOW

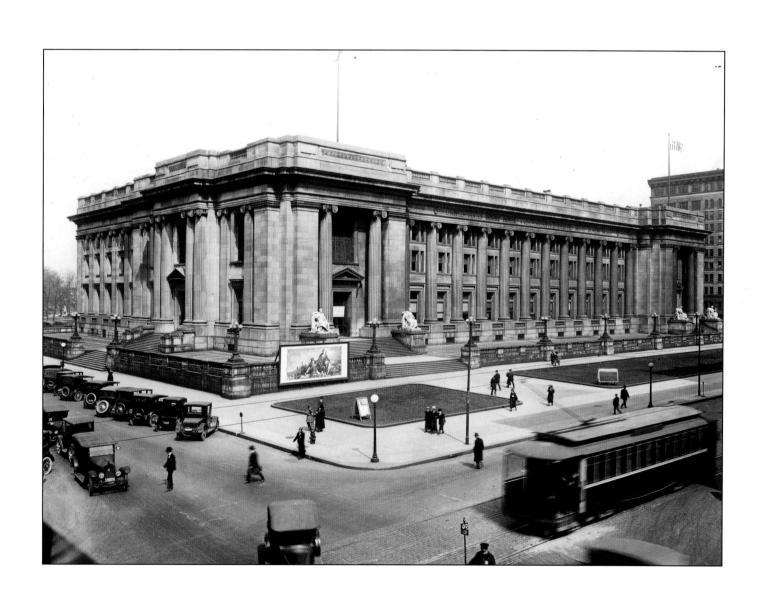

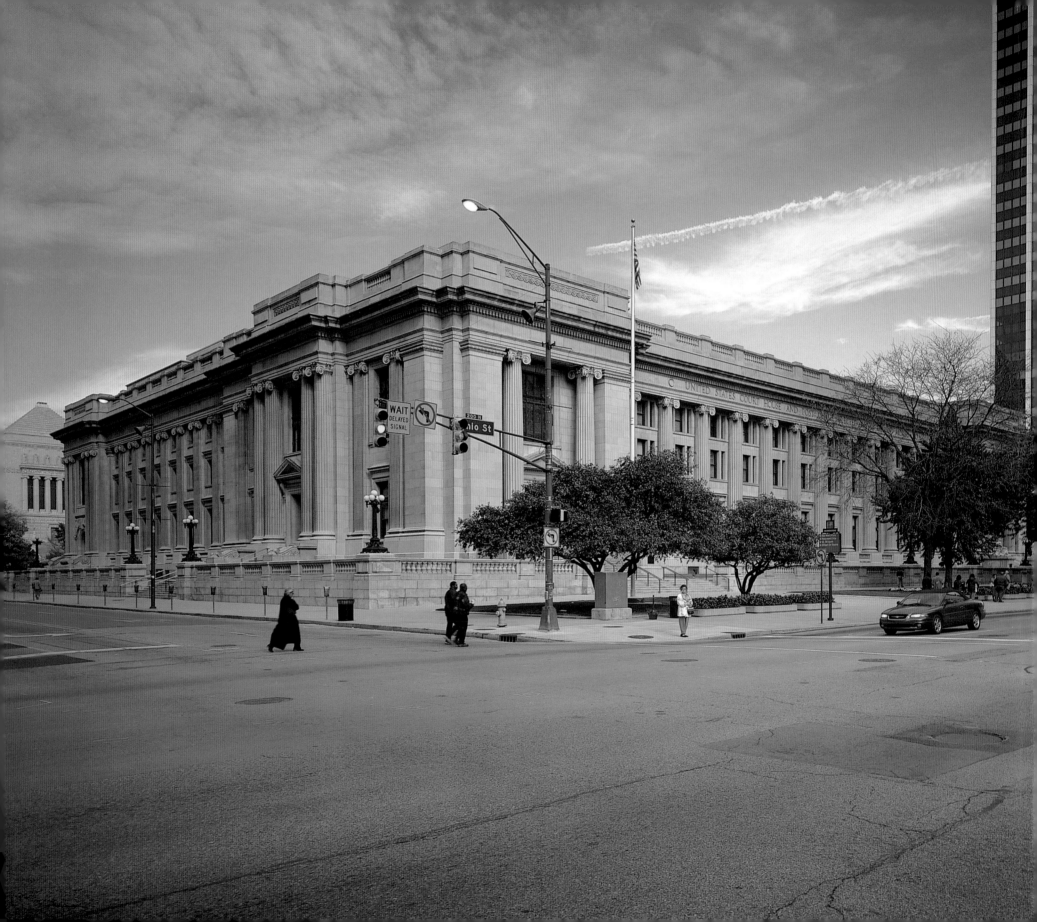

INDIANAPOLIS THEN & NOW

NELSON PRICE

THUNDER BAY
P·R·E·S·S

San Diego, California

Thunder Bay Press
An imprint of the Advantage Publishers Group
5880 Oberlin Drive, San Diego, CA 92121-4794
www.thunderbaybooks.com

Produced by PRC Publishing,
The Chrysalis Building, Bramley Road, London W10 6SP, United Kingdom

An imprint of Chrysalis Books Group plc

© 2004 PRC Publishing.

All notations of errors or omissions should be addressed to Thunder Bay Press, Editorial Department,
at the above address. All other correspondence (author inquiries, permissions) concerning the content
of this book should be addressed to PRC Publishing, The Chrysalis Building, Bramley Road, London
W10 6SP, United Kingdom. A member of the Chrysalis Group plc.

ISBN-13: 978-1-59223-208-6
ISBN-10: 1-59223-208-6

Library of Congress Cataloging-in-Publication Data
Price, Nelson.
 Indianapolis then & now / Nelson Price.
 p. cm.
 ISBN 1-59223-208-6
 1. Indianapolis (Ind.)--Pictorial works. 2. Indianapolis (Ind.)–History--Pictorial works.
I. Title: Indianapolis then and now. II. Title.

F534.I343P75 2004
977.2'52'0222–dc22

2004040739

Printed and bound in China

3 4 5 6 7 09 08 07 06 05

ABOUT THE PHOTOGRAPHER

Garry Chilluffo, an Indianapolis-based commercial photographer since 1976, specializes in
architectural and advertising photography and has a strong personal interest in historic
preservation. His recent photography book projects include *The Art of the 92 County Walk*
for the Indiana State Museum (2003). You can find him on the Web at www.chilluffo.com.

ACKNOWLEDGMENTS

Special thanks in the preparation of this book are extended to Tina Connor, Wanda Willis, Jennifer
Hanson, Bill Selm, James Glass, Bill Brooks, Michelle Laird, Jane Rulon, Chris Pohl, Scott Truax,
Cindy Highberg, and Robert Joseph. I would also like to credit the following sources for providing
information for this book: *The Insider's Guide to Greater Indianapolis* by Skip Berry and Jenny Phelps
Ketzenberger, *The Encyclopedia of Indianapolis* by David J. Bodenhamer and Robert G. Barrows, *The
Main Stem of North Meridian Street* by David J. Bodenhamer, Lamont Hulse, and Elizabeth B.
Monroe, *Indianapolis: Hoosiers' Circle City* by George A. Geib, *IUPUI: The Making of an Urban
University* by Ralph Gray, *Indianapolis Union Station* by James Hetherington, *Indianapolis Architecture*
by the Indianapolis Architecture Foundation, *Indianapolis: The Story of a City* by Edward A. Leary,
Lost Indianapolis by John P. McDonald, and *The Circle: The Center of Indianapolis* by Ernestine
Bradford Rose.

PICTURE CREDITS

The publisher wishes to thank the following for kindly supplying the photographs that appear in this
book:

"Then" Photographs:
Indiana Historical Society: 6, 10, 28, 34, 46, 56, 58, 60, 60 inset, 62, 68, 74, 90, 100, 104, 106, 132,
134; Indiana Historical Society, Bass Collection (negative numbers in brackets): 12 (310579-2), 14
(330100-F), 16 (5172), 18, 20 (6514), 22 (63367), 22 inset, 24 (26199), 26 (200470-F), 30 (24702),
32, 36 (238555-F), 40 (299683), 40 inset, 50 (17336), 54 (91531-F), 64 (4576), 70, 72 (A395), 76
(63789), 78, 80, 84 (208021-F), 96 (69902-F), 98 (91622-F), 102 (228081-F), 108 (92875), 110
(5144), 112 (65877), 116, 120, 122 (201459-F), 126 (C30), 130 (321224-F), 136 (238280-F-E), 138
(26232), 140, 142 (93791); Artemis Images/Indianapolis Motor Speedway: 94; Bettmann/CORBIS:
92; BroadRippleHistory.com:128; Children's Bureau of Indianapolis: 52; Crown Hill Cemetery
Archives: 118; Historic Landmarks Foundation of Indiana: 44; Indiana State Library: 8, 38, 66, 86;
IUPUI University Library Special Collections and Archives: 88; President Benjamin Harrison Site,
Indianapolis: 114 and 114 inset; Riley Museum Home: 42; Tim & Avi's Salvage Store: 48; Times
Collections/Tiffany Studios, Indianapolis: 82; University Archives, Butler University Libraries: 124

"Now" Photographs:
All photographs were taken by Garry Chilluffo with the exception of the photograph on page 93,
which was supplied courtesy of Keegan/Newsport/CORBIS.

Pages 1 and 2 show: Federal Building, 1919 (photo: Indiana Historical Society, Bass Collection),
and as it looks today (photo: Garry Chilluffo/© PRC Publishing); see pages 96 and 97 for further
details.

COVER PICTURE CREDITS

Front and back cover photographs show: the English Hotel and Opera House / Monument Circle,
then (photo: Indiana Historical Society, Bass Collection, neg no. 310579-2) and now (photo: Garry
Chilluffo/© PRC Publishing). See pages 12 and 13 for details.

Front flap shows: Indiana Statehouse, then (photo: Indiana Historical Society, Bass Collection, neg
no. 93791) and now (photo: Garry Chilluffo/© PRC Publishing). See pages 142 and 143 for details.

Back flap shows: Indianapolis Motor Speedway, then (photo: Bettmann/CORBIS) and now (photo:
Keegan/Newsport/CORBIS). See pages 92 and 93 for details.

INTRODUCTION

When writers and visitors refer to the twelfth-largest city in America as "Indy," it's almost always with warmth and frequently followed by a remark about the sheer vitality of the place. The origins of the city can be traced to 1820, when Hoosier dignitaries gathered at early settler William Conner's log cabin on the White River near Noblesville to plan a new state capital. Corydon, which had been serving as the capital since Indiana achieved statehood in 1816, was judged to be too far south for statewide convenience. The new capital needed to be in the middle of the nineteenth state, the pioneer powerbrokers decided.

The undeveloped lowland that would become Indianapolis was chosen because of its central location. The next year, surveyor Alexander Ralston, who had helped design Washington, D.C., put forth a plan for Indiana's capital city that reflected the nation's. He laid out Indianapolis on a grid; a "Mile Square" was bounded by North Street, South Street, East Street, and West Street and four diagonal avenues radiated from a circle at the center of the Mile Square. The Governor's Mansion would be built in the center, surrounded by Circle Street.

This design didn't go to plan, however. The Governor's Mansion was built at the center, but no Indiana governor ever lived there. According to folklore, the reasons include early first ladies' objections to hanging their families' laundry, particularly undergarments, at the center of the city for all to see. Meanwhile, no sooner had residents arrived to build and settle in Indianapolis than a malaria epidemic swept the city in 1821. The second physician to show up in town, Dr. Isaac Coe, blamed the epidemic on vapors from the swamps and lowlands on which the Hoosier capital was built.

From that inauspicious beginning, a bustling city did emerge. During the late 1800s and early 1900s, art and literature flourished, with national celebrities such as Pulitzer Prize–winning novelist Booth Tarkington and poet James Whitcomb Riley among the city's illustrious residents. Tarkington and other notables lived in magnificent mansions built during the 1920s on North Meridian Street; their restored homes remain showplaces nearly one hundred years later. The same goes for the enchanting Lockerbie neighborhood, which was Riley's home base when he wasn't performing at the White House or crisscrossing the country on tour. Lockerbie, too, has been preserved. Visitors to today's Indianapolis invariably marvel at the neighborhood of cobblestone streets, white picket fences, and historic homes only a stroll away from downtown skyscrapers.

During the first half of the twentieth century, jazz music burst from clubs along legendary Indiana Avenue. During the day, teenagers like future novelist Kurt Vonnegut and future foreign policy expert Richard Lugar produced the nation's first daily high school newspaper, the *Daily Echo*, at a public school considered one of the finest in the land, Shortridge High School.

The inaugural Indianapolis 500 on May 30, 1911, placed a spotlight on the city as Americans got caught up in the car craze. Three decades of thrills ensued at the two-and-a-half mile, oval-shaped track. During World War II, though, the Indianapolis 500 was suspended. By 1946, the racetrack was nearly overgrown with weeds. Terre Haute businessman Tony Hulman came to the rescue when he bought the Speedway in 1946 and initiated a massive improvement campaign that propelled the Indianapolis 500 to glory years that surpassed those of the prewar era.

During the 1970s Indianapolis showed signs of deterioration, but the 1980s brought the beginning of an astonishing rejuvenation of the downtown area and an image overhaul. In 1984 the newly built RCA Dome (known then as the Hoosier Dome) became the home of the Indianapolis Colts, vaulting the city into major-league status, at least in the eyes of those who make assessments based on sports and cultural attractions. Three years later, Indianapolis was hosting the exhilarating Pan American Games. Governing bodies for half a dozen Olympic sports, like U.S.A. Gymnastics, U.S. Diving, and U.S.A. Track & Field moved into offices next to the bricked, flag-waving courtyard that became known as Pan American Plaza. Even U.S. Rowing moved its headquarters to landlocked Indianapolis and the NCAA moved its headquarters and hall of fame to Indianapolis in 1999.

By then, Alexander Ralston's Mile Square had other gems, among them Circle Centre, a $307 million retail and entertainment complex that opened in 1995 amid much fanfare. Owned by the Indianapolis-based Simon Property Group, the nation's largest developer of shopping malls, Circle Centre incorporated facades of some historic downtown retail outlets even as other structures were demolished. Restaurants, nightclubs, and new or significantly enhanced museums opened downtown and in the nearby White River State Park area, providing alternatives to long-popular Broad Ripple dining spots, bars, and boutiques on the Northside. On sunny days, the new Monon Trail, created from a reclaimed railroad right-of-way, bursts with runners, cyclists, in-line skaters, and walkers, as do the European settings along the scenic downtown canal of the White River, which now make Indy a vibrant place.

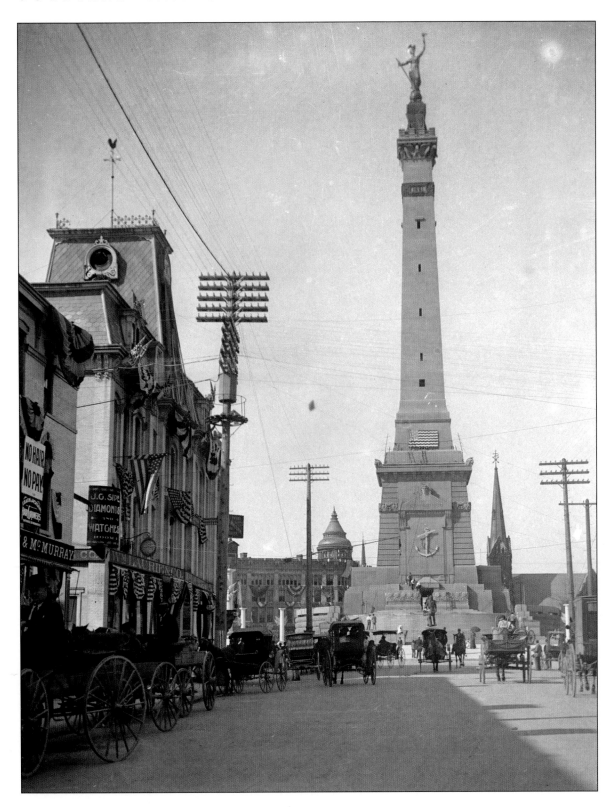

The Soldiers' and Sailors' Monument has become an international symbol for the Hoosier capital and was initially designed to honor Civil War veterans from Indiana. From 1888 to 1901, this monument was built at the city's heart, the center of Circle Street (renamed Monument Circle in 1917), after a crusade by the state's most famous Civil War veterans, including Colonel Eli Lilly and General Lew Wallace. In this image, c. 1893, buildings surrounding the monument are draped with flags and bunting for a city celebration. German architect Bruno Schmitz won an international competition to design the monument, which was dedicated at a gala in 1902. Nearly 75 percent of Hoosier men of military age served in the Union army, a higher percentage than any other state except Delaware.

Having endured more than a hundred years of celebrations and hardships in the city that surrounds it, the Soldiers' and Sailors' Monument today stands as a tribute to the valor of Hoosier men and women who served in all of the nineteenth-century wars. The monument is built of gray limestone from the quarries in Owen County, Indiana. Its height from street level to the Lady Victory statue on top is 284 feet and six inches, making the Soldiers' and Sailors' Monument just seventeen feet shorter than the Statue of Liberty. The monument was designed so it could be integrated into the Circle, with fountains, pools, and terraced steps. In 1999, the Colonel Eli Lilly Civil War Museum opened in the monument's basement.

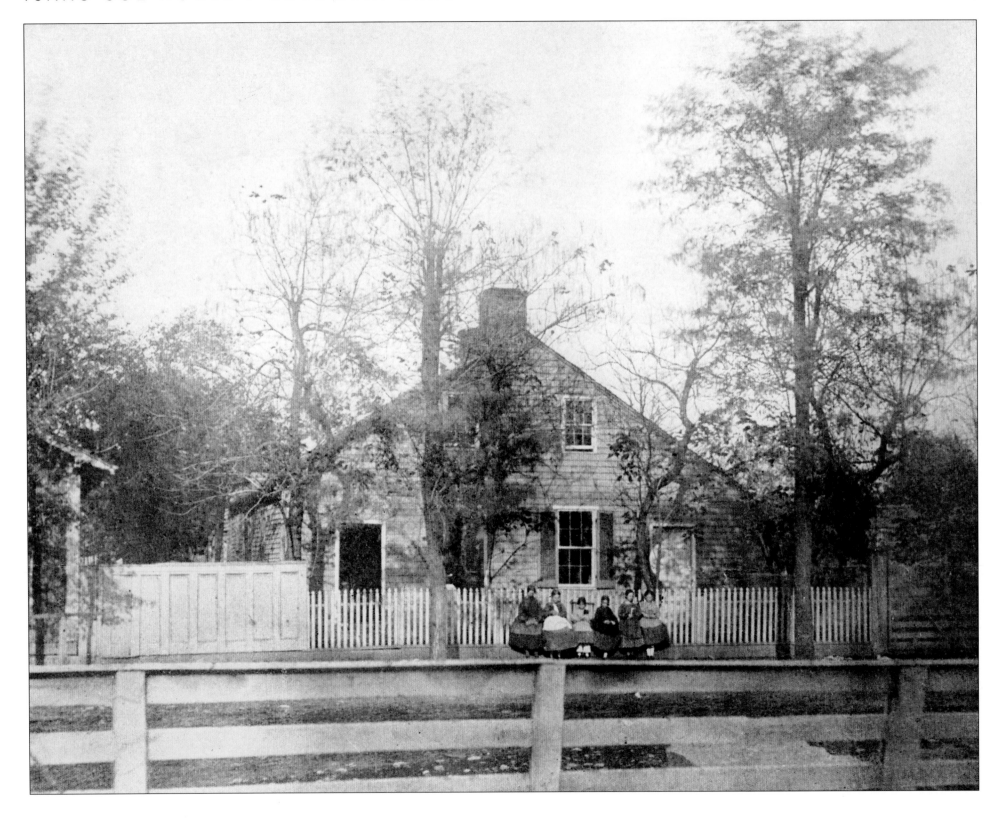

Left: Before construction of the Soldiers' and Sailors' Monument, the circular street at the heart of the city—now known as Monument Circle—was the address for several private homes. They included the residence of Dr. Isaac Coe (1782–1855), who became the second physician in Indianapolis when he moved here in 1821, just in time to treat victims of a malaria epidemic that hit the brand-new city. Dr. Coe's house, as seen in this image from the 1850s, was on the northeast quadrant of what was then called Circle Street. For most of the 1800s, the Circle was a mix of residential and religious structures. Four churches had been built on Circle Street by 1843, including the First Presbyterian Church, where Dr. Coe served as an elder. Coe's office is visible to the left of his house in this photo.

Right: One of the most prestigious private clubs in Indianapolis, the Columbia Club opened on the former site of Dr. Coe's house in 1925. The ten-story building has banquet rooms, a fitness center, a library, and overnight guest rooms. The Columbia Club quickly gained a reputation as a bastion for influential Republicans. Meanwhile, members of the rival Indianapolis Athletic Club, who opened a clubhouse at Meridian and Vermont streets, were generally perceived as Democrats. By the 1980s, though, both clubs had shed their rigid partisan identifications and pitched themselves as gathering spots for a range of Hoosier business and civic leaders. By 1980, both of the former "men's clubs" had admitted their first women members.

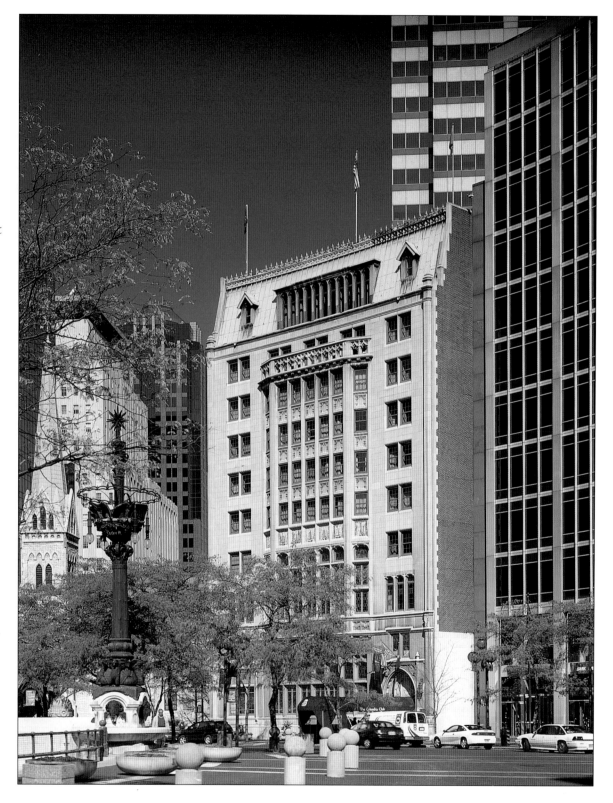

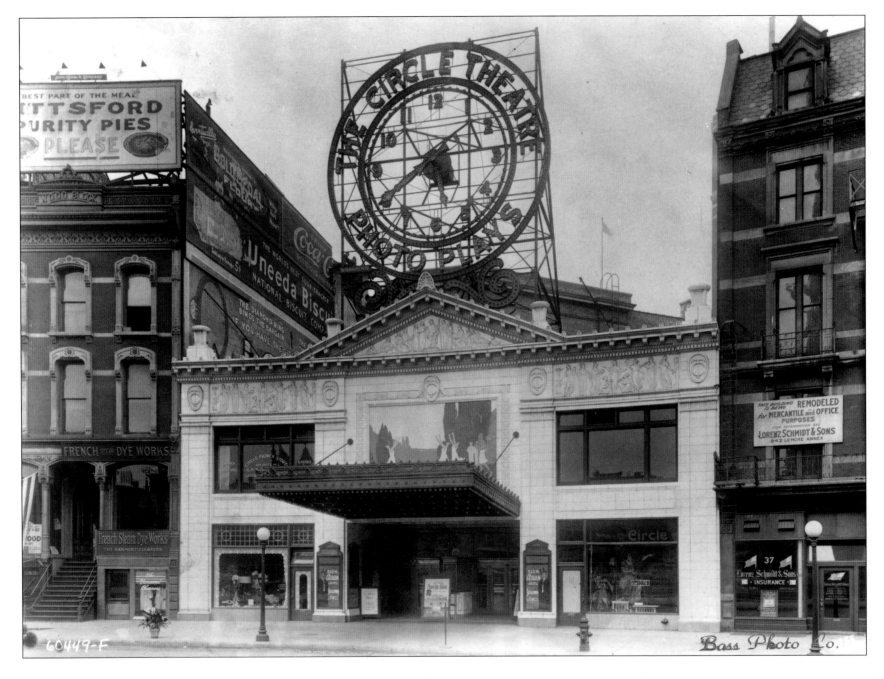

During the early 1900s, movies in Indianapolis were shown primarily on storefronts. In 1916, though, the lavish Circle Theatre opened in the southeast quadrant of Monument Circle as one of the first motion picture palaces in the Midwest. Indeed, the neoclassical-revival building became one of the first theaters west of New York built specifically to show movies. For sixty-five years, the terra-cotta Circle Theatre with its marquee of classical ornamental friezes—as seen in this photo from 1917—primarily showed movies, with occasional concerts by the likes of Frank Sinatra and jazz legend Dizzy Gillespie. However, with the proliferation of multiscreen cinemas in suburban malls during the 1960s, the once-elegant Circle Theatre began showing second-rate movies and slid into seediness.

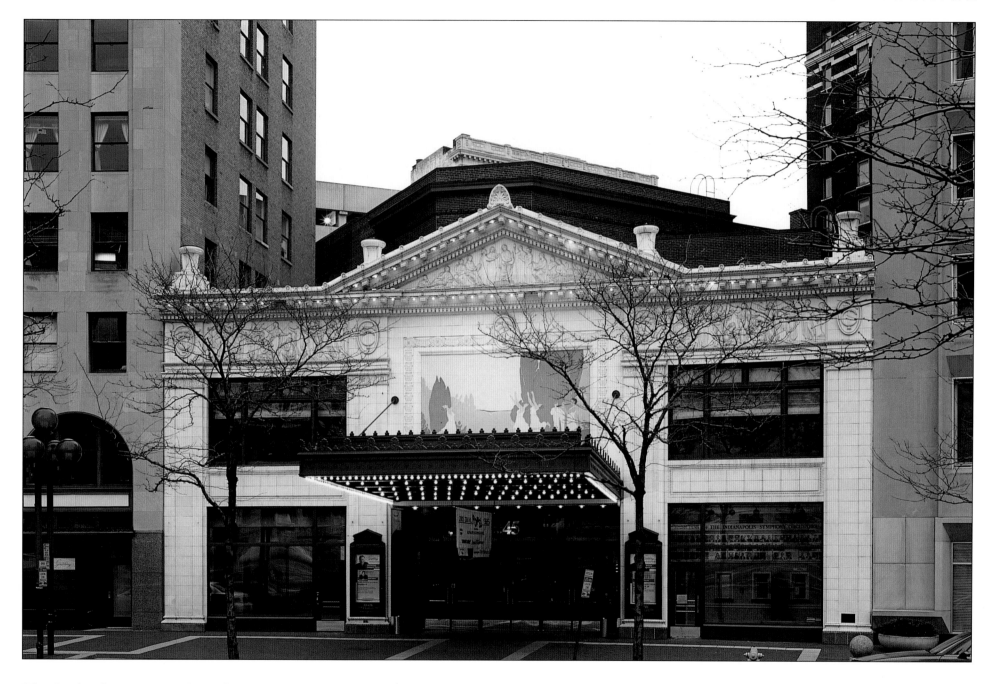

The Circle Theatre—now the Hilbert Circle Theatre—had a $6.8 million renovation in 1984. The historic theater's stage was reconfigured and enlarged to accommodate the Indianapolis Symphony Orchestra, which made the renovated theater its home. The renovation included everything from restoration of the theater's seats to replacement of storefronts and playbill cases. In 1991, actress Kitty Carlisle hosted a centennial celebration of the birth of composer Cole Porter, a native Hoosier. Five years later, Indiana residents Stephen and Tomisue Hilbert donated $10 million to the symphony, resulting in the renaming of the concert hall as the Hilbert Circle Theatre. Occasionally, the theater reverts to its original use as a movie palace; it hosted the world premiere of *Hoosiers* in 1986.

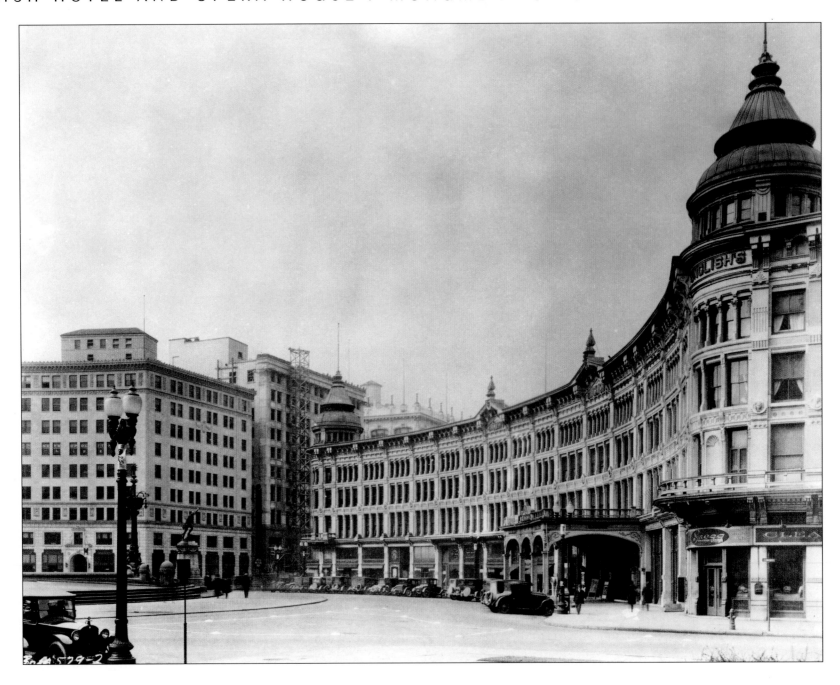

For decades, the stunning English Hotel and Opera House dominated the northwest quadrant of Monument Circle. The majestic buildings, as seen in this photo from about 1925, were created by William H. English, a Democratic congressman and one of the city's first millionaires. The four-story opera house opened in 1880 and impressed the public with its frescoed walls and ceiling, massive pillars, elaborate chandeliers, and exterior balcony.

With the largest stage in the city and plush red seats, the opera house presented opera, ballet, musicals, and lectures. Legendary performers such as Sarah Bernhardt and the Barrymores captivated audiences at the opera house, a showplace of the Midwest. After William English died in 1896, his son oversaw the completion of the hotel's second section, which stretched to Market Street.

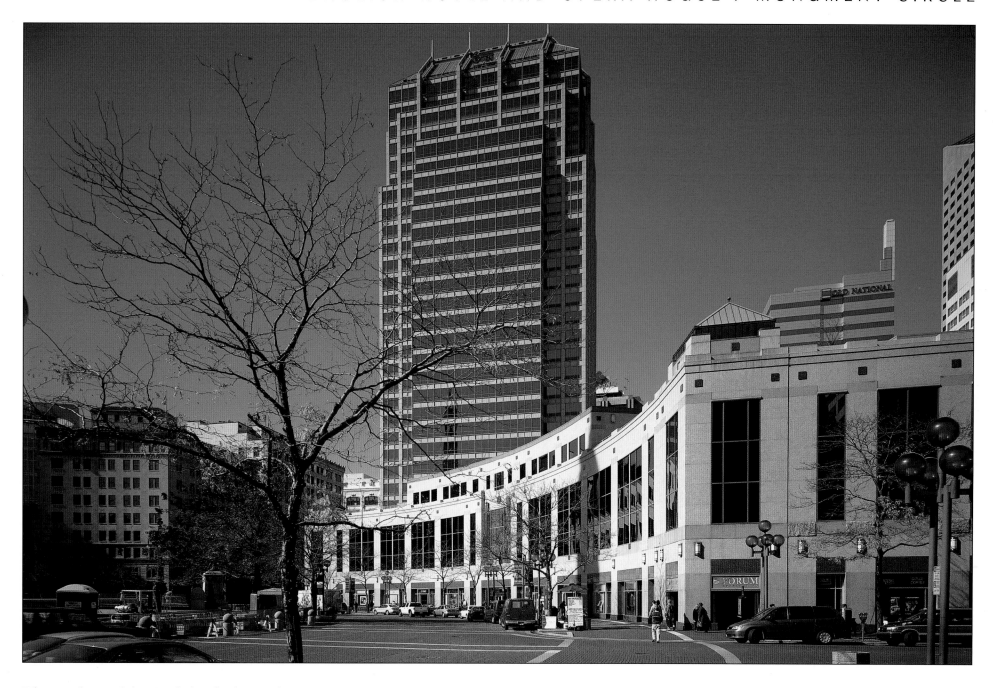

This quadrant of the Circle has had several renovations and occupants since the English Hotel and Opera House was demolished amid a loud outcry from the public in 1948. The hotel and opera house gave way to a building that was leased to the J. C. Penney chain, which opened a department store there in 1950. The J. C. Penney store remained on the Circle for almost thirty years, when downtown decline resulted in the store's closure. The prized location on Monument Circle once enjoyed by the English Hotel and Opera House is today the site of an office complex that includes Anthem Inc., an Indiana-based health benefits provider. The complex also houses a FedEx office and a printing company's outlet.

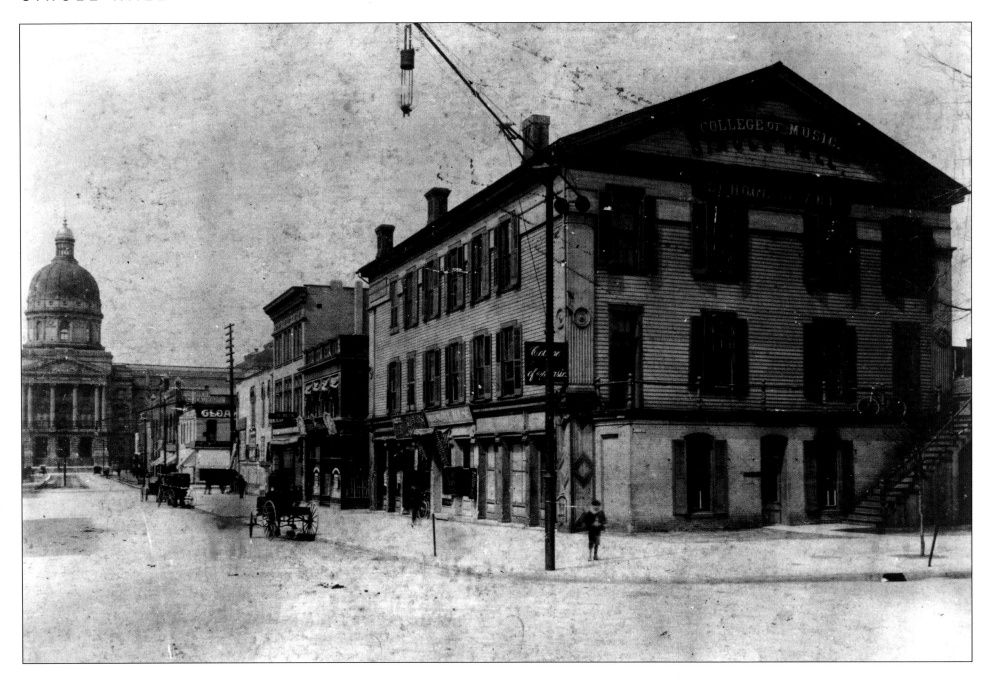

Shown here is Circle Hall in 1895, located on the northwest section of Monument Circle at the Market Street corner. The structure was originally built in 1840 as the Second Presbyterian Church, where the young pastor Reverend Henry Ward Beecher was a popular and dynamic orator. In 1844 he won national acclaim when his sermons about morality were published as "Lectures to Young Men." Following a series of renovations and the removal of the belfry, the church became Circle Hall. It housed various stores, offices, art and music schools, and for a time, the Indianapolis City Hall.

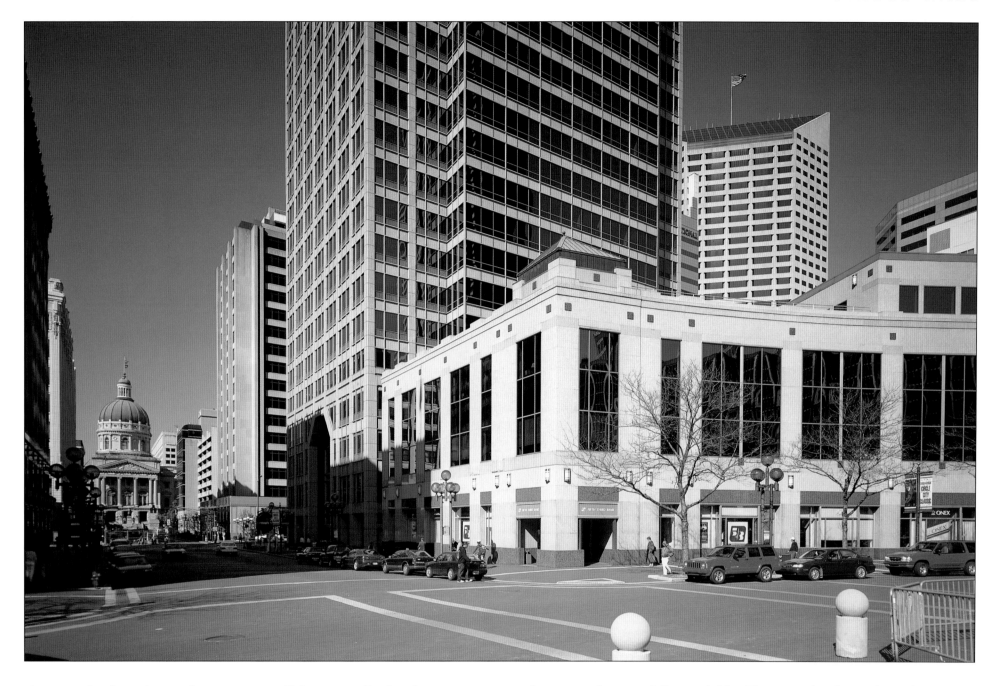

A view today from the northwest section of Monument Circle takes in Market Tower (rising out of the center of the photo). Market Tower is a thirty-story building of reddish-brown granite siding and blue-green tinted glass selected to match the patina of the bronze on the Soldiers' and Sailors' Monument. Completed in 1987, Market Tower houses the Bingham McHale law firm, real estate development companies, a conference center, a gift shop,

and a spectacular waterfall in its lobby. The view also shows the Indiana Statehouse, just as surveyor Alexander Ralston envisioned it when he planned the city in 1821. The large congregation of Second Presbyterian now worships much farther north at Seventy-seventh and Meridian streets; just as in Beecher's day, many of the city's power brokers are among its members.

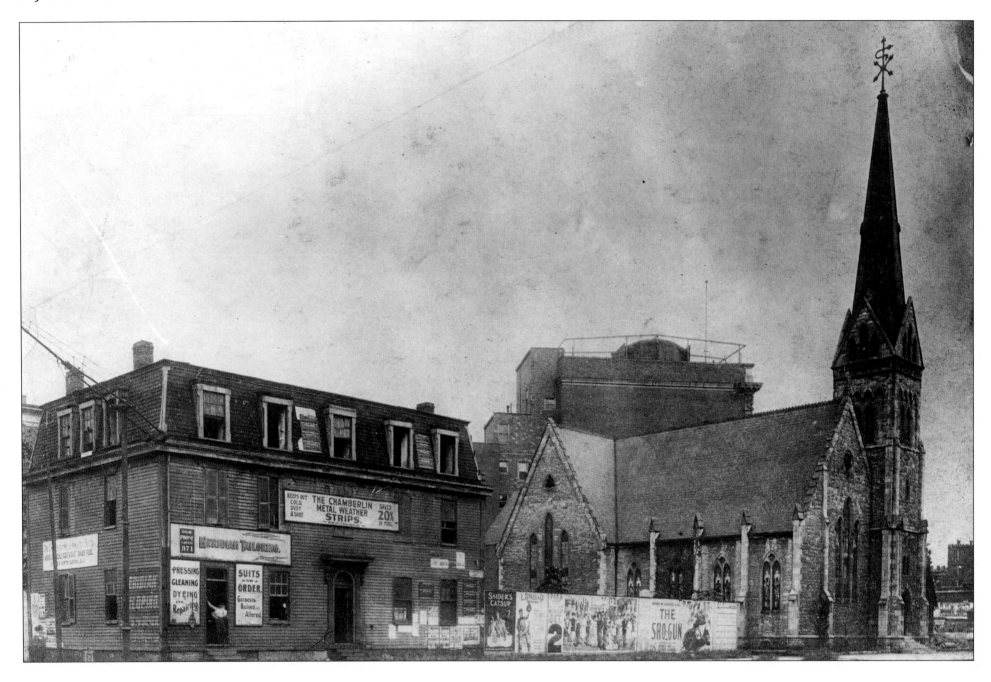

The Pyle House, seen on the left, was a sleepy-looking boardinghouse on the southeast corner of Meridian and Ohio streets that was torn down in 1905. It was replaced by an office building that served as the Indianapolis Chamber of Commerce. The Christ Church Cathedral is visible in the photo to the right of the Pyle House. The cathedral, with its entrance on Monument Circle, was constructed between 1858 and 1861 and is the oldest religious structure in Indianapolis; the Episcopal congregation's roots extend even further back to its original cathedral, which was built in 1837. Designed in the English Gothic style, Christ Church Cathedral is renowned for its choirs and support of the arts.

The forty-eight-story Bank One Tower, built in 1990 on the former Pyle House site, is the tallest building in the state of Indiana. Bank One Corporation is based in Chicago, although it has roots in the Indianapolis banking community as a result of various mergers involving the former Indiana National Bank. Before the Bank One Tower and its antennae changed the Indianapolis skyline, the state's tallest building was the thirty-eight-story American United Life Tower, constructed in 1981. In addition to the bank, the downtown complex also houses at its ground level (inset) an investment firm and offices of Guidant, a manufacturer of cardiovascular devices and medical equipment.

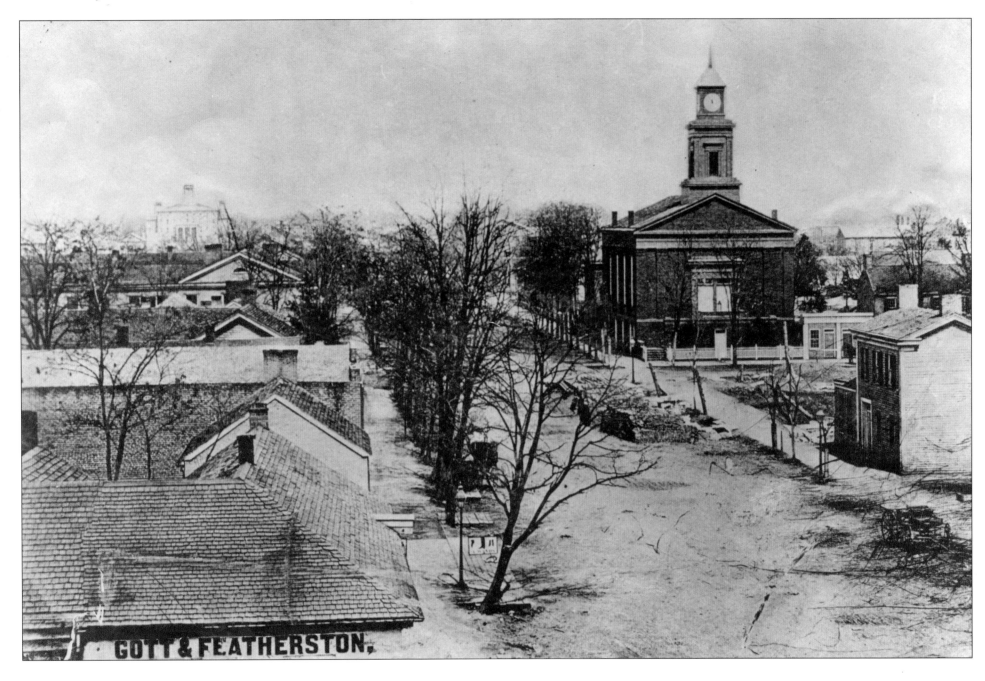

GOTT & FEATHERSTON,

This ca. 1854 street scene is the oldest known photograph of Indianapolis. The whereabouts of the original photo, a daguerreotype, are unknown. The downtown scene depicts North Pennsylvania Street—still a dirt road—looking northward from East Washington Street. The building in the lower left was an auction house. In the upper right is the Roberts Park United Methodist Church (then known as Roberts Chapel) in its original location at Pennsylvania and Market streets; the church had just installed its clock tower. In the southeast (right) corner, houses are being demolished to make way for the construction of the U.S. Post Office. In 1854, the population of Indianapolis, which was then undergoing rapid growth, was about 13,000, compared to just 2,692 in 1840.

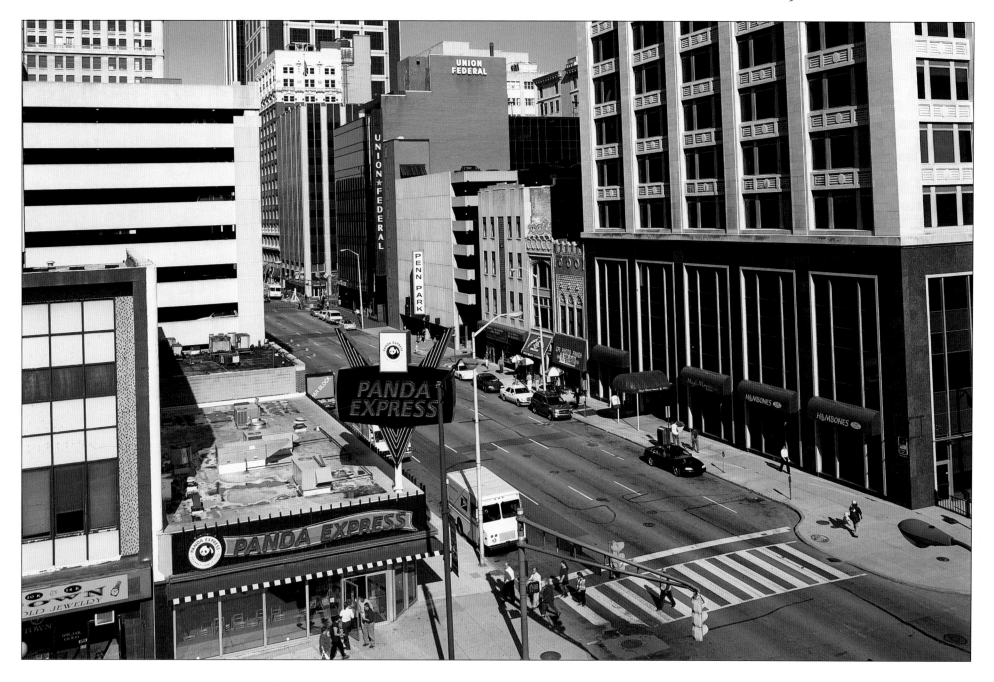

Looking sleek and modern today from the vantage point at Pennsylvania and Washington streets, downtown is the epicenter of a metro area of 1.6 million people, according to the 2000 U.S. Census. Nearly one fourth of all Hoosiers now live in the Indy metro area. The population of consolidated Indianapolis (Marion County) is 782,000, making it the twelfth-largest city in the country.

The view up Pennsylvania takes in several office towers, as well as Panda Express, a Chinese takeout restaurant. Panda Express is on the long-time site of Roselyn Bakery, an Indianapolis-based pastry chain that closed in the mid-1990s. In 1869, the Roberts Park United Methodist Church moved to its current location at Vermont and Delaware streets.

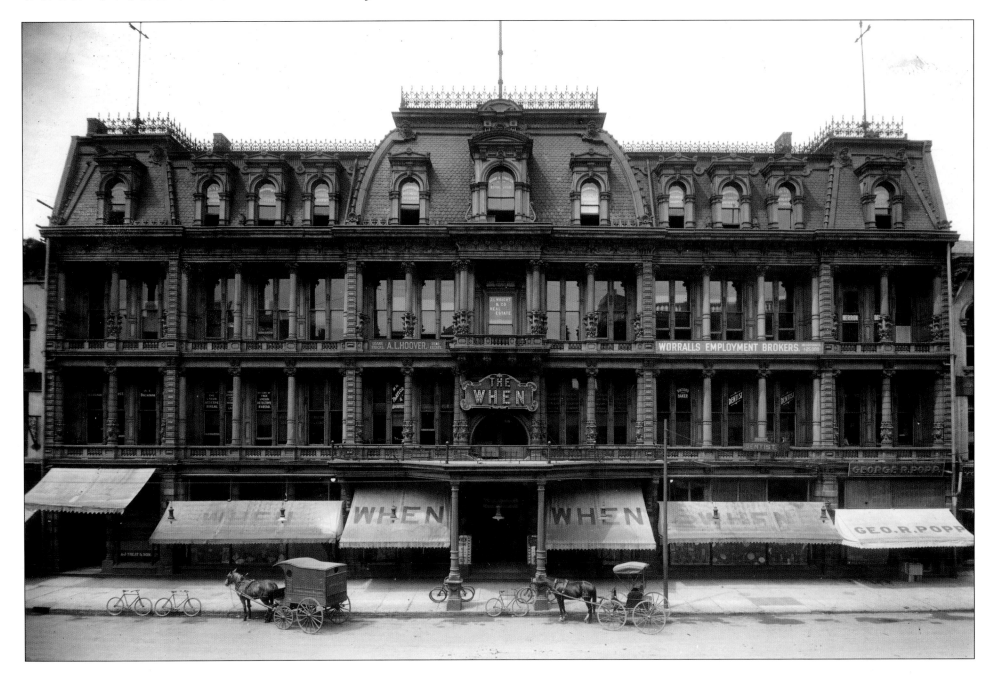

"WHEN is the store going to re-open?" was the teaser promotional campaign for a clothing store that shut down for remodeling in 1875. A flamboyant personality, store owner John Brush didn't stop there. He also rented roofs of barns across Indiana and had "WHEN?" painted on them. The gimmick proved so successful that the structure at 36 North Pennsylvania Street became known as the When Building and the emporium as the When Store.

Shrewdly, Brush had capitalized on his major frustration: the uncertain reopening of the store was due to needless delays in the remodeling. The When Building, seen here in a 1905 photo, had a mansard roof and an interior courtyard. The building was remodeled in the 1940s, when the balconies and balustrades lining the rooftop were eliminated.

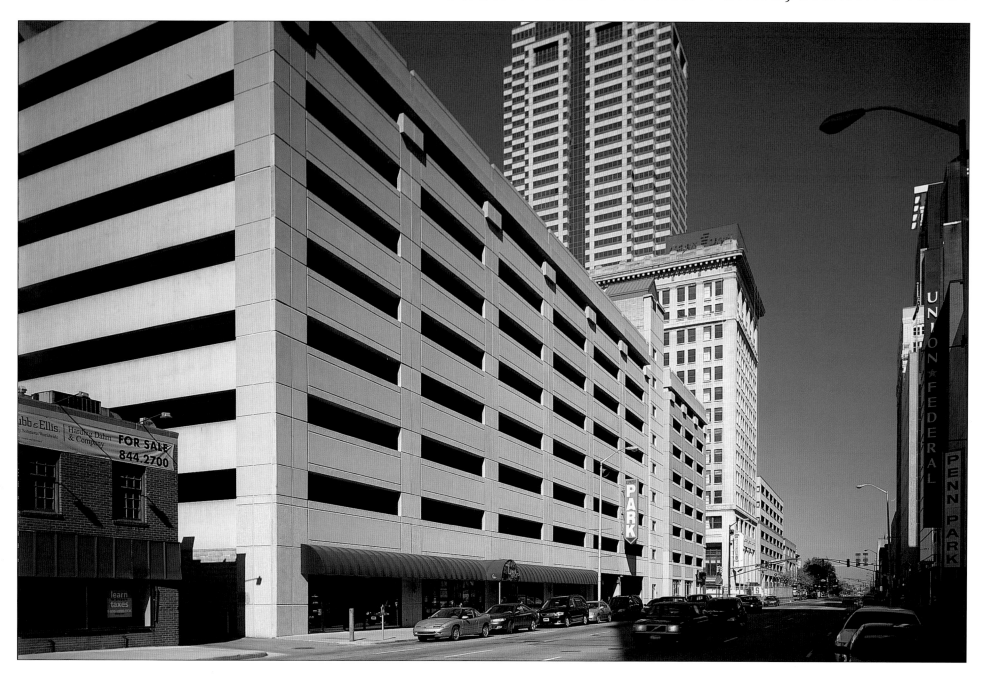

The When Building was renamed the Ober Building and then demolished in 1995. The block of North Pennsylvania Street today has a mix of uses, including the Cozy Restaurant and Lounge at 20 North Pennsylvania, a popular hangout for attorneys, as well as retail outlets and a multistory parking garage. City planners encourage developers of new downtown parking garages to create "pedestrian-friendly" businesses on the sidewalk level, such as cafés and retail outlets, so that downtown workers and visitors don't have to stare at garage doors or rows of parked cars. The former American Fletcher National Bank Tower, to the right of the Cozy Restaurant and Lounge, is being converted into an upscale hotel as part of a $23 million project. The Hilton Garden Inn is expected to have 108 rooms.

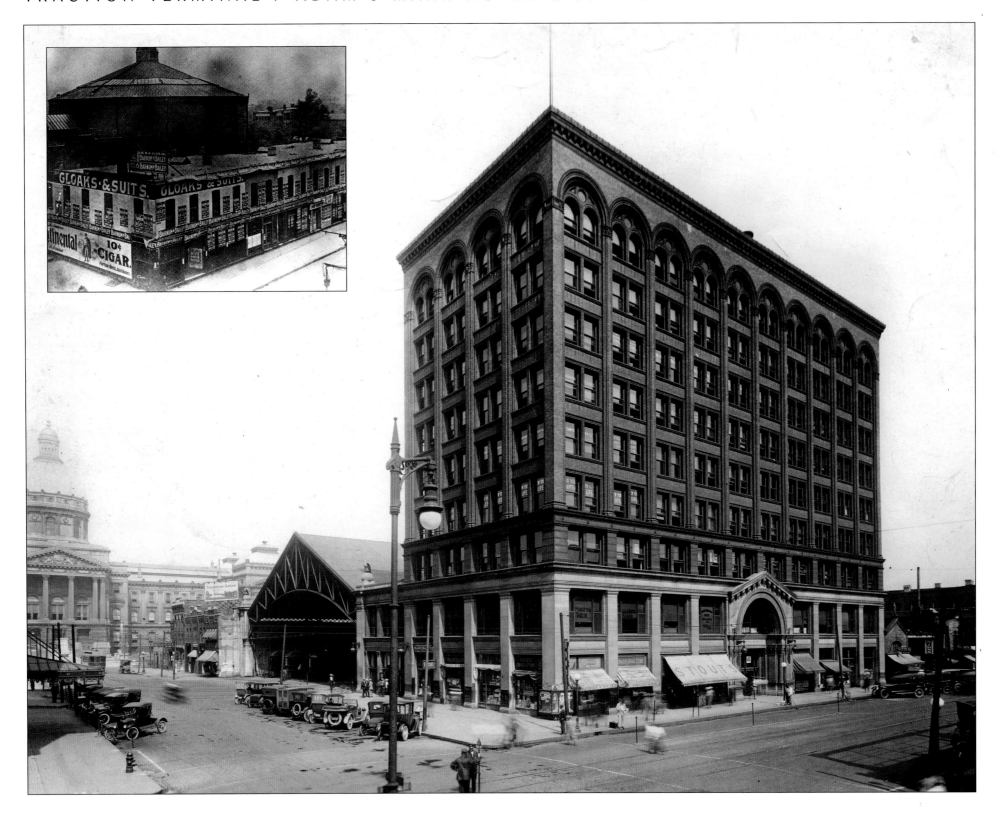

Left: The northwest corner of Market and Illinois streets has had several lives in Indianapolis history. In 1888, it became the site of the dome-shaped Cyclorama, shown here around 1900 (inset), an exhibition hall with gigantic Civil War murals. The windowless Cyclorama was razed in 1903 for construction of the massive Indianapolis Traction Terminal, seen here in 1918, the hub of the state's popular interurban electric rail system. The nine-story Traction Terminal was touted as the largest in the world when it opened on September 12, 1904. It housed 250 offices and a waiting room. Passengers rode the interurbans to neighborhoods such as Woodruff Place or nearby towns like Broad Ripple.

Right: By the late 1930s, most interurban lines had been discontinued and many tracks were paved over for use by buses. The terminal building became a hub for bus operations before being demolished in 1972, four years after the old train shed was torn down. For many years, the site was occupied by an office tower for BlueCross BlueShield of Indianapolis. Adam's Mark Hotel & Suites opened here in 2000 at 120 West Market Street, the site of the long-gone Traction Terminal. The Adam's Mark, which has 332 guest rooms, was part of a downtown hotel boom that included the opening of a new Marriott in 2001.

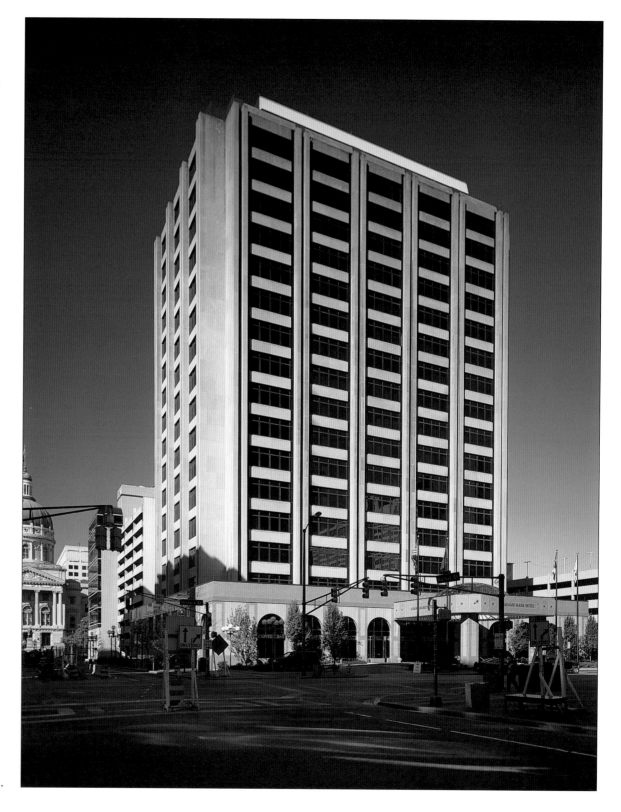

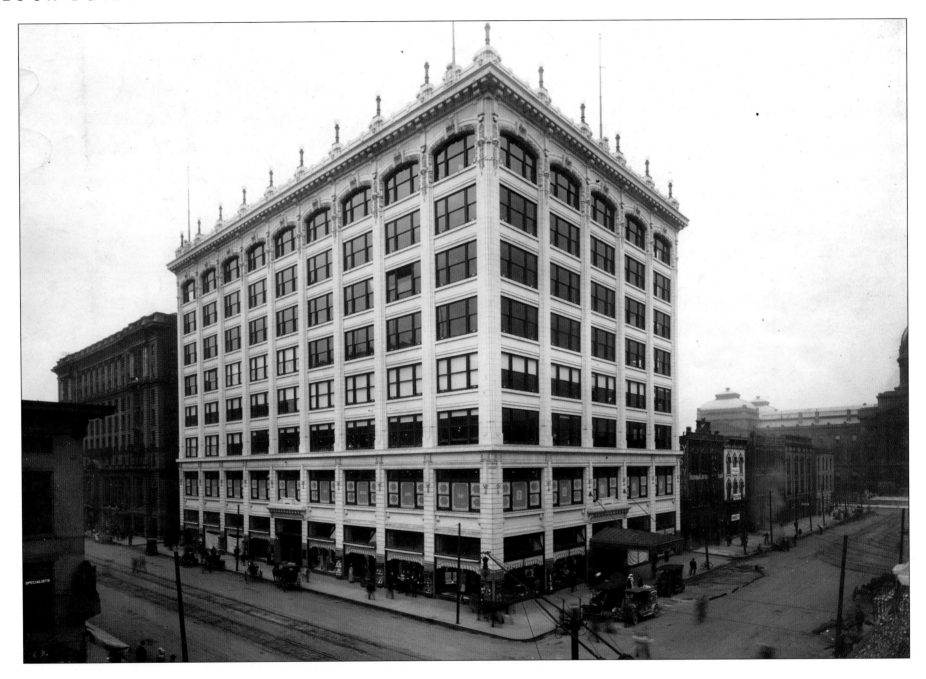

An indefatigable immigrant from Hungary, William H. Block founded a department store that became a favorite for generations of Indianapolis residents. Block studied to be a rabbi in his homeland, then failed at several endeavors elsewhere in America, including farming and telegraphy, before he moved to the city in 1896. His legendary department store is seen here in 1911, the year of its grand opening on the southwest corner of Illinois and Market streets. Known far and wide as Block's, but officially called the William H. Block Company, the store had previously operated for about fifteen years in a building on Washington Street. The eight-story Block store benefited from its location across from the bustling Traction Terminal.

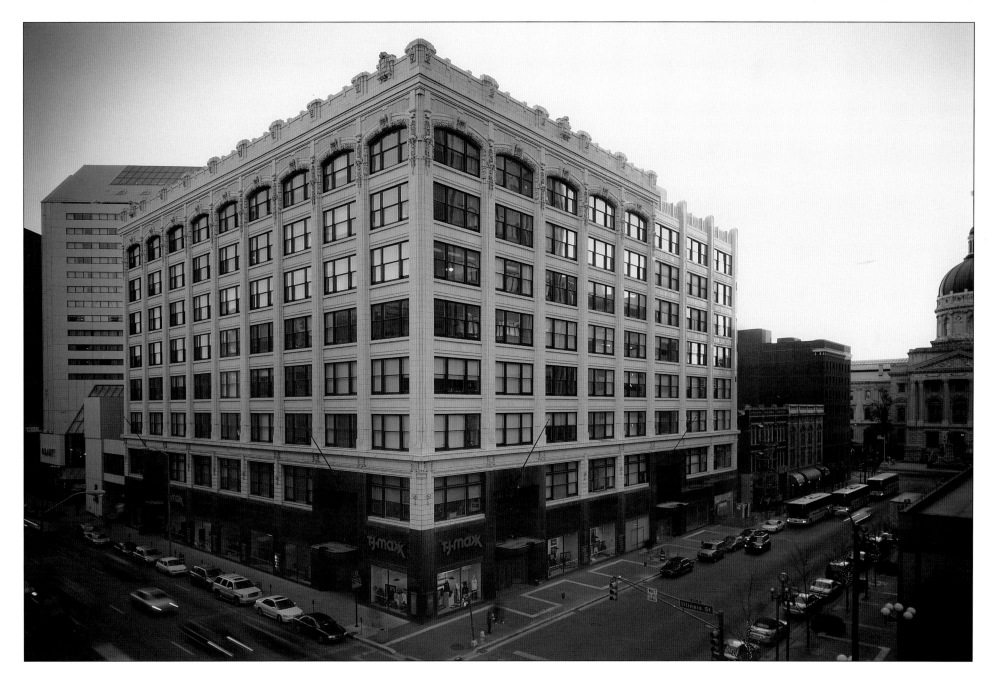

More than 105 years after William H. Block showed up in Indianapolis with a dream, the building that housed his department store is still associated with retailing. A large clothing store is located on the first floor, and the upper floors of the former Block Building are being converted into residential units. Block, who became a benefactor of the Riley Hospital for Children and various charities, died in 1928. His sons oversaw expansion of the department store, opening Block outlets in shopping centers in suburbs such as Glendale. A series of ownership changes, though, meant that in 1988 all of the Block stores in Indiana became part of the Cincinnati-based Lazarus chain. Lazarus closed the flagship Block store in 1993, opening the door for today's retailers, including the T.J. Maxx store seen here.

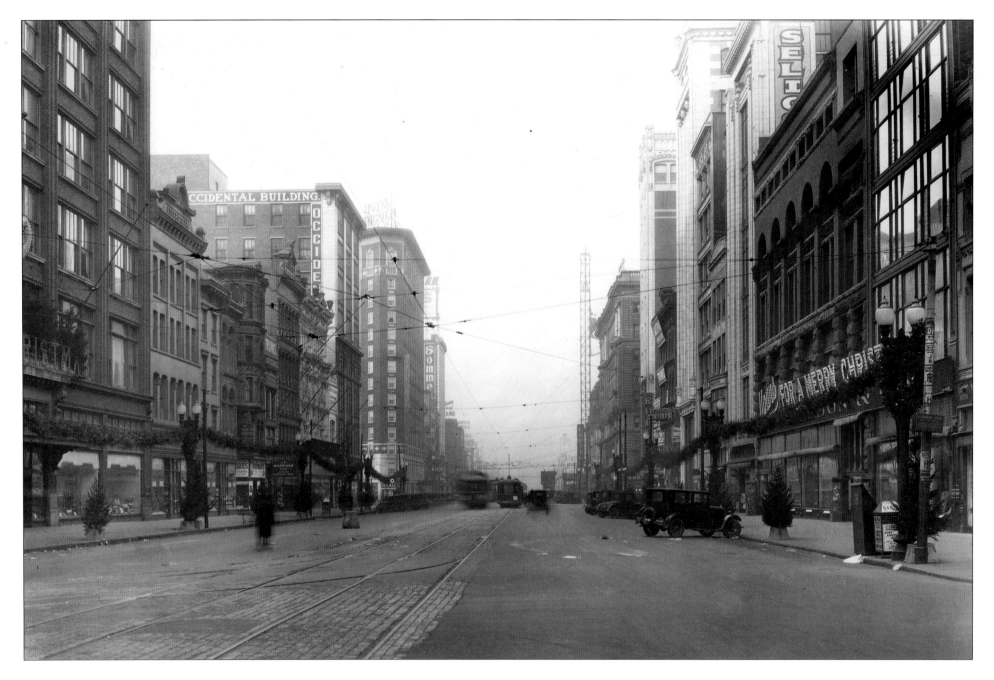

During the yuletide season of 1926, the view looking west along Washington Street takes in various department stores, including the flagship of arguably the most beloved of all Indianapolis-based retailers, L. S. Ayres & Co. The store was founded by local merchant Lyman S. Ayres (1824–96), whose son, Frederick, assumed control after his father's death. The westward view down Washington Street also takes in part of the grand Lincoln Hotel. The streetcar tracks and the broad width of Washington shows it was designed to be the city's main east-west artery. Although the street's width hasn't changed, L. S. Ayres has undergone several transformations. The chain was purchased in 1986 by St. Louis–based May Department Stores Company. Seven years later, the company announced Ayres would not be part of the Circle Centre Mall and closed the downtown store.

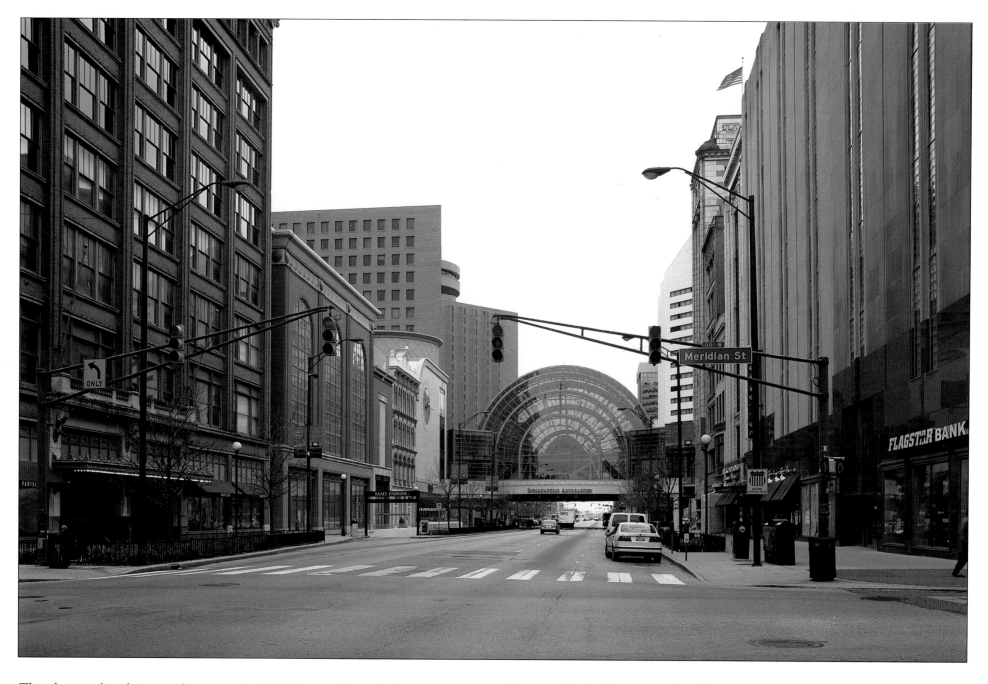

The glass-enclosed Artsgarden spanning Washington Street is the most striking symbol of Circle Centre, the $307 million retail and entertainment complex that's the crown jewel of downtown rejuvenation. Circle Centre, which features 130 specialty stores, restaurants, bistros, bars, and the retail anchors of Nordstrom and Parisian, opened in 1995 with a black-tie celebration that involved fireworks, rousing music, and tributes from famous Hoosiers. Circle Centre was developed by the Indianapolis-based Simon Property Group, the country's largest owner of shopping malls. However, the Artsgarden is owned and operated by the Arts Council of Indianapolis, a private nonprofit group. Seven stories tall with a large atrium, the Artsgarden serves as an elegant setting for receptions and exhibits. It stretches across Washington at its intersection with Illinois Street.

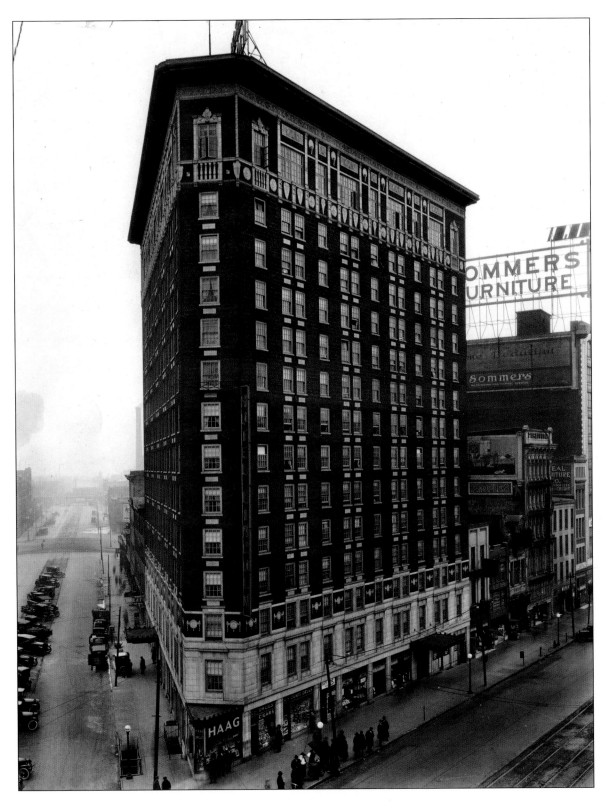

Hoosiers have always felt they had a special relationship with Abraham Lincoln, who lived in southern Indiana from when he was seven until he was twenty-one; the distinctive, flatiron Lincoln Hotel was one of many buildings and businesses named in honor of "the Great Emancipator." The hotel opened in 1918—four years before this photo was taken—at the corner of West Washington Street and Kentucky Avenue. It quickly became the setting for political, civic, and social gatherings, as did the rival Claypool Hotel. The posh Claypool, which opened in 1903 at Illinois and Washington streets, was built on the site of the legendary Bates House, where Abraham Lincoln spoke from a balcony to a crowd of Hoosiers in 1861. During his White House years, Lincoln said, "I grew up in Indiana"—even though many Americans associate him exclusively with Kentucky and Illinois. The Indianapolis hotel named in his honor closed in 1970 and was demolished three years later.

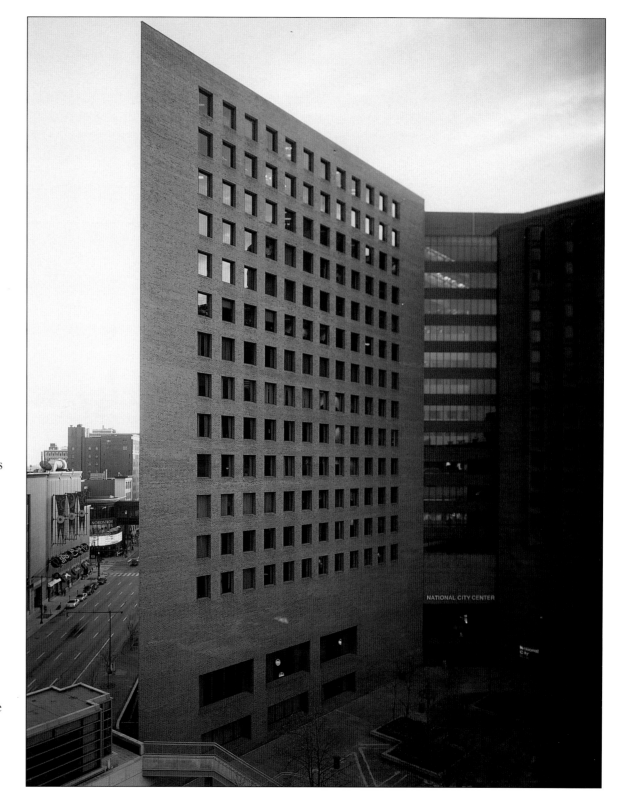

Among the first modern urban hotels built in Indianapolis was the Hyatt Regency Hotel, which opened in 1976 on the former Lincoln Hotel site. The Hyatt is part of a complex known as the National City Center; by the time of its construction, most of the grand hotels of the early twentieth century were gone. The Claypool Hotel, where celebrity guests ranged from Eleanor Roosevelt to Gene Autry, closed after a fire in 1967. This photo of the National City Center was taken from the ninth floor of the Embassy Suites, which is on the former Claypool site. With more than 500 rooms and dazzling glass elevators, the Hyatt Regency has a twenty-story atrium, a bank, and several restaurants, including a revolving rooftop dining spot. Because the Hyatt is near the city's sports arenas, the hotel is a favorite of visiting NFL and NBA players.

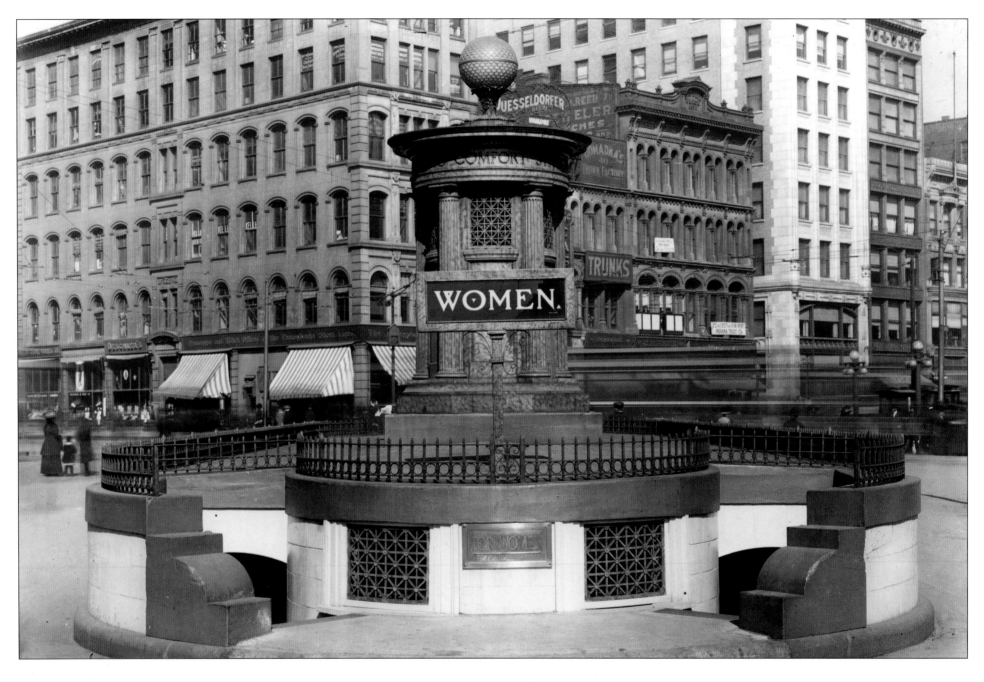

The "comfort stations"—one serving female pedestrians, with an adjacent one for males—provided a basic service in 1911, when this photo was taken. Then only one year old, the comfort stations were belowground public restrooms built for $17,000 on an island at the intersection of Kentucky Avenue and West Washington Street. The city council prohibited shoeshine stands at the comfort stations because they might encourage loafing. Within six months of the stations' opening, women's groups were expressing concerns about their sanitary conditions and lack of ventilation. Even so, the comfort stations were used for decades, particularly by early- and late-shift workers who could not use the facilities in department stores and office buildings.

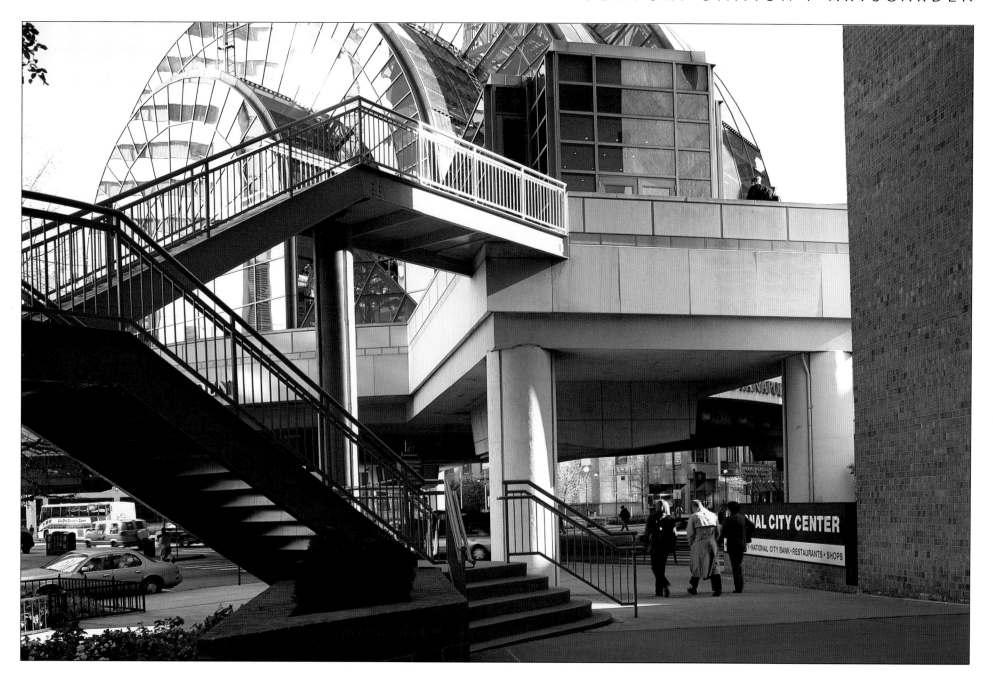

Over the years, concerns about safety in the comfort stations increased. They were sealed off in 1963. In Indianapolis, the view at the site of the long-gone comfort stations includes the Artsgarden, the symbol for the Circle Centre Mall; part of the office wing of Merchants Plaza; and such historic storefronts as the former Goodman Jewelers store and two neighboring buildings, all of which date to the 1890s. The three structures are scheduled to be part of a retail and office complex, with apartments on upper floors, that will adjoin a new downtown hotel.

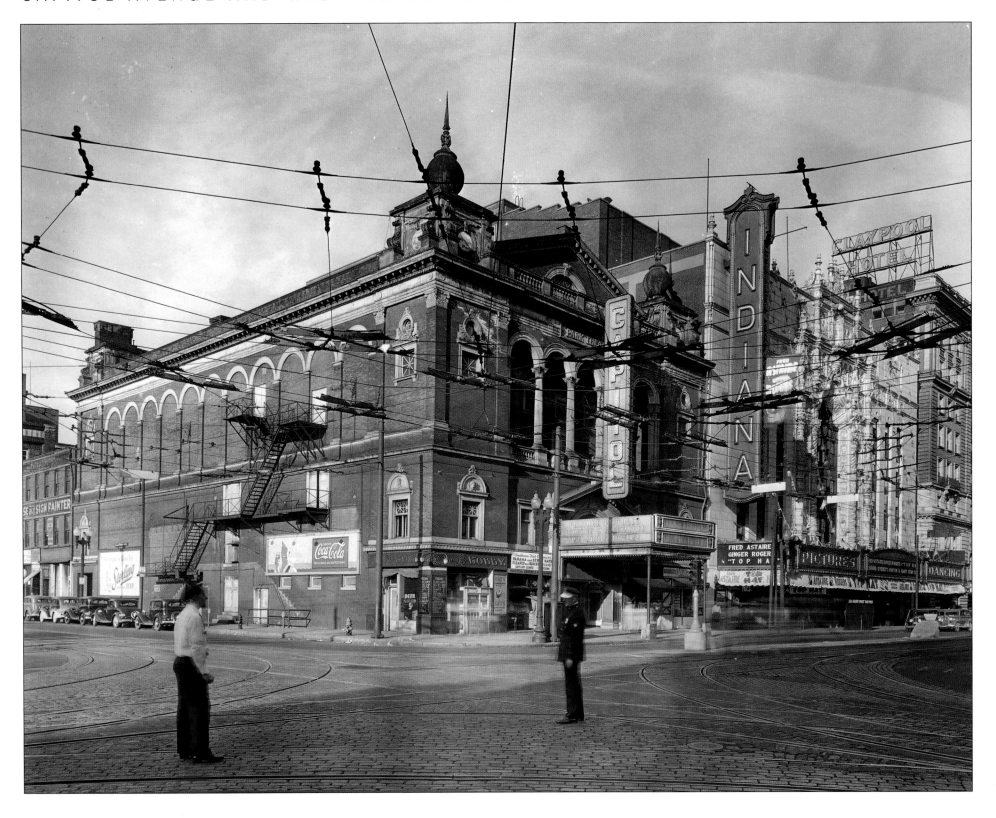

Left: Although they existed side by side when this photo was taken in 1935, the Indiana Theatre and the Capitol Theatre had vastly different histories and would have far different fates. The Spanish Baroque–style Indiana Theatre, built as a movie palace, was only seven years old when this photograph was taken. The auditorium of 3,200 seats made it the largest cinema constructed in the city at the time. In contrast, the Capitol Theatre had been built at Washington Street and Capitol Avenue way back in 1858. Known then as the Metropolitan, it was a favorite venue for circuses and vaudeville. It was from the Metropolitan stage in 1861 that a local military veteran announced the grim news that the Civil War had broken out. The Metropolitan later became the Park before another name change to the Capitol. Stock companies performed comedies and melodramas there, although it also began showing movies after being renamed the Capitol Theatre.

Right: As majestic as ever, the terra-cotta Indiana Theatre today is the home of the Indiana Repertory Theatre, a professional equity theater that presents plays ranging from British classics to world premieres by American playwrights. As a movie theater, the Indiana became the first in the state with Panavision, 3-D capabilities, and stereophonic sound. Even so, the Indiana Theatre was slated for demolition before it underwent a $5 million renovation so the acclaimed Indiana Repertory Theatre could move in. The six-story theater now has three auditoriums, including the 600-seat Mainstage Theatre. On the top floor is the Indiana Roof Ballroom, which features a deep blue ceiling of twinkling "stars." The Capitol closed in 1935; an office tower has occupied the site since 1982. Today it houses Duke Realty, a bank, a school board association, and the Indiana Department of Commerce.

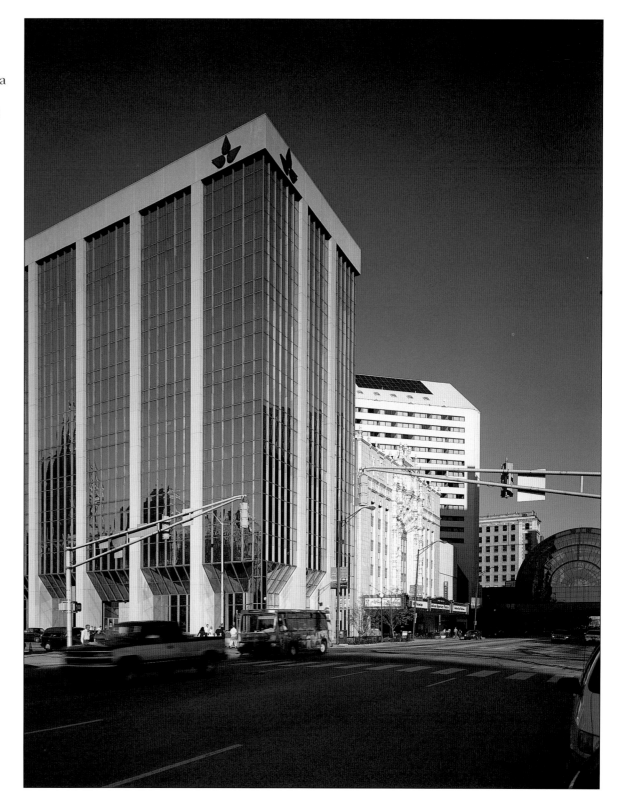

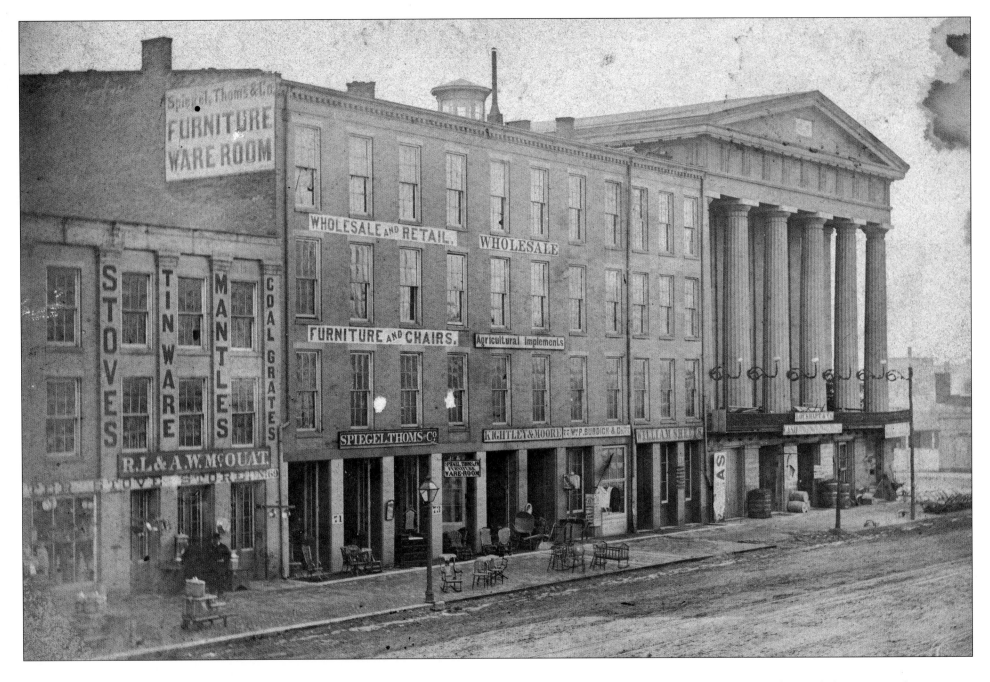

In 1851, Masonic Hall (far right) was only a year old on the southeast corner of Capitol Avenue (then Tennessee Street) and West Washington Street when it served as the site of Indiana's second constitutional convention. Debate was limited to the daytime hours because the hall, with its gas-lit chandeliers and chairs of red upholstery, was double-booked—at night, there were theatrical and musical performances by a touring company. The opening of Masonic Hall, shown here around 1870, enhanced the city's sophistication as a venue for opera concerts. Next to Masonic Hall was a German-owned furniture store, Spiegel, Thoms & Co.; it was one of an astonishing ninety-one German American businesses that were flourishing in the vicinity by 1875. By the turn of the nineteenth century, almost 70 percent of the city's population was of German ancestry.

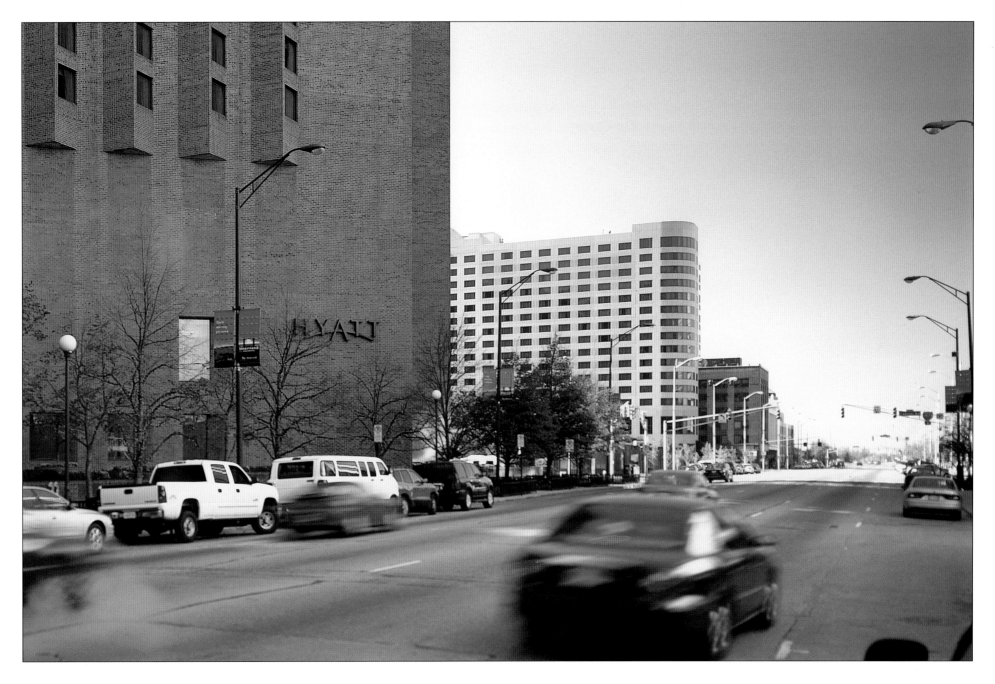

Clearly visible from the former site of Masonic Hall is the cream-colored Westin Hotel (right), situated near the Hyatt Hotel (mentioned in detail on page 29). Like Masonic Hall, the Westin, at 50 South Capitol Avenue, has a strong link to conventioneers. The 573-room hotel is connected by a covered bridge to the Indiana Convention Center and RCA Dome complex, making the Westin popular among visiting politicians and other dignitaries, not to mention visiting NFL players preparing to take on the Indianapolis Colts. The Westin, which opened in 1989, is second only to the Marriott Downtown as the largest hotel in the metro area. Today, about 17 percent of Indianapolis residents identify themselves as having German heritage, a shift that reflects the increasing percentages of Hispanics, African Americans, and other ethnic groups in the city.

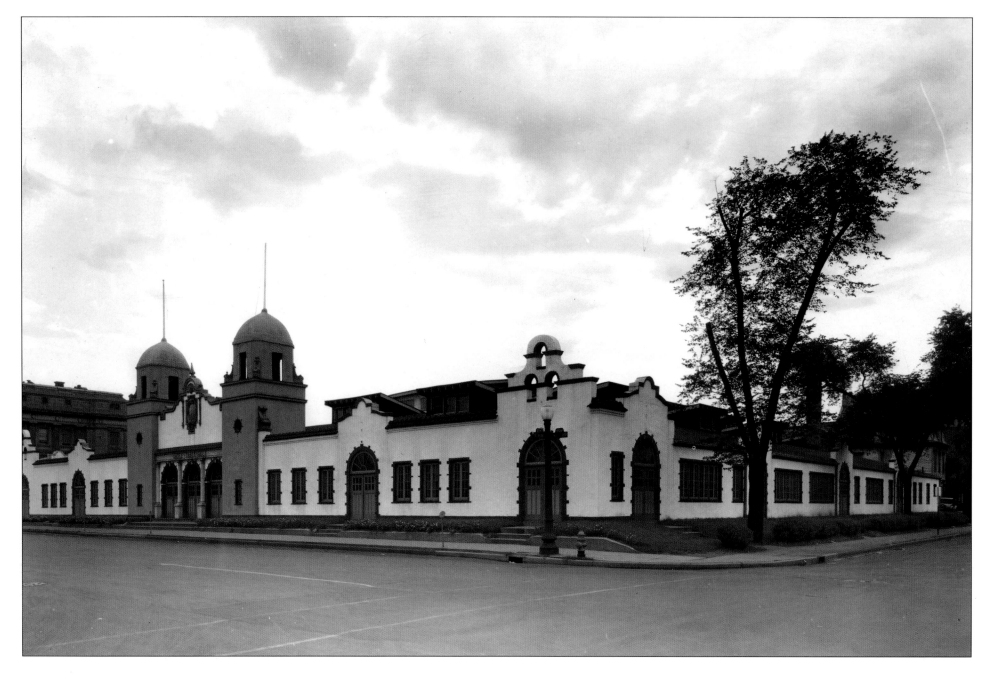

The Cadle Tabernacle, shown here in 1937, hosted a variety of public events, including religious revivals, teachers' conventions, and dance marathons. A Spanish-style convention center and revival house with a whitewashed facade, the tabernacle was built in 1921 on the northwest corner of Ohio and New Jersey streets. The owner, entrepreneur E. Howard Cadle, intended for the tabernacle to be used to promote nondenominational Christianity, but the building's use expanded to hundreds of secular gatherings. In the 1920s, when the Ku Klux Klan dominated Hoosier politics, several of its rallies were at the tabernacle. With a seating capacity of 10,000, it was ideal for large events. Glamorous film star Carole Lombard, a Fort Wayne native, spoke here in 1942 at war bond rallies. After her final visit, she was killed when her plane crashed en route to Los Angeles.

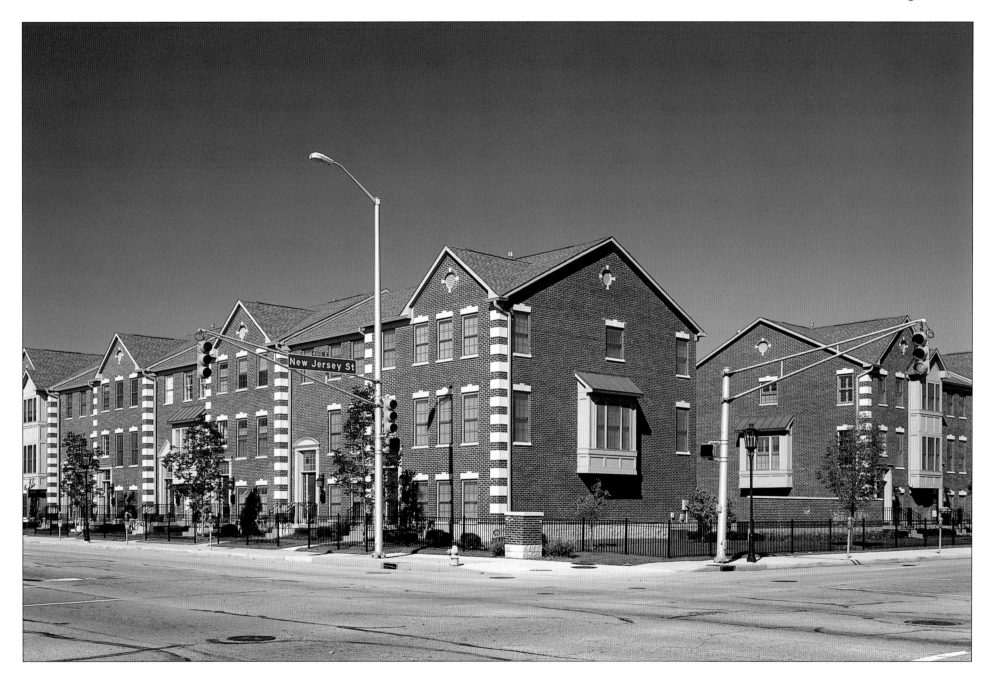

The Cadle Tabernacle was demolished in the late 1960s to create parking lots for banks and other businesses east of Monument Circle. Before and after the implosion of Market Square Arena in 2001, upscale housing was developed in the blocks surrounding the arena, including the former Cadle Tabernacle site. Town houses and condominiums are springing up as part of the downtown rejuvenation and resulting clamor for luxury urban living. In 1999, the Firehouse Square condo complex (shown here) opened on the Cadle Tabernacle site with a waiting list of 500 buyers for the fifty-six units. A similar residential boom of condos and apartments has been underway since the late 1990s west of Monument Circle.

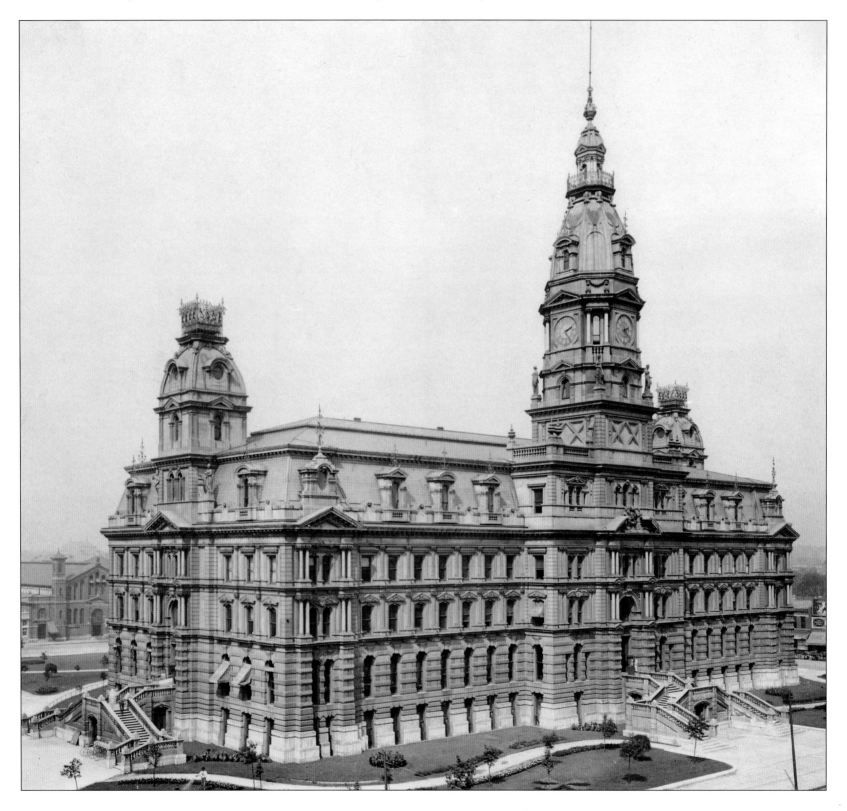

Left: The architectural jewels in most of Indiana's ninety-two counties are the courthouses, many built in the 1800s. Many small Hoosier cities designed their town squares around their courthouses. With its circular center, Indianapolis didn't do that, but for eighty-five years the ornate Marion County Courthouse remained in use. Designed in the Second Empire style with a ninety-seven-foot tower and clock, the courthouse cost $1.4 million when built in 1876 on East Washington Street. Several city government offices were located in the Marion County Courthouse (seen here around 1899) until 1909, when the first Indianapolis City Hall was built amid much hoopla at Ohio and Alabama streets. By the 1960s, both the courthouse and city hall were considered outdated and inadequate for their purposes. The city hall building was used as the home of the Indiana State Museum until 2002. The decaying Marion County Courthouse was torn down in the early 1960s.

Right: A twenty-eight-story, starkly rectangular structure, the City-County Building serves for many Hoosiers as the symbol of Unigov, even though the office tower was built almost eight years before the pioneering merger of city and county governments. Offices for the mayor and workers for city as well as county governments are housed in the building, which opened in 1962 on the former courthouse site. Championed by Indianapolis Mayor Richard Lugar in the late 1960s, Unigov consolidated local governments, stretching the newly merged city from eighty-two to 402 square miles. As a result, the city's population almost doubled, jumping from 480,000 to 740,000. The new twenty-nine-member city council had its first meeting in the City-County Building in 1971, a year after Unigov became effective. The mayor's office is on the top floor of the tower.

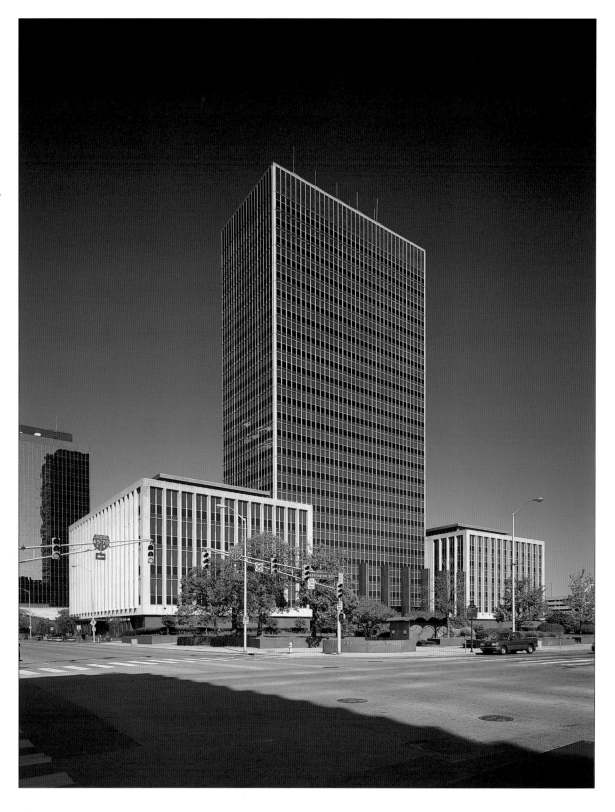

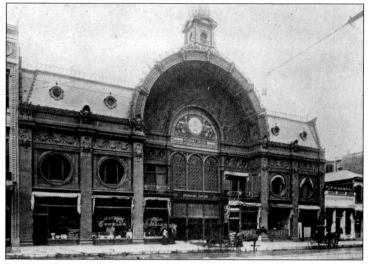

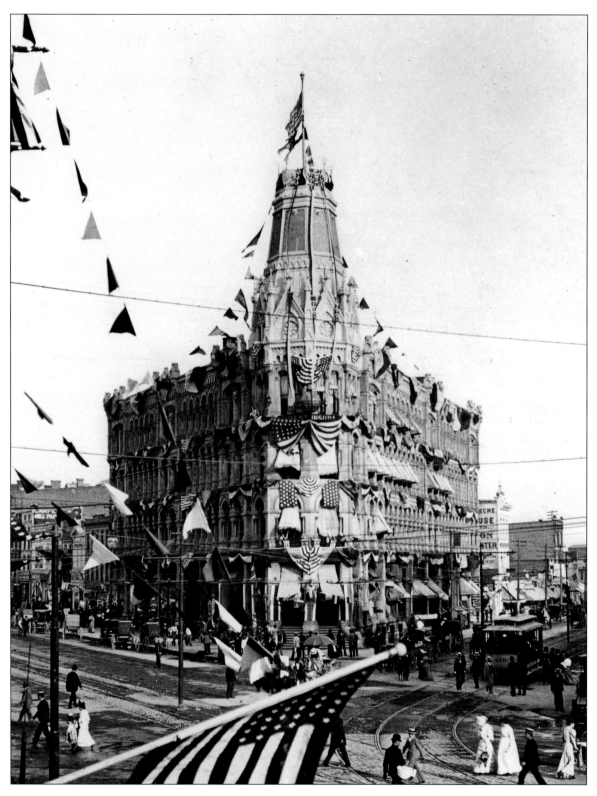

This 1893 photograph shows the majestic Vance Block building at the three-way corner of South Pennsylvania Street, Virginia Avenue, and East Washington Street. In 1876, the Vance Block became the first building in Indianapolis with an elevator. The Vance Block housed a range of businesses, including a bank, a savings and loan, and a business college. The building is decorated in this photo for a Grand Army of the Republic encampment, a Civil War reunion. Also at the three-way intersection was an equally distinctive building, the ornate Pembroke Arcade, which was built in 1895 (inset). A tunnel-shaped building of retail shops, the Pembroke Arcade had an ornamental iron balcony and two facades, one on Virginia and the other on Washington. The Pembroke Arcade was inspired by European-style buildings exhibited at the 1894 Chicago World's Fair. Although the arcade opened amid much fanfare, many of the small shops soon were struggling. The arcade was razed in 1943.

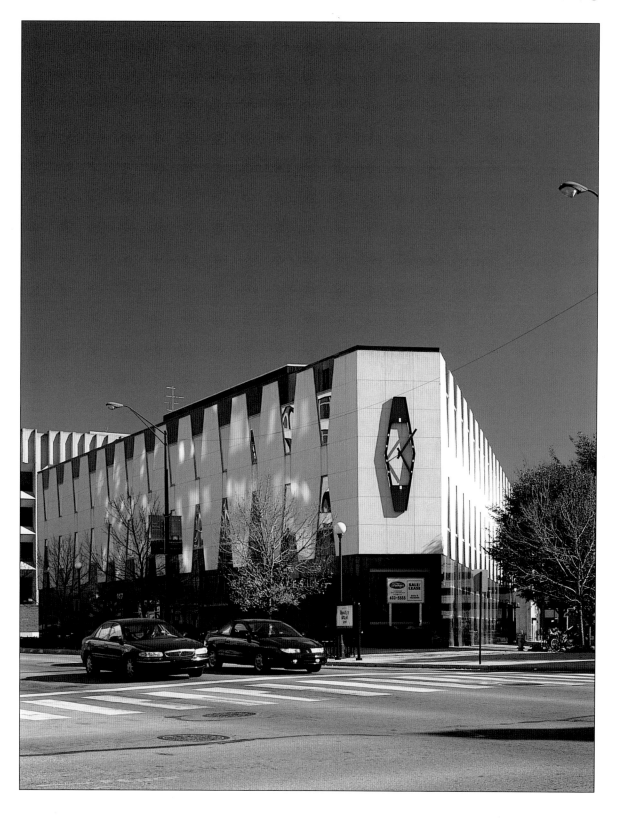

It's easy to see why the "Zipper Building" is the widespread nickname for the office structure that's at the intersection today. The isometric Zipper Building, which houses an advertising agency, is an example of the international style of modern architecture popular in the late 1960s and early 1970s, when it was constructed. This design approach rebelled against historic architectural styles; in the case of the Zipper Building and other boldly designed structures, the goal was to create a building that would be distinct from its environment.

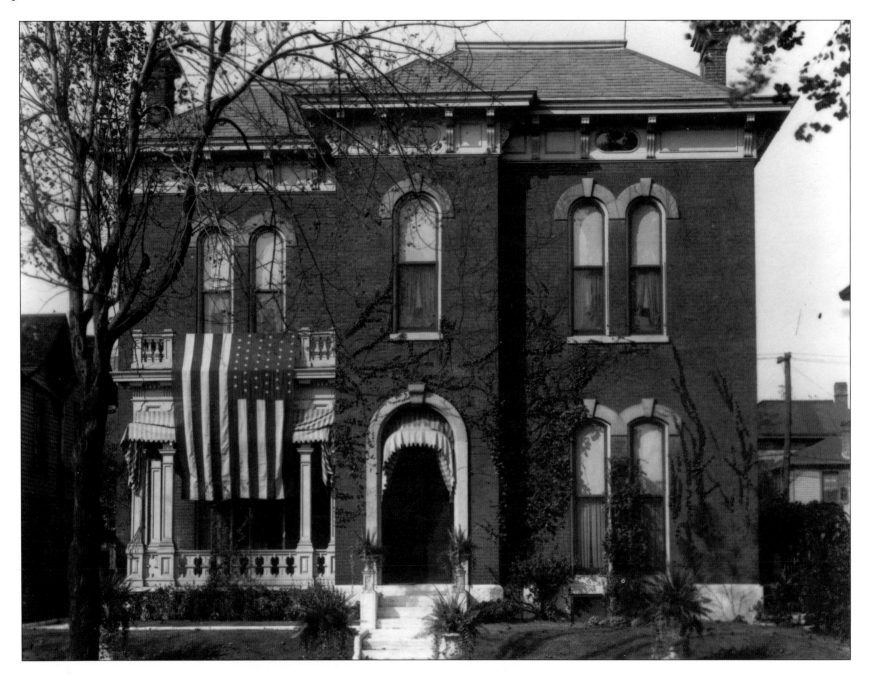

Many called him "the Hoosier Poet." Certainly, James Whitcomb Riley was Indiana's best-known poet. Beloved for his poems celebrating rural life and the joys of childhood such as swimming holes, bullfrogs, and jack-o'-lanterns, Riley was born in 1849 in Greenfield, east of Indianapolis. For about thirty years, he lived in this house in the Lockerbie neighborhood. A masterful entertainer who elicited hoots, cheers, and stomps from audiences when he read his poems in Hoosier dialect, Riley performed at the White House and became wealthy as a result of cross-country tours. He had written more than 1,900 poems, including "The Raggedy Man" and "Little Orphant Annie," by the time he died in this house in 1916. After his funeral, more than 35,000 mourners filed by his casket when it lay in state in the rotunda of the Indiana Statehouse.

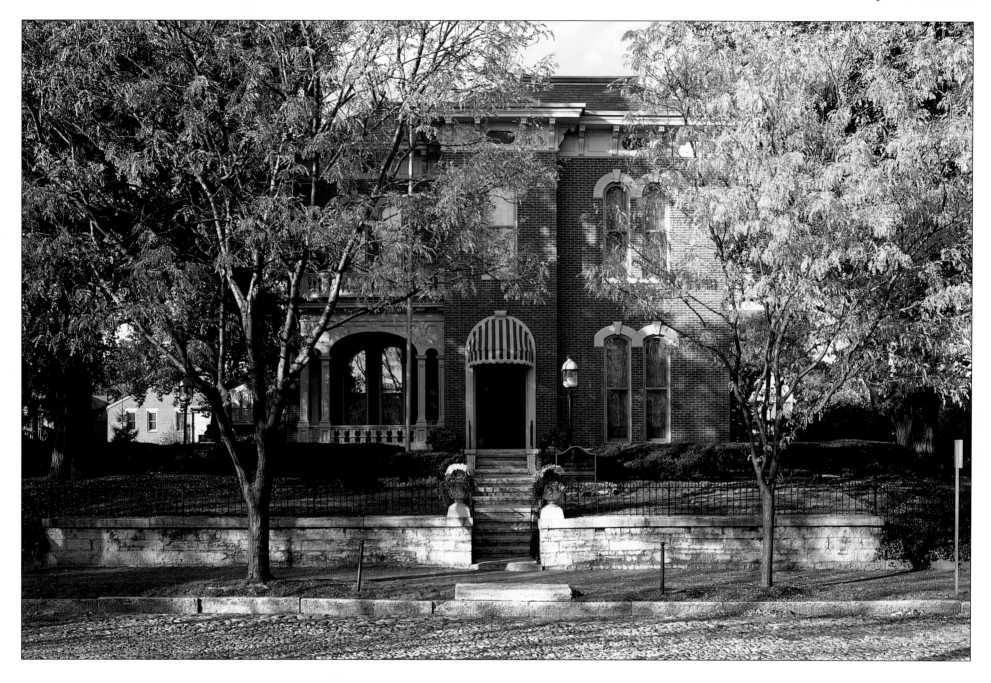

The elegant Italianate home where James Whitcomb Riley lived during his years as the biggest celebrity in Indianapolis is now a house museum. Interestingly, Riley never owned the home, even though experts say he made more money from his poetry than any other American poet, including Robert Frost and Carl Sandburg. Instead of becoming a homeowner with the demands of his tour itinerary, Riley, a bachelor, preferred to be a permanent "paying guest" in the house at 528 Lockerbie Street, living amid a cozy family atmosphere during breaks in his schedule. After his death, several of his friends established the acclaimed Riley Hospital for Children in Indianapolis as a tribute to the poet.

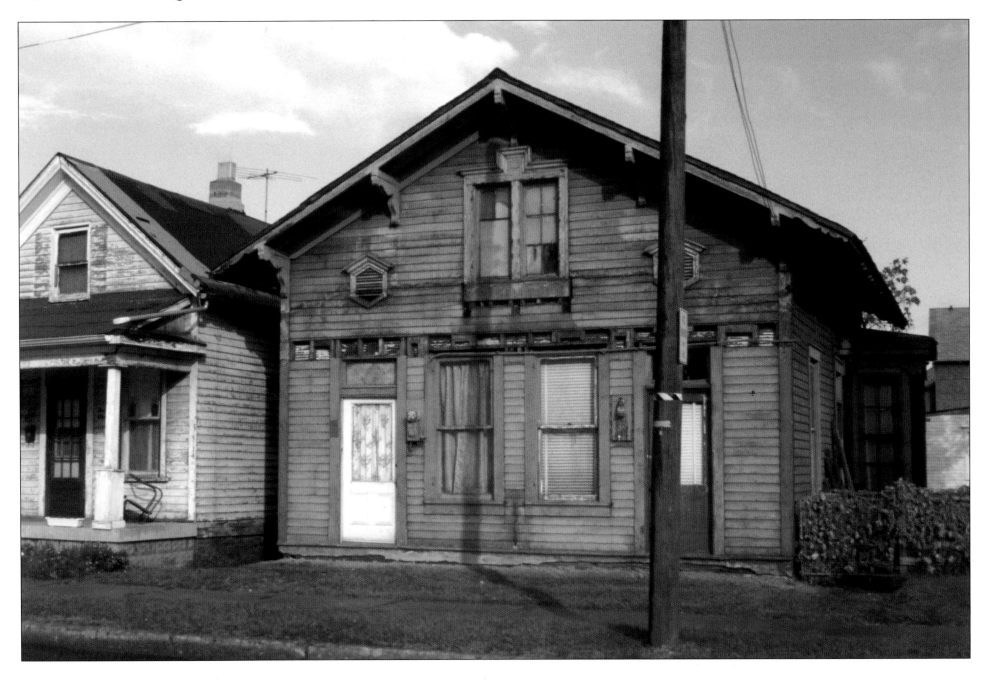

Lockerbie Square, one of Indianapolis's oldest neighborhoods, dates to the 1830s. Early settlers Thomas and Janet McQuat developed the neighborhood at this time, which is less than one mile—a brisk walk—east of Monument Circle. The McQuats named Lockerbie Street in honor of Janet's father, Scottish immigrant George Murray Lockerbie. The neighborhood became popular for a mix of uses, from the homes of celebrities such as poet James Whitcomb Riley to workers' cottages, a general store, and a doctor's office. However, Lockerbie's charm for many Hoosiers had diminished by the mid-1930s. This photo shows the deterioration of cottages on the 400 block of North Park Avenue, startling to those who know the neighborhood now as an area of historic restoration. The cottage on the right was built around 1860; it was the home of Herman Lieber, a businessman and arts patron.

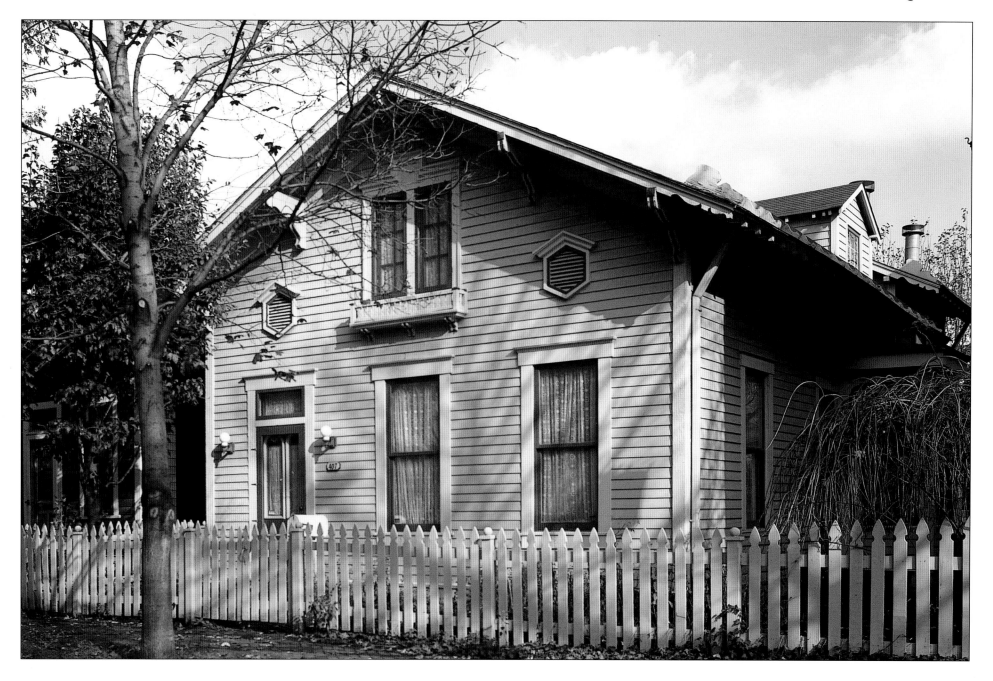

With its white picket fences, cobblestone streets, and restored historic homes, Lockerbie Square is a source of civic pride and continually visited by tourists. Unlike many Midwestern cities, where much of the nineteenth-century downtown housing stock was demolished, the Lockerbie cottages endured despite economic reversals and shifts in popular taste. Amid the towering trees, pedestrians on Lockerbie's bricked sidewalks can almost forget they are in a modern city—even though nearby office towers are visible from many vantage points. Spearheaded by the Historic Landmarks Foundation of Indiana, major restoration of Lockerbie's private homes picked up steam once the neighborhood was added to the National Register of Historic Places in 1973. With one of the city's strongest neighborhood groups, Lockerbie residents host popular home tours and a Fourth of July celebration.

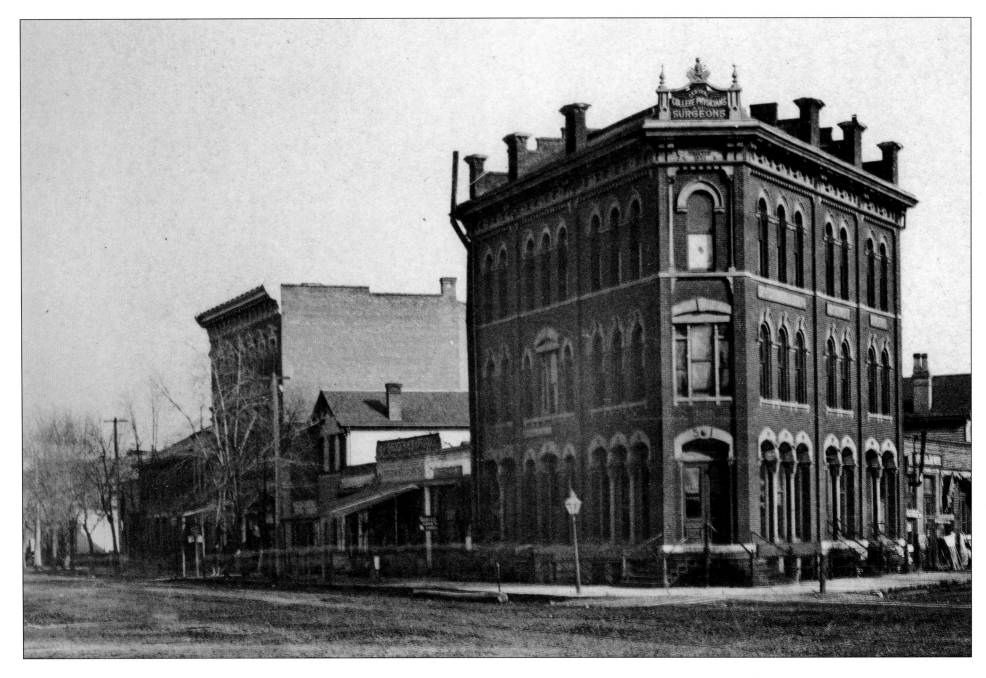

This Italianate building with six chimneys at 310 Massachusetts Avenue has been everything from a doctor's house to law offices, a fishing tackle shop, and a college for surgeons. Known as the Hammond Block Building when it was constructed in 1874, the brick structure was designed as a flatiron, a term used to describe the shape buildings took to fit odd-sized lots such as this location on the diagonal, three-way intersection of Massachusetts, Delaware, and New York streets. In the 1870s and 1880s, the building was a physician's office and residence. From 1887 to 1891, the Central College of Physicians and Surgeons conducted classes on the second and third floors; cadavers and all kinds of medical equipment were kept here. The college, a forerunner to the Indiana University School of Medicine, was using the building when this photo was taken in 1888.

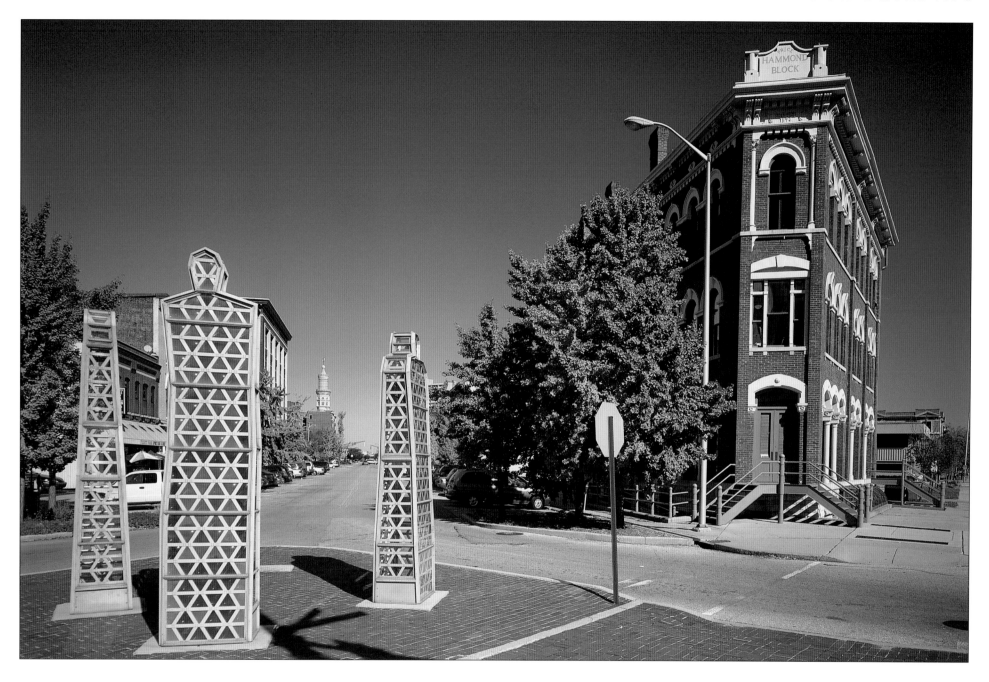

Considered inefficient because their design resulted in odd-shaped rooms, many flatiron buildings were demolished in the mid-twentieth century. The Hammond Block Building was slated for the wrecking ball in 1979 when local attorney Henry Price decided to save it. Then an eyesore, the structure had been called the Burdick Building since 1945. Its owners had hoped to open a liquor store, but couldn't obtain licenses because of the building's proximity to churches. After the renovation initiated by Price, the renamed Price Hammond Block Building became law offices. The three-piece sculpture seen on the left, titled *Viewfinders*, was created by Indianapolis artist Eric Nordgulen in 1996; it serves as the gateway to today's Massachusetts Avenue arts district.

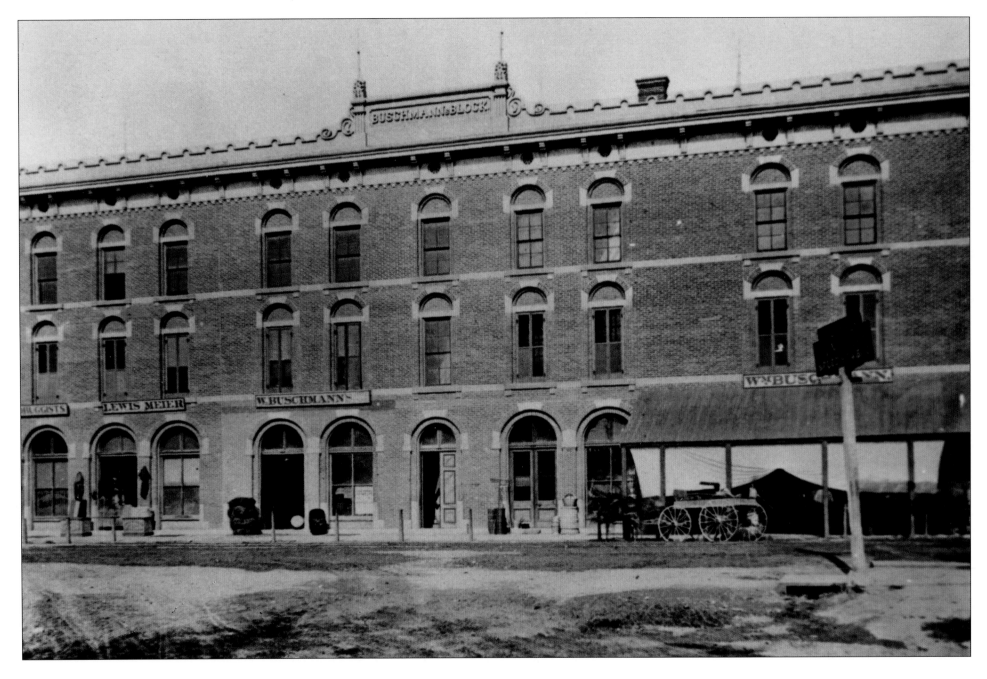

A Prussian immigrant who came to Indianapolis in 1852, William Buschmann settled in the St. Joseph neighborhood just as the city was expanding northward from its original Mile Square boundary at North Street. A savvy entrepreneur, Buschmann decided the neighborhood, a mixed-use community of row houses and retail shops, was ripe with opportunity. In 1871 he erected the first portion of the Buschmann Block, an L-shaped, three-story building with seven bays on the 900 block of Fort Wayne Avenue. Buschmann ran successful grocery and dry goods operations in his namesake building. Upper floors were used as residences for the extended Buschmann family. At some point after 1895, the upper floors were converted for warehouse use. But the St. Joseph neighborhood—a triangular area of about fourteen blocks—struggled after the 1930s. In 1939, the grocery shut down.

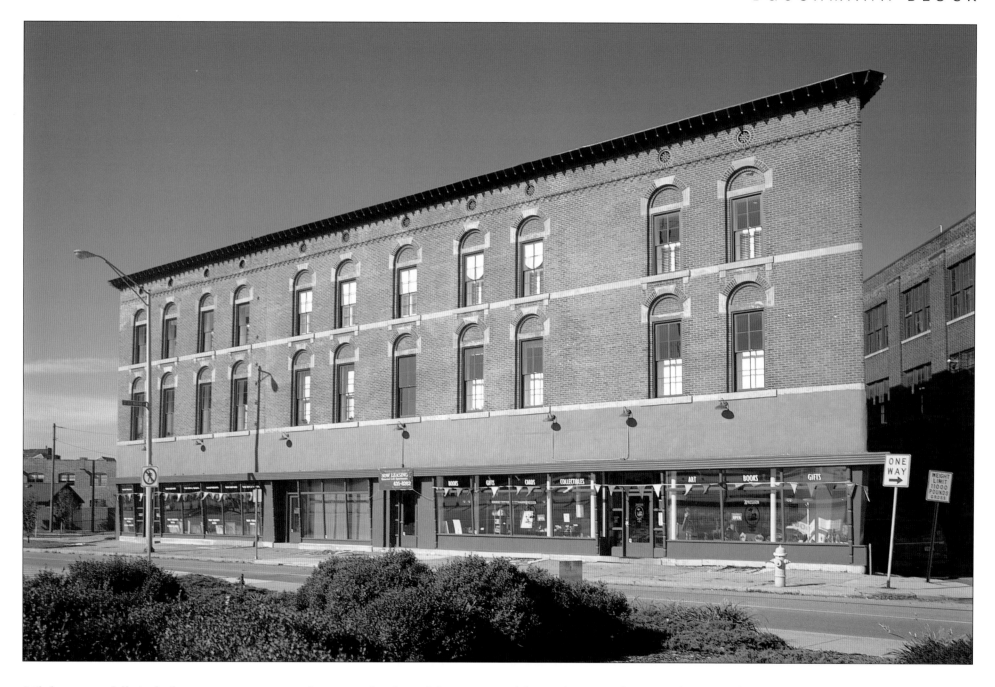

Life has come full circle for many structures in the triangular-shaped St. Joseph neighborhood, including the Buschmann Block. Regarded as one of the few large Italianate commercial buildings left in Indianapolis, the Buschmann has a decidedly mixed use today that reflects its beginnings in the 1800s: retail stores on the first floor and residences on the upper floors. Businesses at the sidewalk level include a deli and a bookstore specializing in

African American history. The upper floors of the Buschmann Block have been remodeled into about a dozen apartments. The restoration of the Buschmann Block, which today is listed in the National Register of Historic Places, is a sterling example of efforts underway in St. Joseph, which has become a hot spot again.

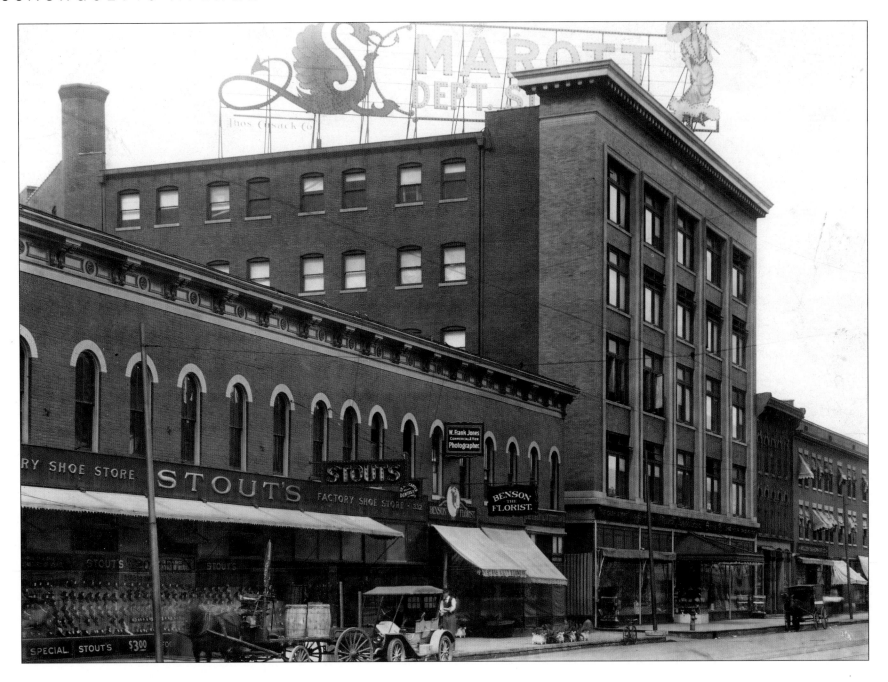

During the 1870s, the 300, 400, and 500 blocks of Massachusetts Avenue were developed as a new retail district. Although shopping along "Mass Ave" never had the prestige enjoyed by the merchants on the Circle or Washington Street, the area in the northeast part of the Mile Square experienced solid retail and commercial success. Early merchants included Harry Stout, who opened this small shoe store at 318 Massachusetts Avenue.

Almost from the beginning, Stout's Shoes specialized in hard-to-find sizes. Stout's was located just south of Marott's Department Store, which promoted itself as "the holiday department store of 1910," one year before this photo was taken. The store's owner, English merchant George Marott, had also started in the shoe business; by 1910, his wealth was estimated at more than $2 million.

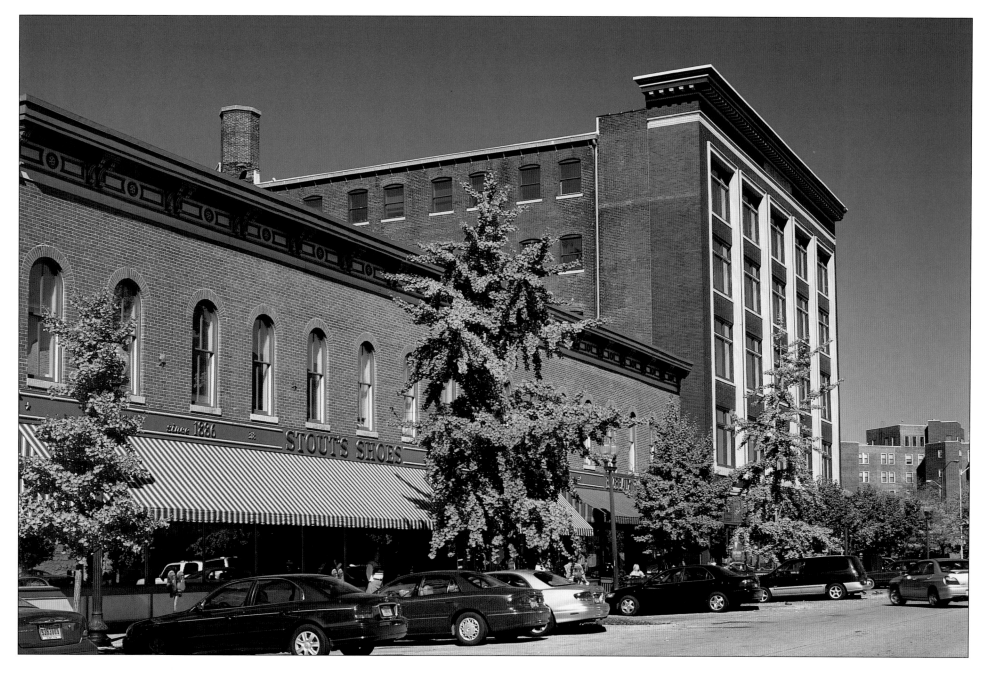

The Massachusetts Avenue of the twenty-first century enjoys as much bustle as it did in the nineteenth, but it is now bustling with an artistic edge and with culinary delights. With the Theatre on the Square, arts galleries, sculptures and other public artwork, and the nearby American Cabaret Theatre, Mass Ave is considered to be the epicenter of a downtown arts district. Upscale and ethnic restaurants have flourished since the 1990s and nearby are renovated buildings such as the Real Silk condominiums, which once housed a parachute and women's silk hose factory. Nightclubs along Mass Ave include the Chatterbox, a tavern known for its year-round Christmas lights, jazz music, and Jamaican patties. Although the five-story Marott's Department Store is now the Marott Center health care offices, one neighborhood landmark is unchanged—Stout's Shoes remains.

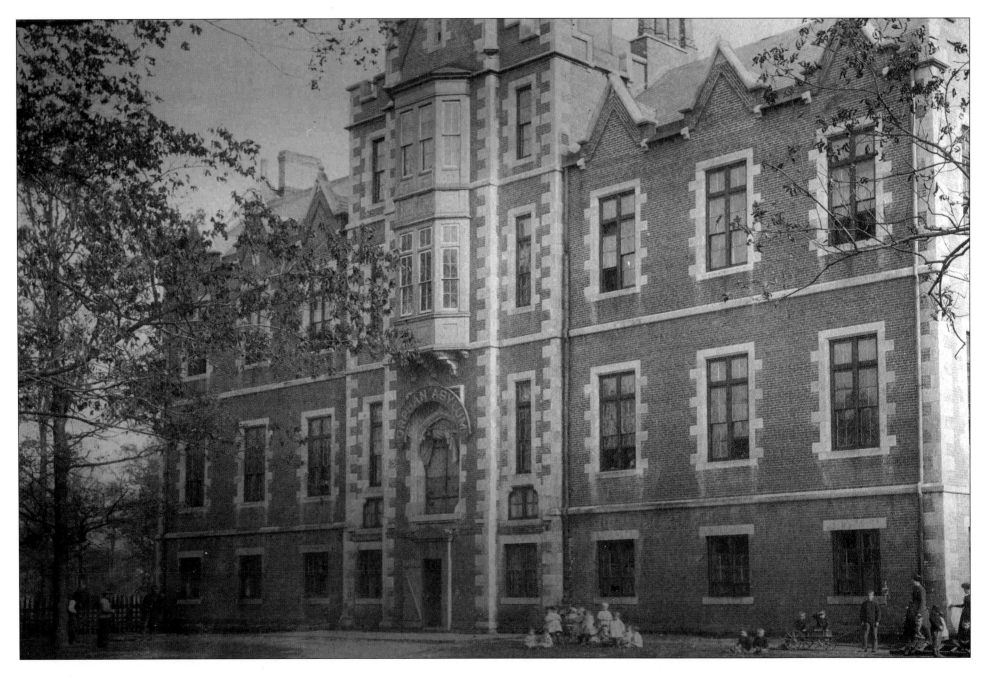

When this photo was taken in the 1880s, the imposing structure at Thirteenth Street and College Avenue had already experienced two very different uses. Built in 1855, it was the original site—and the only campus building at the time—of North Western Christian University, which was renamed Butler University thirty-two years later. The campus building was on land donated by college founder Ovid Butler, who lived nearby in a mansion that still stands at Thirteenth Street and Park Avenue. After the college moved east, the building was rented to the Indianapolis Orphan Asylum. More than a hundred children were institutionalized at the asylum; an on-site doctor and nurse ran a clinic and immunization program. In 1905, the Orphan Asylum moved into a complex of four buildings on the Eastside; it evolved into the Children's Bureau of Indianapolis.

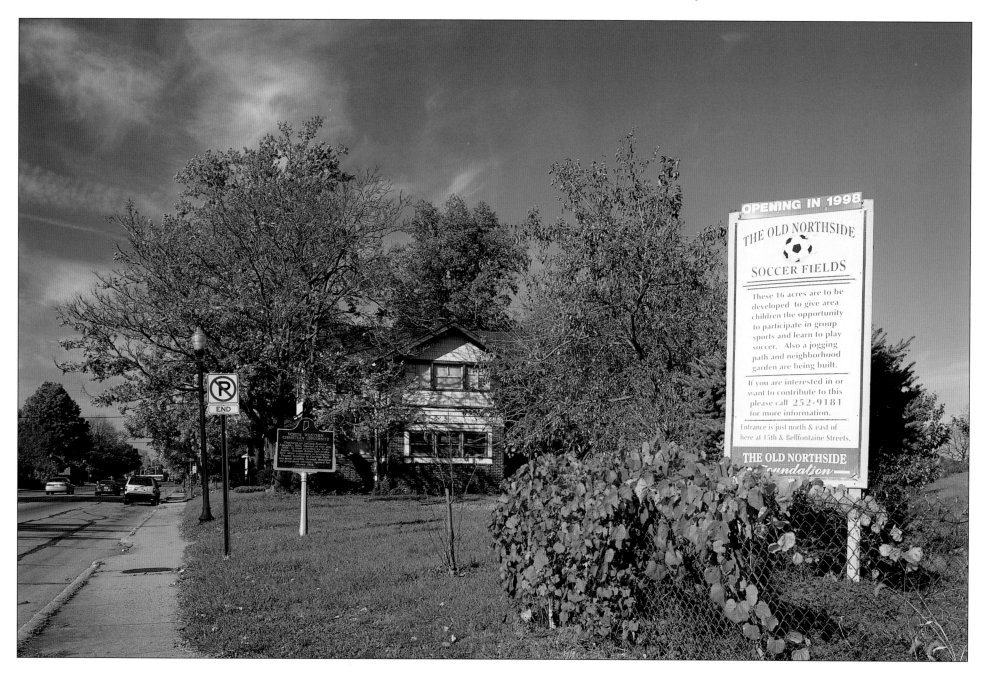

A marker in the Old Northside neighborhood serves as one of the few reminders that North Western Christian University began on the site, now a grassy lot. The building was torn down in 1912. The network of interstates that cuts through the area took much of the surrounding land, but the Old Northside flourishes today as residents restore nearby historic homes.

Neighborhood leaders also crusaded to create a youth soccer field on vacant lots about one block northeast of the former Orphan Asylum site. The Old Northside Soccer Fields opened in 1998, although the sign announcing its opening still remains up today. The area was recently renamed to honor the late Governor Frank O'Bannon and his wife Judy.

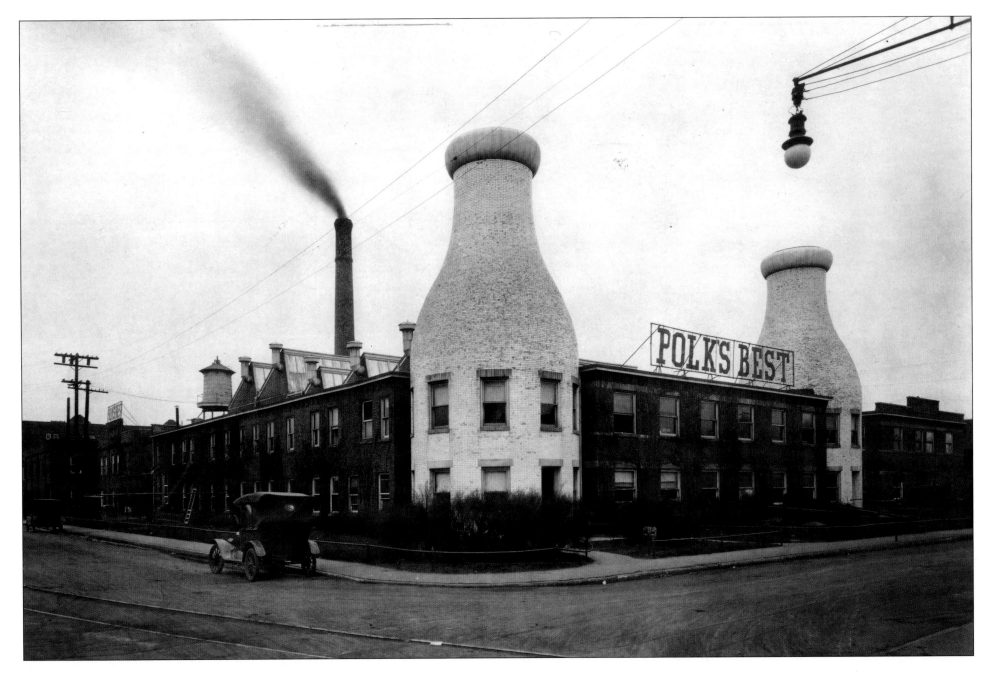

The corners of the Polk's Best Jersey Milk Depot's entrance were shaped like giant milk bottles. This photo was taken in 1925, fifteen years after the dairy was built on the northeast corner of Fifteenth and Lewis streets. The company was founded in 1893 by Greenwood resident James Polk, a Civil War veteran. The company's slogan, "Polk's milk—always ahead," was framed around a cow's head. Contractors had told Polk's son-in-law that dairy bottles could not be created as huge cornerstones. But Polk's son-in-law saw laborers building cisterns and asked them to construct the cisterns upside down and aboveground, and so the dairy ended up with its giant replicas of milk bottles. Polk became the state's largest milk company, but it began experiencing financial problems in the 1950s because of competition from large food chains.

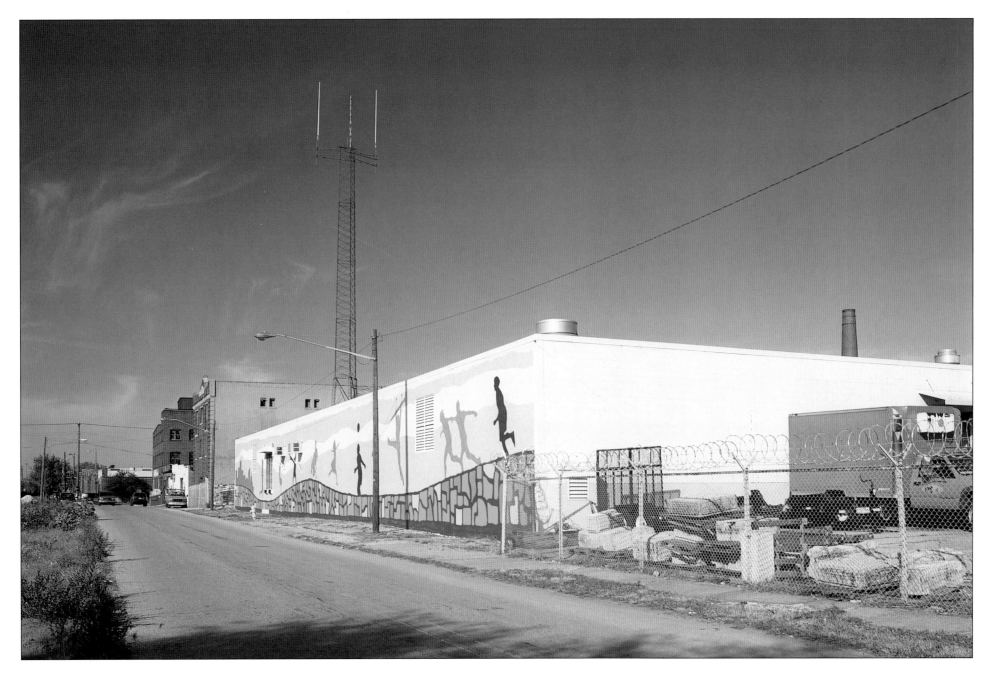

Decorated with a vivid mural, a maintenance building for Indianapolis Public Schools sits just north of the former Polk's site. As the state's largest school district, IPS educates about 40,000 students. The unique bottling plant—with skylights that illuminated the interior's vast bottling room—met the wrecking ball in the 1960s. The dairy's stables still stand, though. The old stables, where Polk kept the delivery horses, are located just south of Sixteenth Street on Lewis Street. The former stable building is part of the IPS maintenance complex. IPS, which has boundaries roughly conforming to the pre-Unigov city limits, is one of eleven public school districts in Marion County.

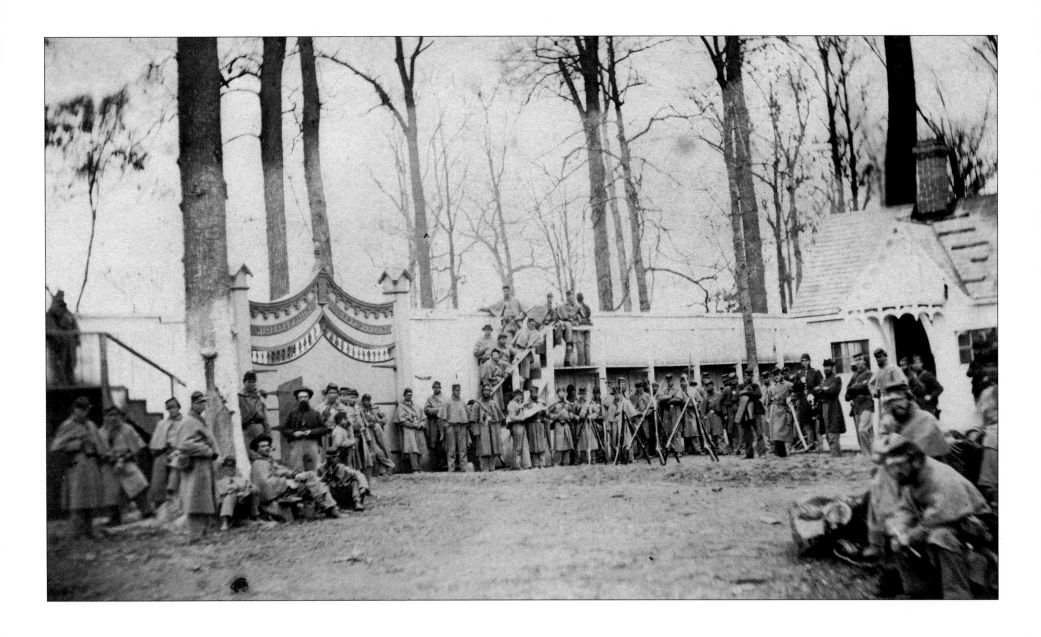

With the outbreak of the Civil War, Governor Oliver P. Morton decided thirty-six wooded acres north of the Mile Square would be the best site for the induction and training of Union army soldiers. Thus, Camp Morton was born near Twentieth and Alabama streets. It primarily became a prisoner-of-war camp, as seen in this photo from 1864. After Morton promised President Lincoln that Indiana would provide 10,000 troops, cattle stalls were converted into barracks. By the time recruits poured in, tents, guardhouses, and a hospital had been erected. By the end of the war, 15,000 Confederate soldiers had been imprisoned at Camp Morton, with a peak of 5,000 in July 1864. When Morton died in 1877, the former camp was being developed into residential lots.

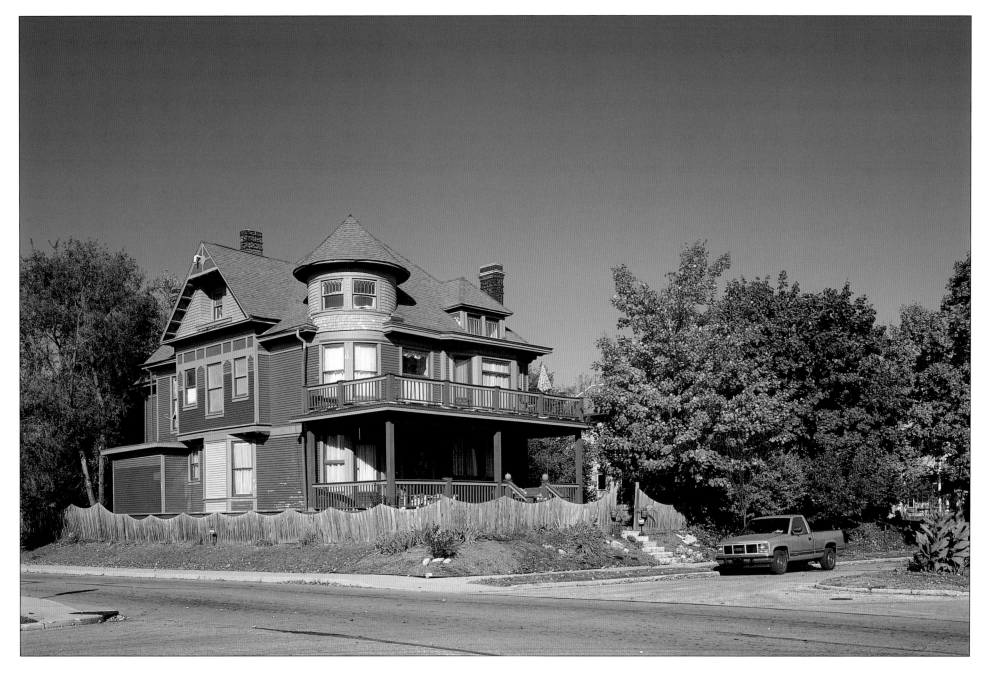

Queen Anne–style houses and other elegant residences were built during the late 1800s and early 1900s on the site of the former Camp Morton. The genteel neighborhood also became the home of Indiana's top art school, the John Herron School of Art. Although all appears to be unchanged today from 1910, the Herron-Morton neighborhood deteriorated dramatically beginning in the 1930s as affluent residents moved northward. Several spacious homes became apartment houses and the crime rates increased. Restoration of Herron-Morton Place kicked off in the 1970s, and by 1983 it was listed in the National Register of Historic Places. In addition to Queen Anne–style homes, the neighborhood features houses of Italianate and Tudor revival architecture.

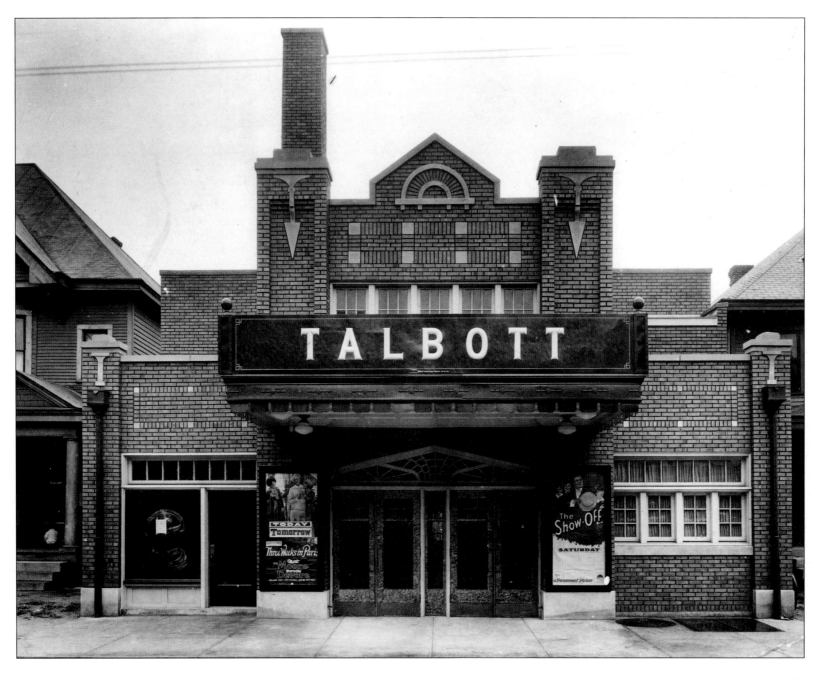

The Talbott Street Theatre opened as a movie house in 1920. But the building (seen here in 1926) would become far better known in other ways during the decades to come, as would four blocks of Talbott Avenue. During the mid-1950s, the art festival that would become one of the city's oldest was established: the Talbott Street Art Fair. It began modestly in an alley as a way for students at the nearby John Herron School of Art to sell their creations in June at the end of the semester. During the 1960s, the Talbott area became associated with peace activists and bohemians, as well as artists. By then, the movie house had become the Black Curtain Dinner Theatre. Along with the adjacent Hummingbird Café, the dinner theater was popular through much of the 1970s.

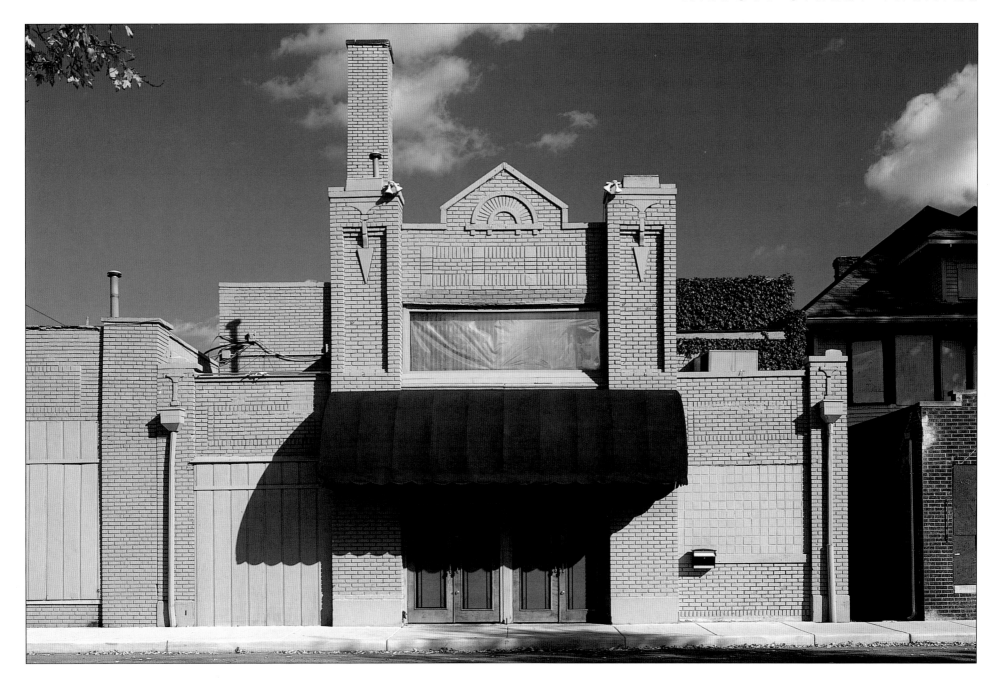

Today the Talbott Street building is a gay nightclub that opened in the former theater at 2145 North Talbott Avenue in 2002, although the area has been known as a welcoming one for the gay community since the early 1980s. The current nightclub, which has a Studio 54–style dance floor, replaced other gay clubs on the same site. Meanwhile, the Talbott Street Art Fair exploded in popularity. Today hundreds of painters, potters, and other artists sell everything from ceramics and macramé wall hangings at the festival that invariably draws elbow-to-elbow crowds. Four blocks of Talbott Avenue are closed to traffic for the annual fair, which is now one of the largest in the city. And yes, the Talbott area is still considered a bit bohemian.

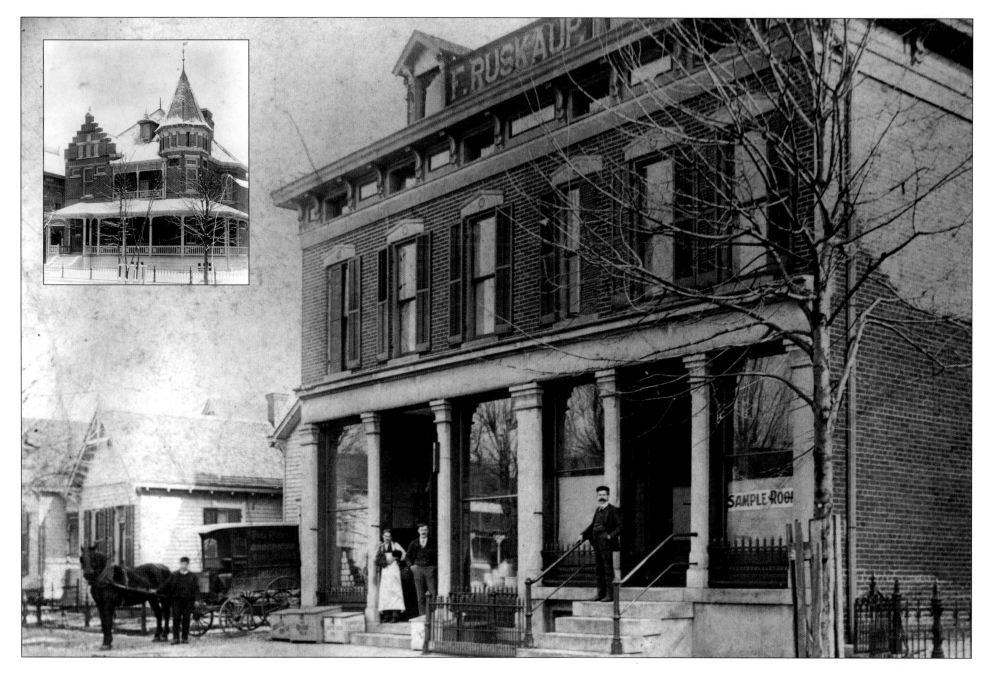

In a working-class neighborhood near the Eastside, just west of the U.S. Arsenal, German immigrant Frederick Ruskaup opened a grocery and butcher shop in 1875. This photo of the Ruskaup Grocery and the photo of his family's spacious adjacent home (inset) in the 700 block of North Dorman Street were taken around 1895. The second floor of the grocery consisted of apartments known as the Ruskaup Flats. Three large, horse-drawn wagons made deliveries daily from the store. Ruskaup ran his grocery and butcher shop in the building's northern half and the south half became a saloon patronized by the Irish and German residents of the neighborhood. The Ruskaup family's home was completed in 1892 by the Indianapolis architectural firm of Vonnegut & Bohn; it was built for about $12,000.

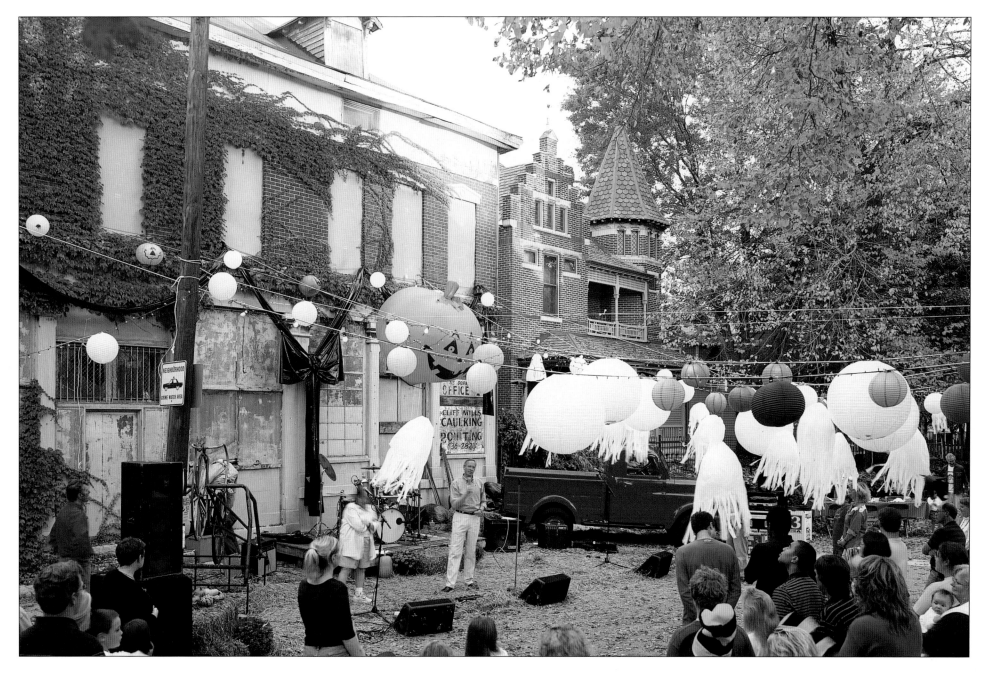

Mayor Bart Peterson spoke during the festivities at the 2003 block party in Cottage Home, the current name for this neighborhood. The Ruskaup house, which has five fireplaces, an intricate stairway, carved woodwork, and a wraparound front porch, was restored in the 1980s by its current owners, John Dugger and Rebecca Garland. Other restoration efforts are underway in the Cottage Home area. The old grocery store is boarded up, but renovations are expected to begin soon. The Cottage Home Block Party has been held since 1984; it's been designated several times as the city's "best block party" by *NUVO*, an Indianapolis newsweekly.

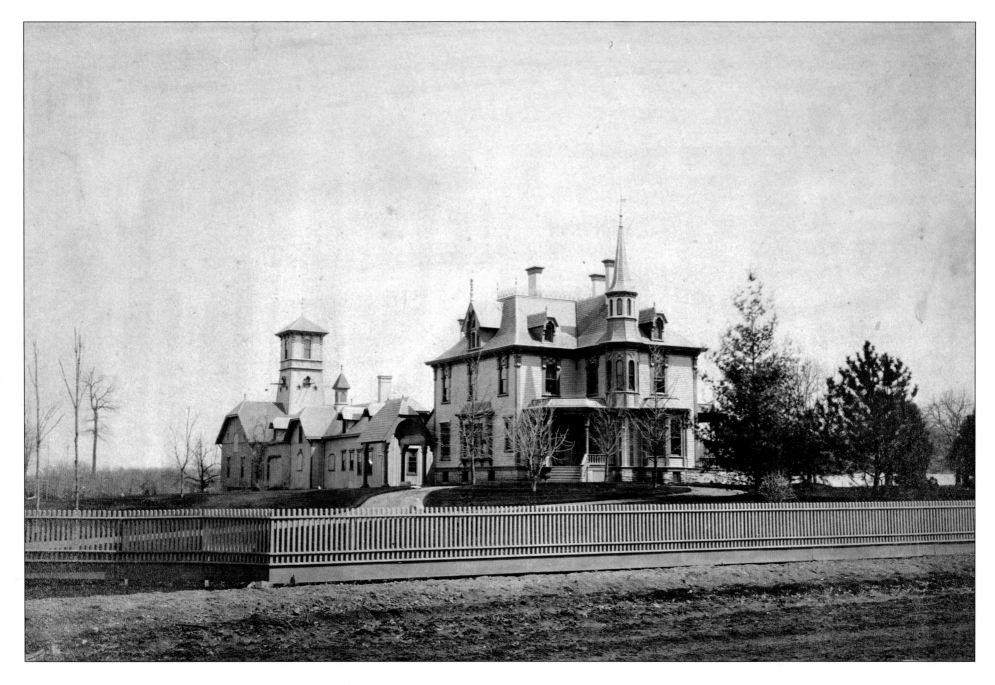

Known as "Clifford Place," the mansion of businessman Stoughton A. Fletcher Jr. was built in the early 1870s on East Tenth Street, part of which was then called Clifford Avenue. When Fletcher built Clifford Place, he was president of the Indianapolis Gas Company. In 1878, he became president of Atlas Engine Works, which reaped enormous success. He moved with his first wife, Ruth, and their four children into the exclusive Clifford Place, seen here in a photo from the 1880s. After Ruth Fletcher's death in 1889, her husband remarried but he also died here six years later. In the late 1890s neurologist Dr. Albert Sterne purchased it and the surrounding estate from the Fletcher family to create an exclusive private sanatorium for the treatment of mental disorders.

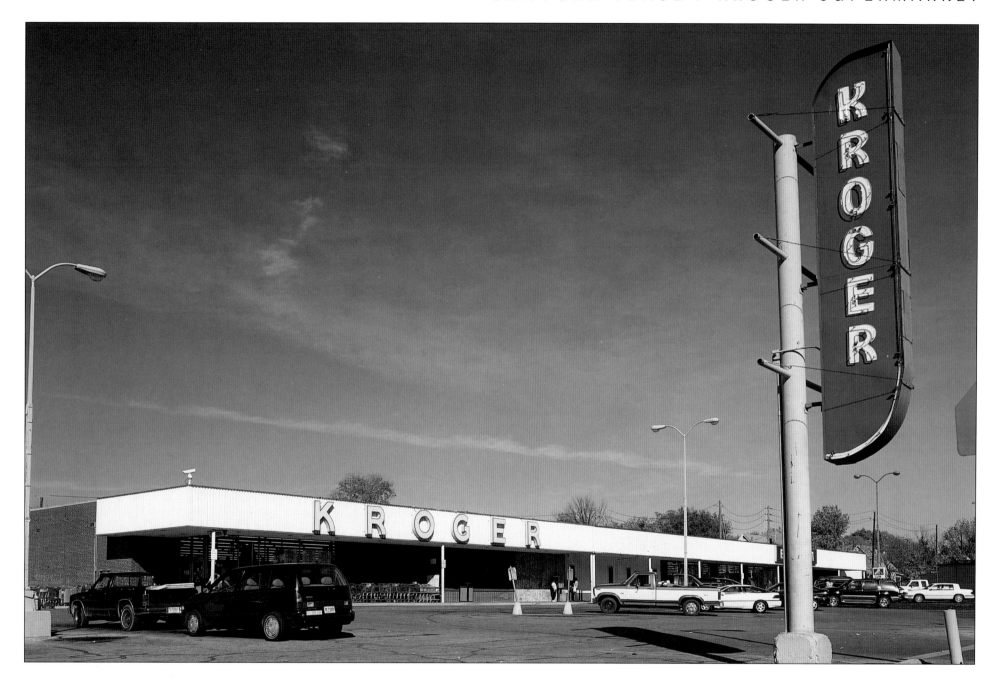

One of the first Kroger supermarkets in Indianapolis was built in 1958 on the former site of Fletcher's mansion. The supermarket at 1800 East Tenth Street is nicknamed "the Fellini Kroger" because its colorful array of customers is often likened to characters in movies by the Italian film director Federico Fellini. This chain of supermarkets was founded in Cincinnati, and today there are thirty-seven Krogers in Indianapolis. The mansion-turned-sanatorium was demolished in 1957 to make way for the supermarket.

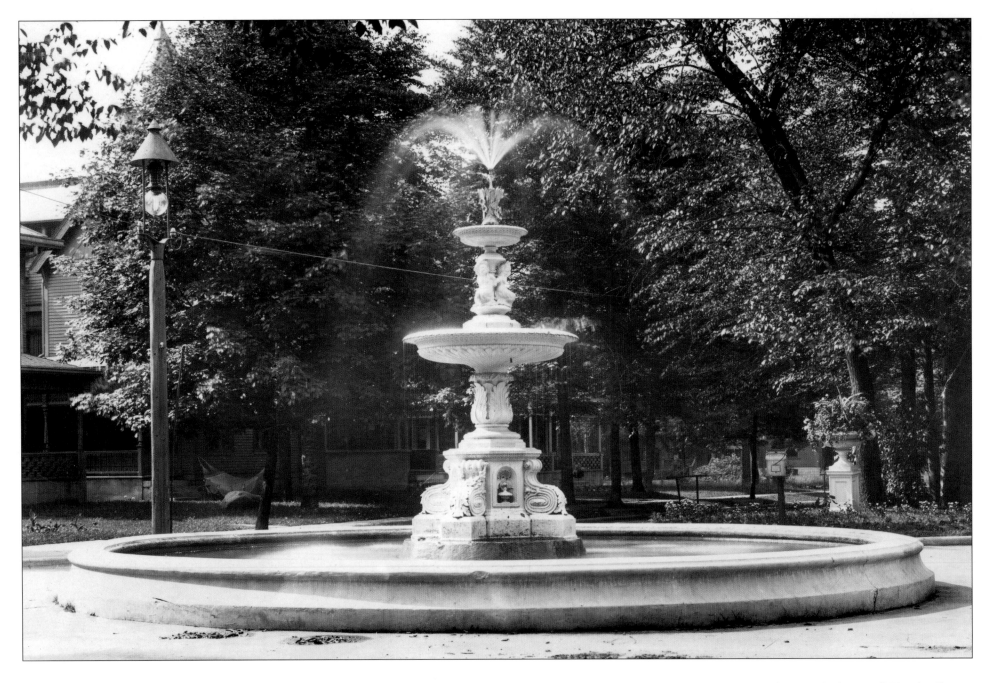

Indianapolis novelist Booth Tarkington used the Victorian-era homes of Woodruff Place as models for the spacious houses of the genteel aristocrats in his book *The Magnificent Ambersons*. This tree-lined subdivision was laid out in the early 1870s with three boulevards bisected by esplanades. Its developer, James O. Woodruff, oversaw the creation of statues cast in pot metal for the esplanades and elegant fountains, as seen in this 1905 photo of Woodruff Place's Middle Drive. James Woodruff's goal was to create a retreat for cultured, affluent Hoosiers. Many of the 300 homes in Woodruff Place were built in the Edwardian and Queen Anne architectural styles.

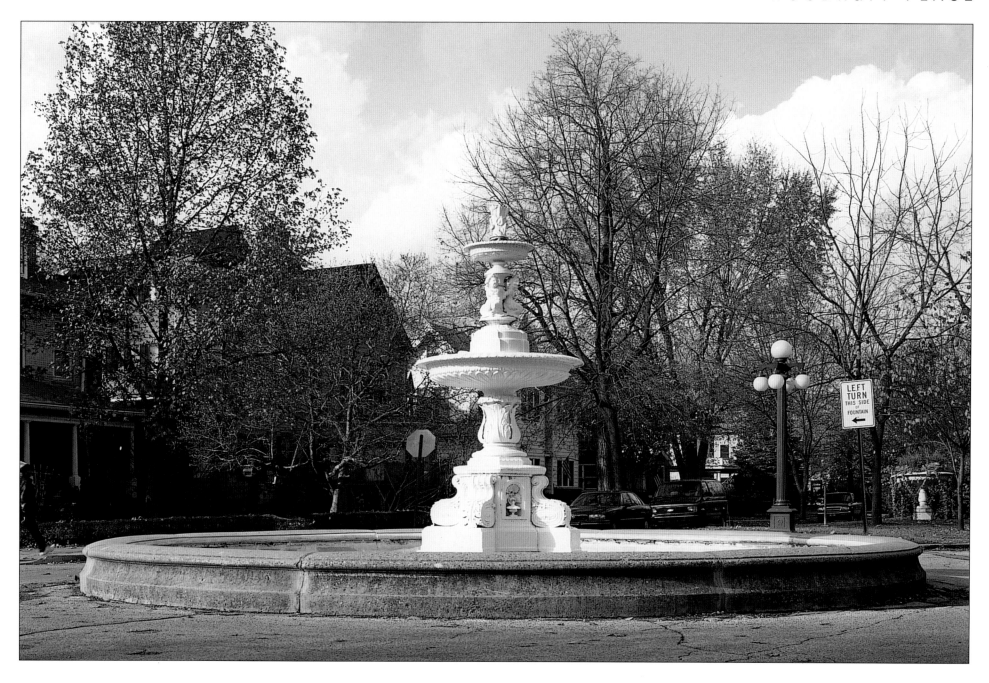

During the first half of the twentieth century, some of the same homes had gradually declined as affluent residents moved to suburban neighborhoods. For some families, the depression of the 1930s meant they could no longer afford the big houses. Many of the Woodruff Place homes were subdivided into apartments, while others became boardinghouses. In 1962, Indianapolis finally annexed Woodruff Place, which was struggling with serious decay. Renovation of the homes began in the 1970s. Many of the roomy Woodruff Place homes have been restored to their elegance of the late 1800s, and the neighborhood hosts one of the city's most popular yard sales each year.

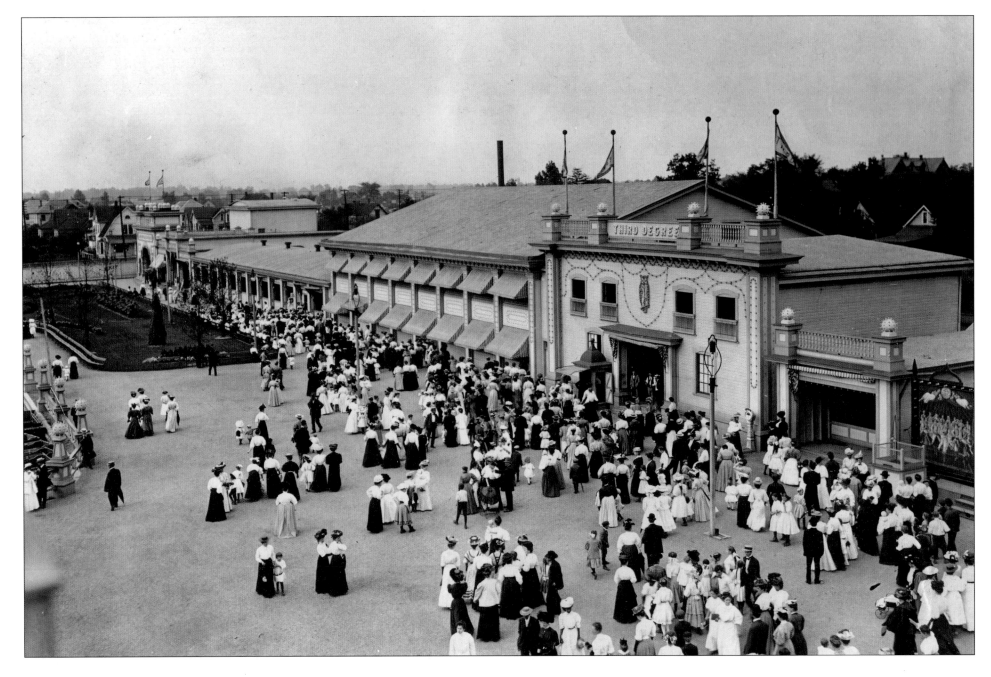

Hundreds of carefree, stylishly dressed people were enjoying themselves in 1910 at Wonderland Amusement Park, a lavish entertainment area on the Eastside. The amusement park featured an artificial lake, diving horses (a mare named Queenie was a crowd favorite), a waterslide, a fun house, and landscaped gardens. The twenty-four buildings of Wonderland, which was at East Washington and Gray streets, were designed in "dreamlike" architecture. When illuminated at night, the park's 125-foot central tower was visible for miles. More than 8,000 people attended the opening of Wonderland in 1906. Special attractions at the park included bands, acrobats, and trick cyclists. Sadly, Wonderland's life was not wonderfully long. On a Sunday in 1911, the amusement park burned to the ground.

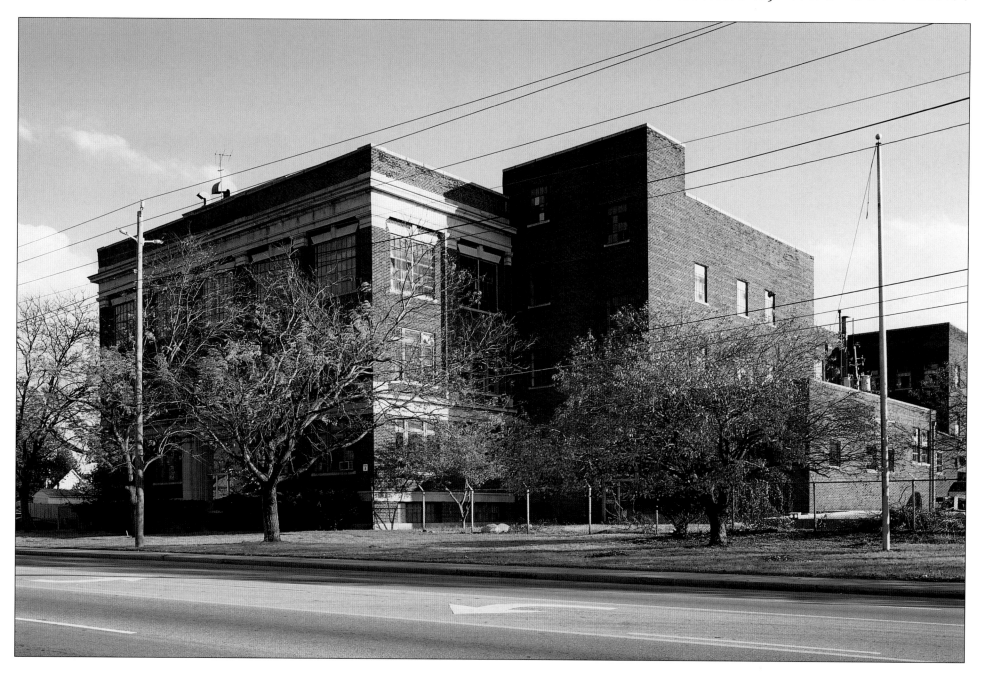

Today the setting of the long-gone Wonderland Amusement Park is the site of a more recently closed operation, the former plant of P. R. Mallory and Co., an Indianapolis-based electrical components manufacturer. Like most of the East Washington Street (National Road) corridor, the site at Gray Street became highly congested. Retail shops, diners, and businesses popped up on both sides of East Washington. In 1958, Eastgate Shopping Center opened at the street's intersection with Shadeland Avenue, becoming one of the city's first and largest suburban shopping centers. During summers in the 1960s and 1970s, Eastgate even had amusement park rides such as a Ferris wheel, although nothing there remotely approached the grandeur of Wonderland. Today Eastgate is struggling to survive as a discount mall.

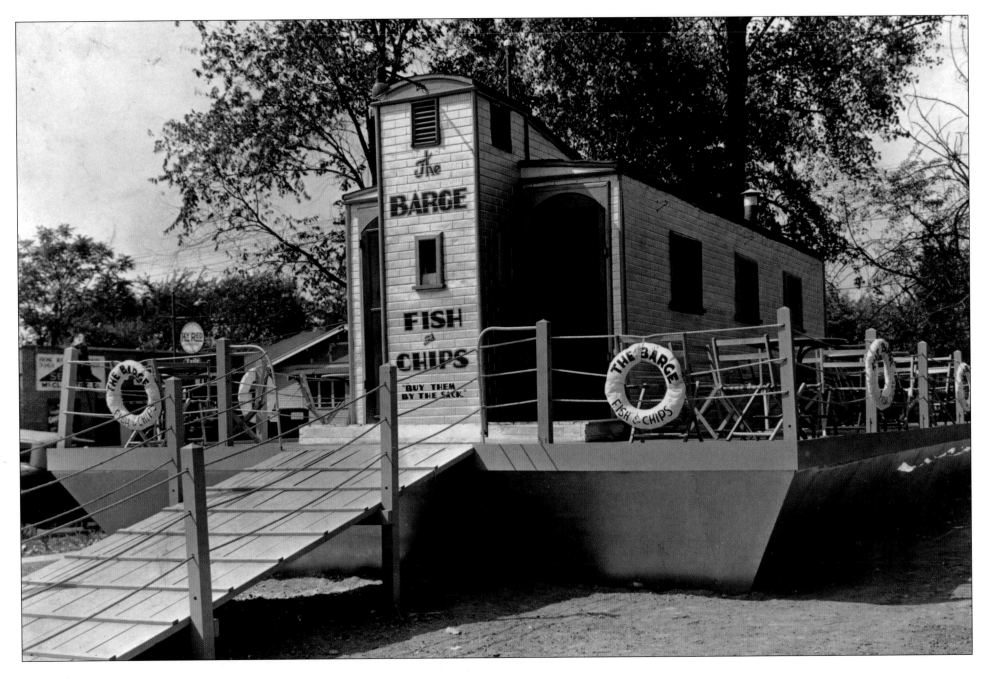

The Barge, seen here around 1935, was a fish and chips eatery shaped like a boat. The restaurant had a gangplank, life preservers, and a roped deck. The "boat" itself was created from an old trolley car. Alas, the Barge, being located on dry land at East Washington and Denny streets, didn't stay at this location for very long, and this site later housed an ice cream parlor in the late 1930s. The Barge, though, was a delightful example of a type of roadside architecture known as "mimetic," in which a building's design mimics the product or services it offers.

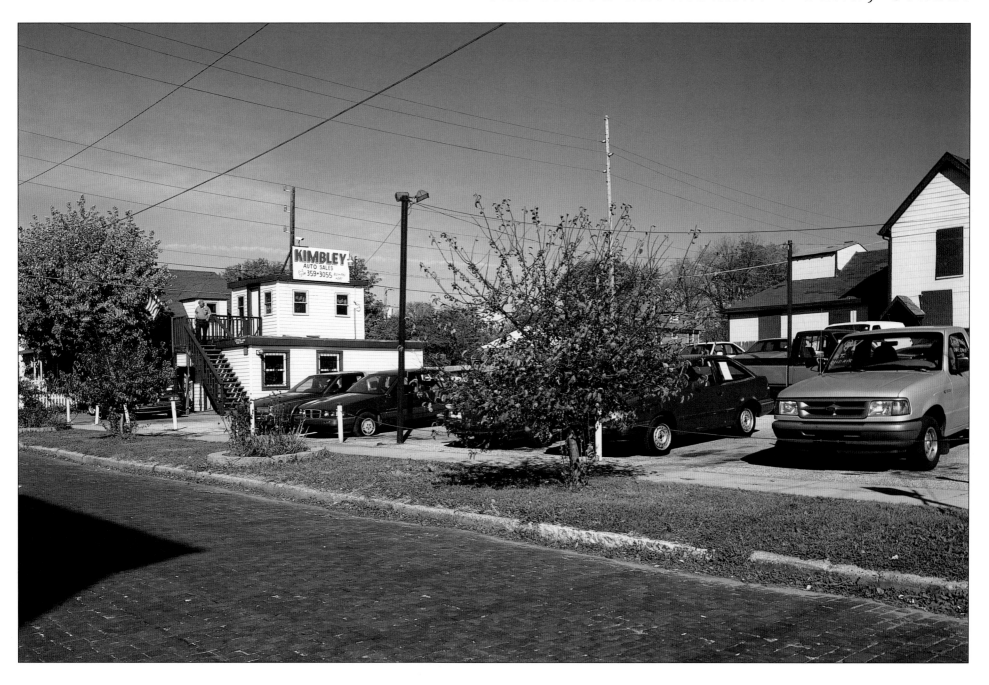

A used car dealership now sits on the former site of the Barge. This photo shows Denny Street from a vantage point just north of East Washington Street. A busy thoroughfare today, the street played an even more significant role in the 1800s and first half of the 1900s as the Indianapolis portion of the National Road. After the railroad boom of the 1850s, use of the National Road declined. It revived with the introduction of the car, then diminished again as a result of interstate highway construction in the 1970s. Some roadside businesses closed and were replaced by pawnshops, tobacco stores, and tanning salons. Today, though, groups concerned with the heritage of the National Road are mobilizing to beautify the areas alongside it.

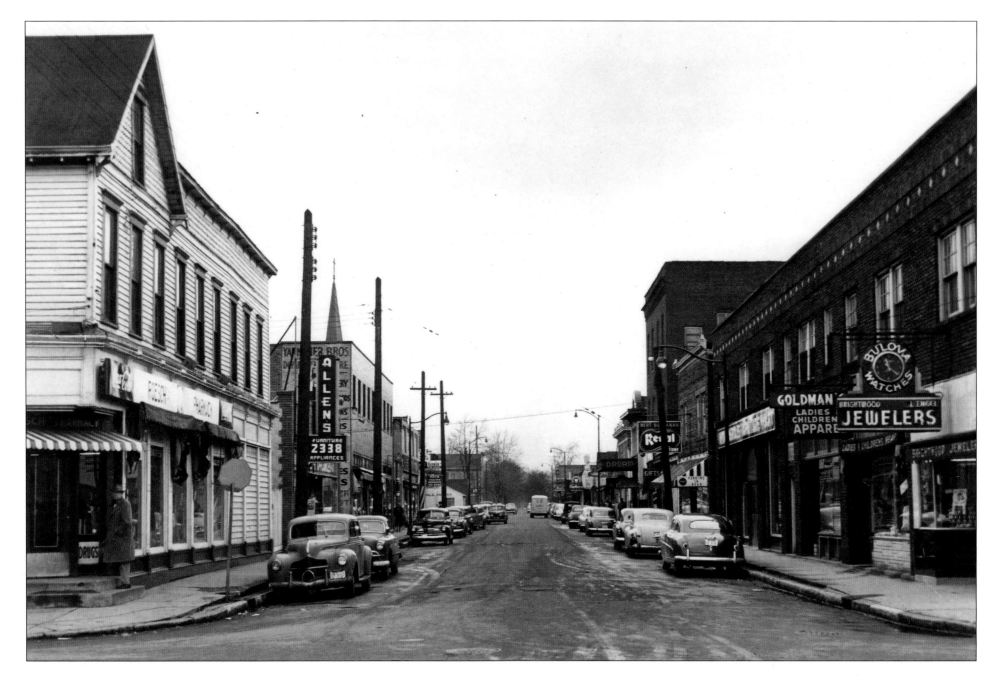

Station Street was the business hub of the Brightwood neighborhood in the Northeastside area during the 1940s when this photo was taken. Initially settled in the 1870s by railroad workers employed at repair shops in the area, Brightwood was soon incorporated as a town. The area consisted primarily of foreign-born and first-generation residents of Irish, German, and British ancestry. It shared a boundary, Martindale Avenue, with the neighborhood of Martindale to the west. Brightwood was annexed into Indianapolis in 1897; about ten years later, several railroads relocated their repair yards to Beech Grove. African Americans gradually became the primary residents of Brightwood. Schools also became a hub of activity for local residents. In 1935, the PTA at School 37 was the first at an African American school to become part of the National Congress of Parents and Teachers.

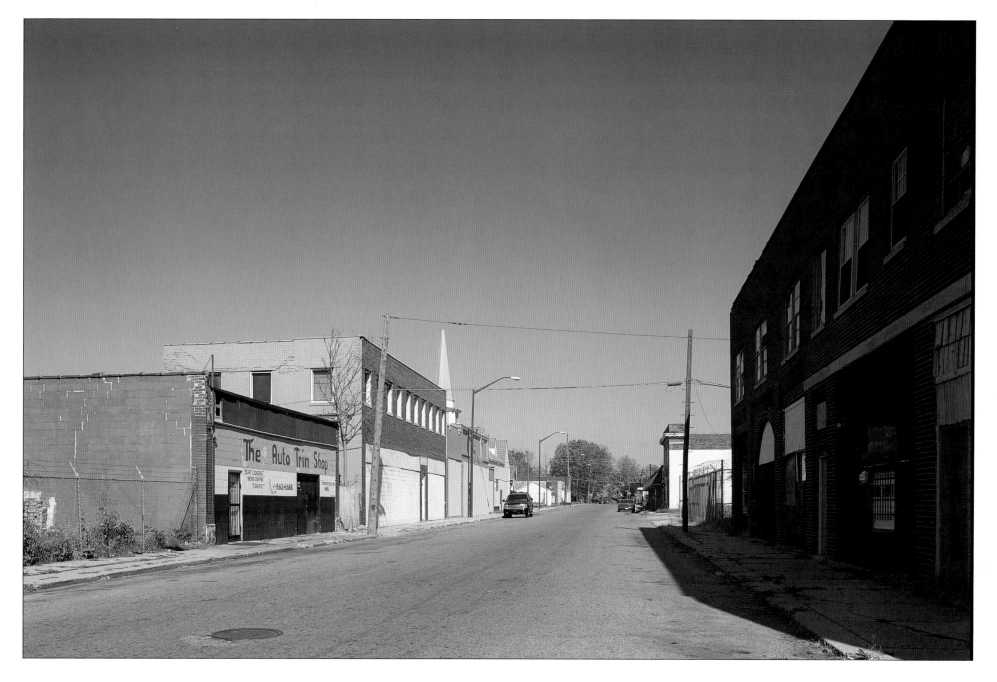

Although many businesses have pulled out of the Brightwood neighborhood since the 1960s, the neighborhood retains a sense of pride for several reasons. About one block south of the Station Street area in this photo is Martin University, a private, nonprofit college attended by about 500 students. Martin University was created to serve low-income, minority, and older students. In 1986, Martindale Avenue was renamed Dr. Andrew J. Brown Avenue. After marching with Martin Luther King Jr. in Selma, Alabama, Brown helped found the Indiana Black Expo, a summer celebration of African American heritage and achievement that is the largest event of its kind in the country. Today, even as Brightwood and Martindale continue to face economic challenges, the neighborhoods are the home of about eighty churches, including many storefront churches.

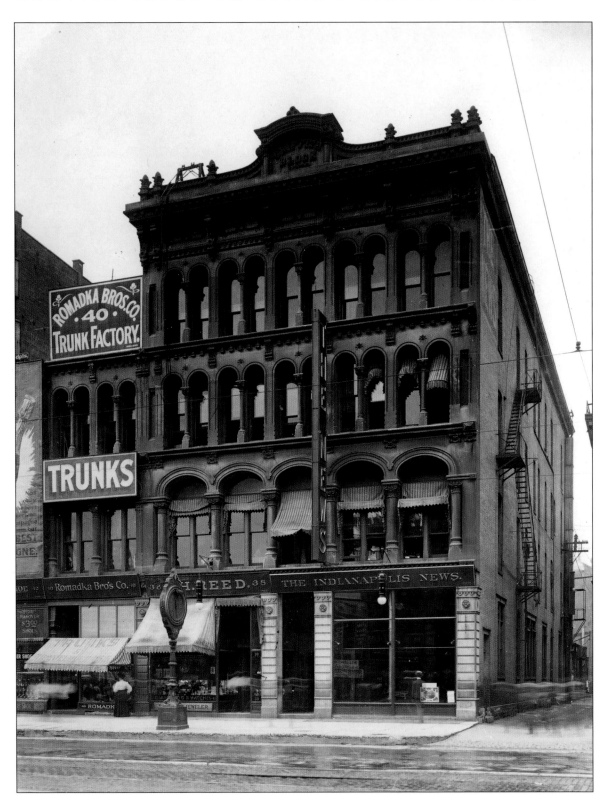

In 1872, the Griffith Block Building was designed in the Venetian Commercial Italianate style and erected on West Washington Street. For decades, the limestone building housed the offices of the *Indianapolis News*, which can be seen on the street level in this photo taken in 1907. The *News*, an afternoon newspaper, was owned (secretly) during this period by former U.S. vice president Charles Fairbanks. A wealthy Republican who served under—and clashed with—President Theodore Roosevelt, Fairbanks did not want Indianapolis residents to regard him as an all-powerful force in town. His ownership of the *News* wasn't revealed until after his death in 1918. His three sons followed him as publisher until the newspaper was purchased by the *Indianapolis Star*'s owner, Eugene C. Pulliam, in the late 1940s.

With the construction of Circle Centre in the 1980s, the Griffith facade became one of eight historical facades incorporated into the mall. The historic limestone facade was moved one block south in 1995 so that it could be part of the mall, which, unlike many suburban malls built during the 1980s and 1990s, has a variety of different fronts instead of being a monolith. Along with facades of the other historic structures (including the Rost Jewelry store built in 1887 with later art deco restorations), the Griffith facade was incorporated into Circle Centre as a tribute to downtown's historic role as the state's retail center. The four-level mall occupies two entire city blocks.

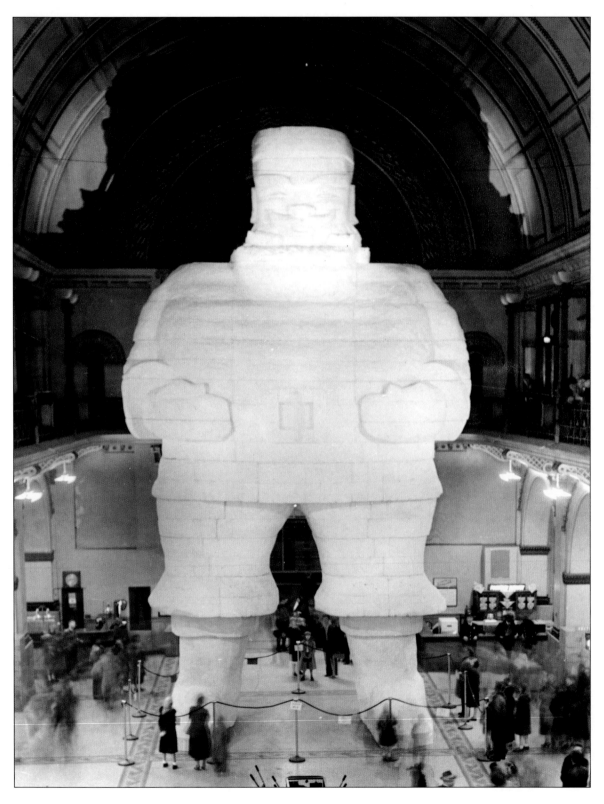

Left: This Romanesque revival train station became a hub of travel, business, and social activity after it was completed in 1888. Each day, thousands of passengers bustled through Union Station, at 39 Jackson Place, from soldiers (and their teary sweethearts) during World Wars I and II to college students and vacationers. Legendary trains such as the *Spirit of St. Louis* that roared through Union Station helped spur the "Crossroads of America" nickname for Indianapolis; at the station's peak, more than 200 trains came through each day. The snow-white Santa Claus in the photo from 1949 was a fifty-one-foot-high "Santa Colossal" made of Styrofoam. He "spoke" recorded Christmas greetings to visitors at the Indianapolis Industrial Exposition; postcards with this image were handed to thousands of yuletide passengers at the terminal.

Right: This former concourse, or "head house," was nearly demolished, along with the rest of the train terminal, in the early 1970s. With the decline in passenger rail service, traffic at Union Station had nearly vanished and Penn Central, the station's owner, filed for bankruptcy. A New Year's Eve party in late 1971 was staged to raise money to save the station, which eventually was placed on the National Register of Historic Places. The bumpy path continued, though, even after a $30 million restoration in which Union Station reopened in 1986 as a "festival marketplace" of boutiques and restaurants. The concept fizzled and the city government searched for new buyers. In 1999 Crowne Plaza leased the facility for a banquet hall and conference center.

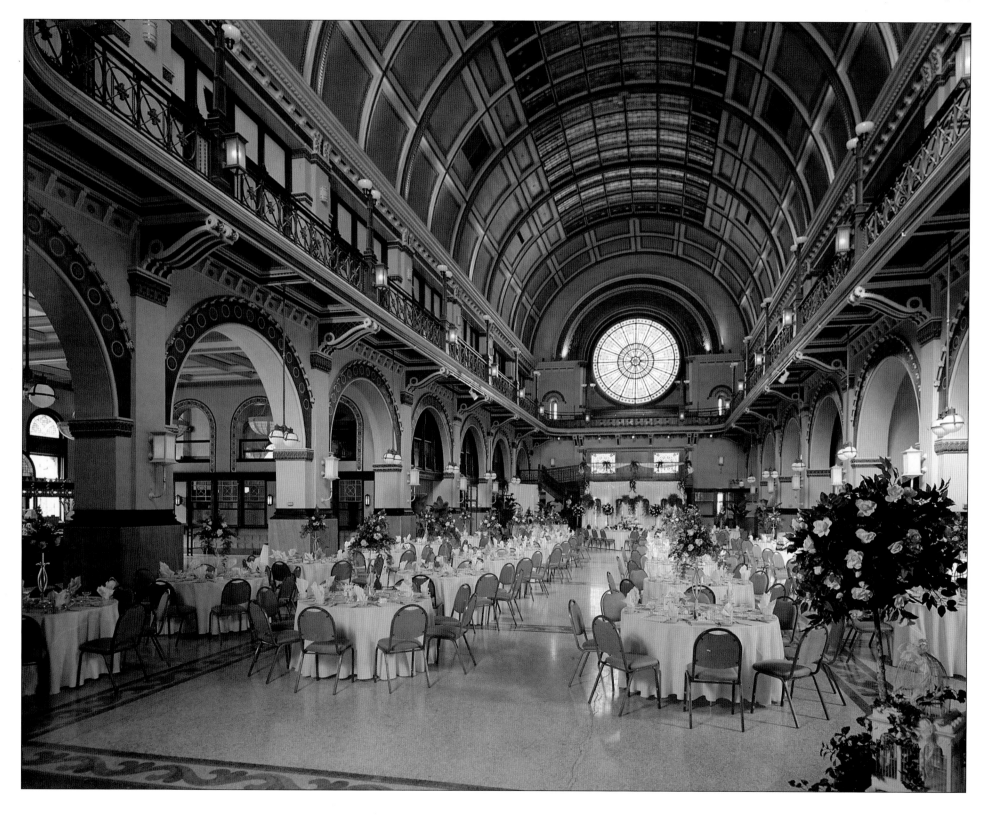

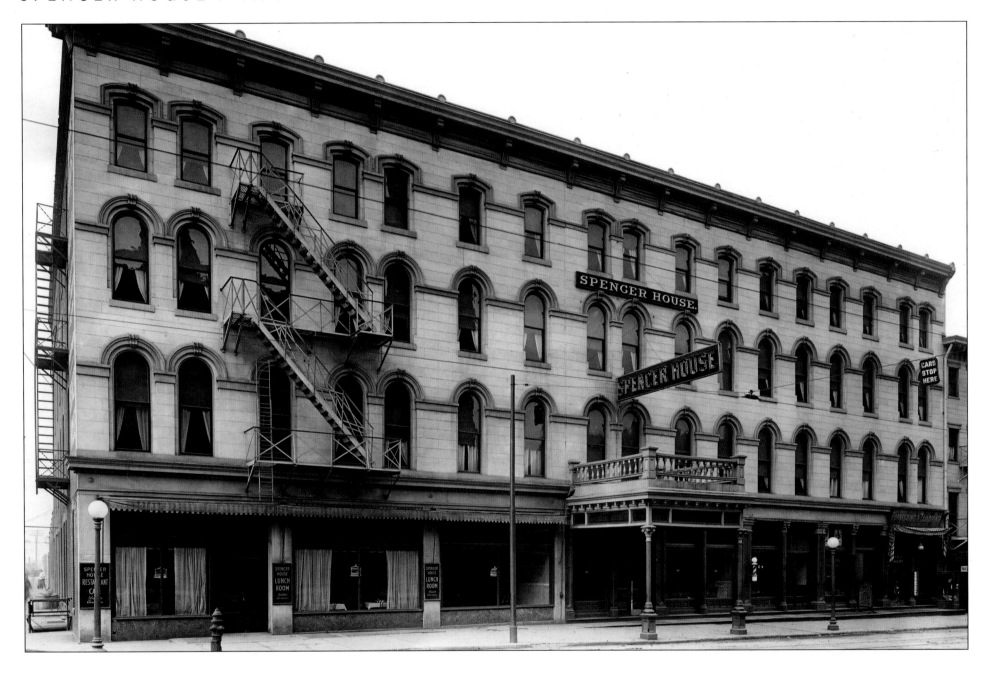

The district of boardinghouses and hotels just west of Union Station became known as "the Levee" during the 1800s. Built in 1857, Spencer House Hotel at 248 South Illinois Street was considered opulent in an era when this area of town was jammed with railroad tycoons, cattle breeders, and politicians. This photo was taken in 1918. Spencer House and neighboring hotels, though, were outclassed with the construction of more lavish hotels a bit farther north, such as the Claypool and Lincoln hotels. The southern stretch of the Levee had decayed into a sort of skid row by the late 1920s. Even so, the deteriorating Spencer House managed to last an astonishingly long time. It wasn't demolished until 1963, by which point the hotel was 106 years old.

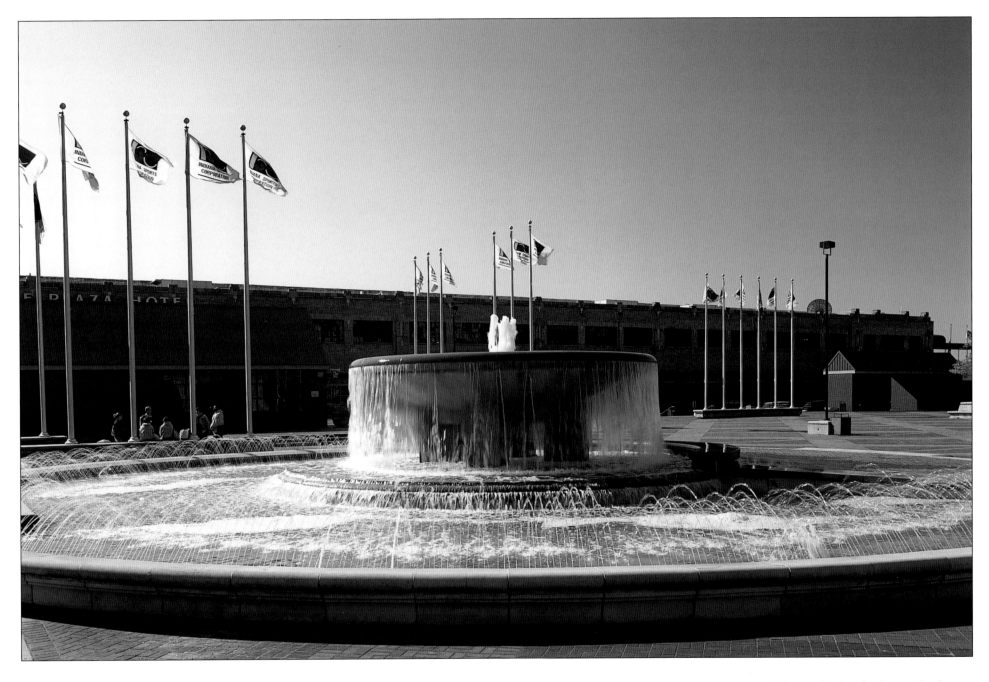

The spectacular 1987 Pan American Games went a long way toward establishing an international presence for Indianapolis, as well as solidifying the city's reputation as the amateur athletics capital of the country. As part of the host city's role, Pan American Plaza was created in the block bounded by Illinois and Georgia streets, the RCA Dome, and Union Station. Initially, flags of all thirty-eight countries from North, Central, and South America that competed in the Pan Am Games waved above the brick plaza, which includes a twelve-story office tower. It is the headquarters for several Olympic sports federations that moved to the Hoosier capital, including U.S.A. Gymnastics, U.S.A. Diving, U.S.A. Track & Field, and U.S. Rowing. The plaza also features two indoor skating rinks. Studies indicated the Pan Am Games pumped $175 million into the city's economy.

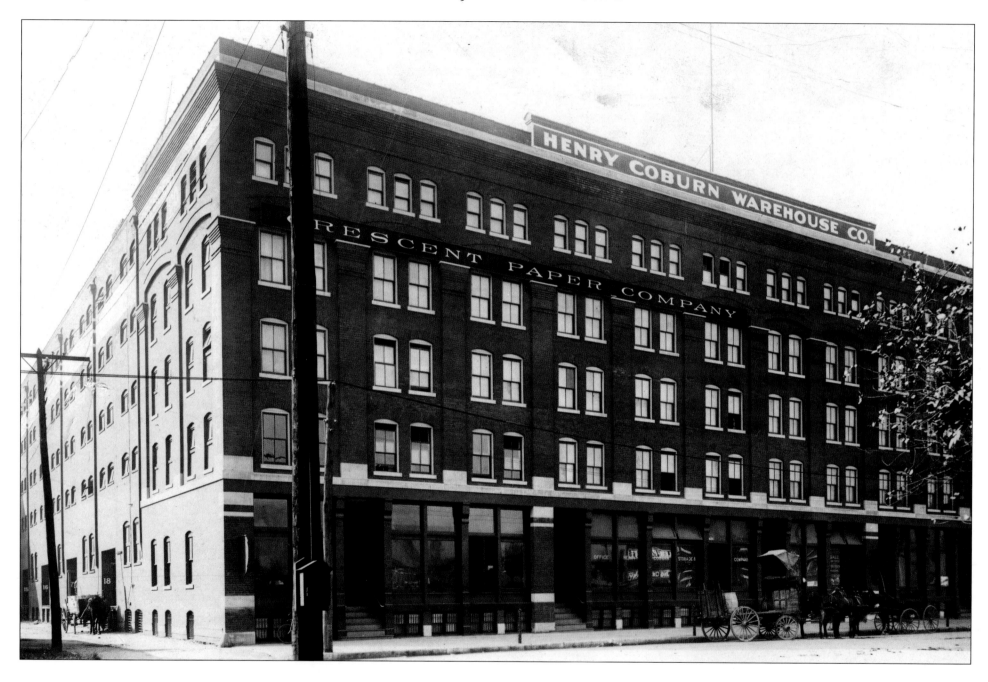

The Henry Coburn Warehouse Company, as seen here around 1905, was a storage business located several blocks southwest of Monument Circle on West Georgia Street. The massive building also housed Crescent Paper Company, a wholesale paper business. By 1907, Indianapolis had a thriving paper industry; six local businesses directed sales forces that ventured into Missouri, Iowa, and even Texas. Of the six, only Crescent sold both wrapping (fine) paper as well as printing (coarse) paper. A major advantage of a business located in this structure—whether a warehouse or a paper company—was that the building's rear backed up to railroad tracks leading to and from Union Station. The building was just southwest of the Wholesale District.

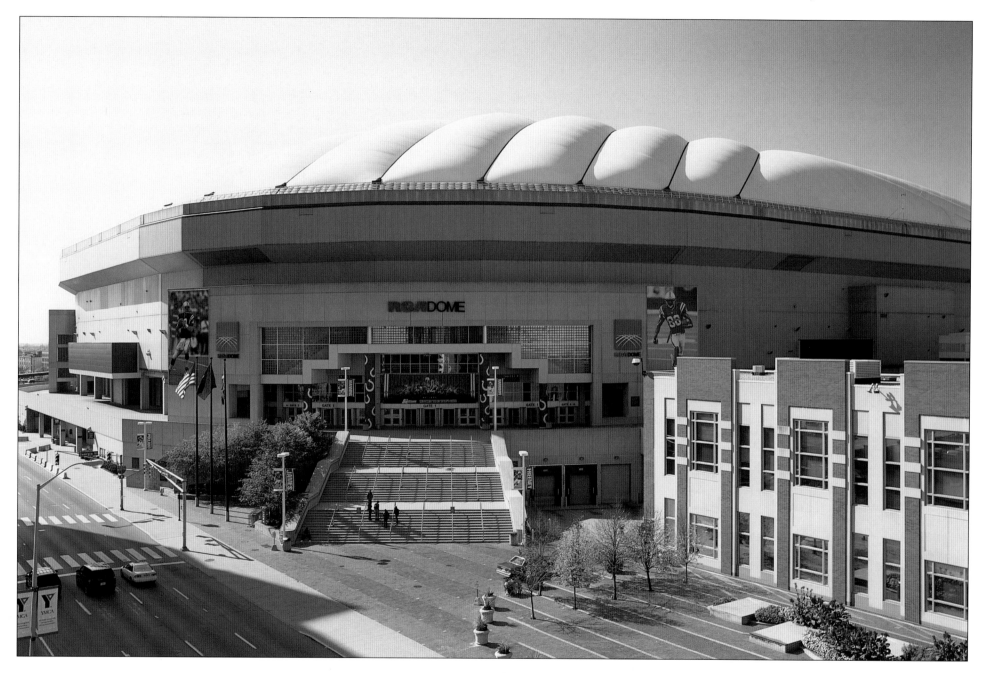

The $82 million RCA Dome (then known as the Hoosier Dome) opened in May 1984, just in time for the city to lure the stadium's big-ticket occupants, the Indianapolis Colts. Although the 55,600-seat domed stadium is now decried as antiquated by some, including current Colts owner Jim Irsay, there was much hoopla in 1984 about its state-of-the-art features, including an eight-acre roof consisting of two layers of fabric. There's no question the arrival of an NFL team enormously enhanced the city's claim to "major league" status, but the Colts were slow to catch fire on the field. However, the Colts have enjoyed recent success with their talented and popular quarterback, Peyton Manning. The stadium is attached to the Indiana Convention Center, which opened in 1972.

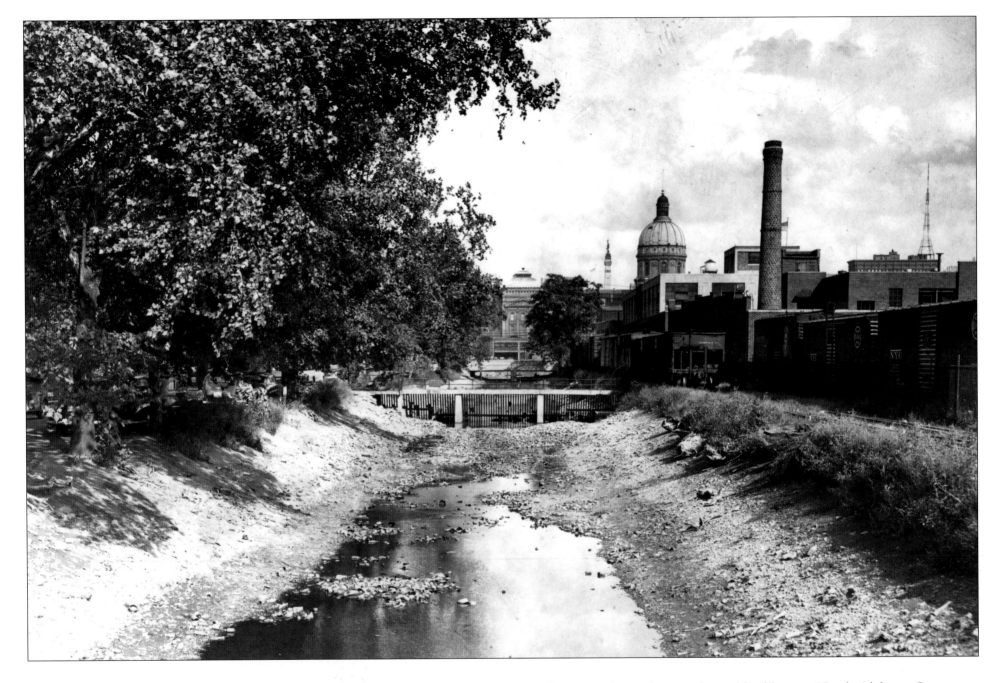

Looking east, the view in the 1950s of the Central Canal just beyond West Street took in the dome of the Indiana Statehouse, but little else of significance except for the grim smokestacks of paper mills that dominated the area. At this time, the Indiana State Museum was located in the basement of the Statehouse. Most of its displays were of artifacts related to natural history. After much public clamor to upgrade the state museum,

in 1967 it moved into the neoclassical building on North Alabama Street, which once served as the Indianapolis City Hall. The view from this spot on the canal, though, would not have changed much in those thirty years. The Indianapolis Water Company owned the canal; the southern area around its banks just beyond the Mile Square was not considered ripe for development.

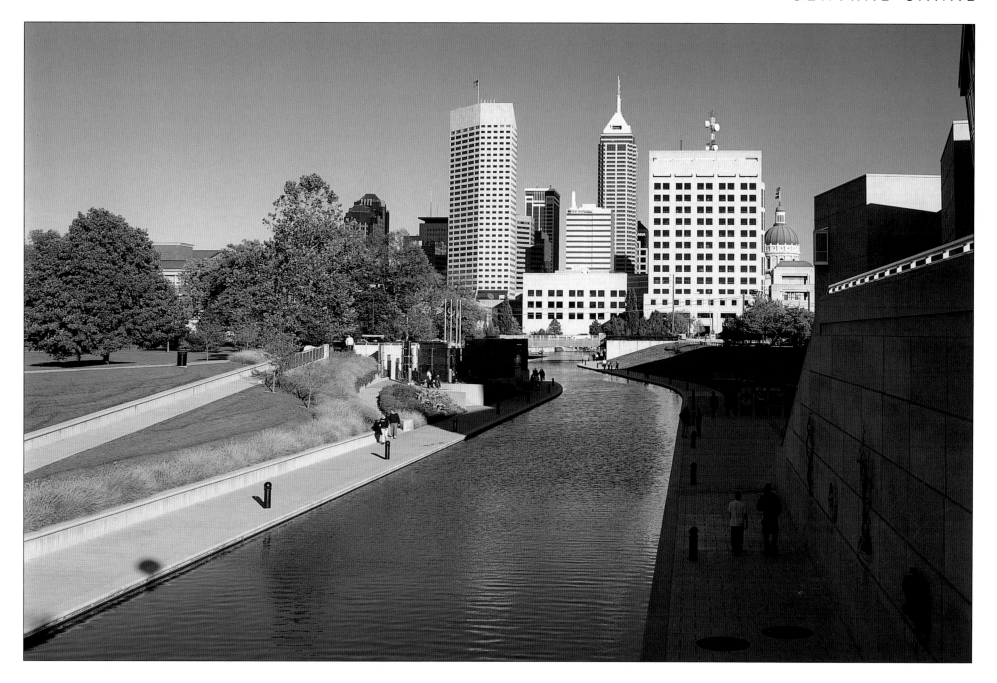

The Indiana Statehouse is visible as ever from the vantage point of the Central Canal. To the right is part of a spectacular structure that's been generating plenty of buzz since its grand opening in 2002. It's the $105 million Indiana State Museum, which is split into two buildings on the east and west banks of the canal, bridged by a 200-foot walkway. Built of Hoosier limestone and sandstone, the museum serves as a kind of monument to the state, beginning with its main lobby that features a fifty-five-foot-tall sculpture spelling "INDIANA" by artist Robert Indiana. The museum's artifacts range from Amish quilts and T. C. Steele paintings to a re-creation of the beloved L. S. Ayres Tea Room. The area around the canal became a pedestrian park.

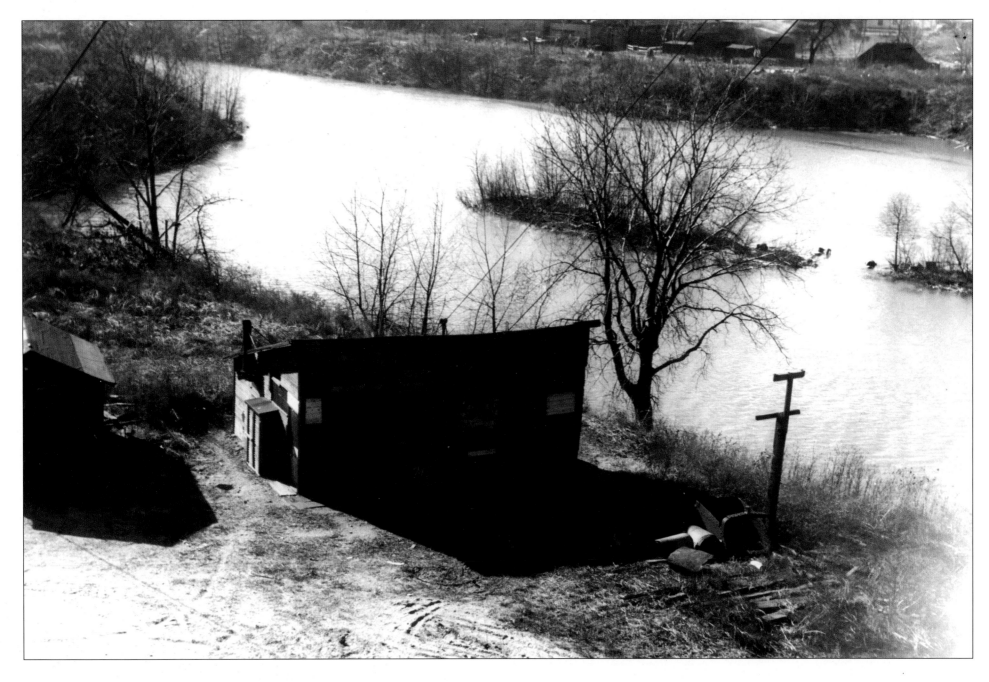

No one in the 1930s would have chosen Curtisville Bottom on the west bank of the White River as the setting for an idyllic stroll. Curtisville Bottom and other nearby neighborhoods were described as "shantytowns." This photo was taken in 1935, the year that Curtisville Bottom was torn down at its site south of West Washington Street. White River, the main waterway in Marion County, remained the butt of deprecatory comments or jokes for many decades. Some wisecracks focused on the river's lack of grandeur; other disparaging remarks had to do with water quality. By the 1970s, most of the riverbank area was considered to be an industrial slum. City residents either ignored the area or regarded it as an eyesore as they drove by.

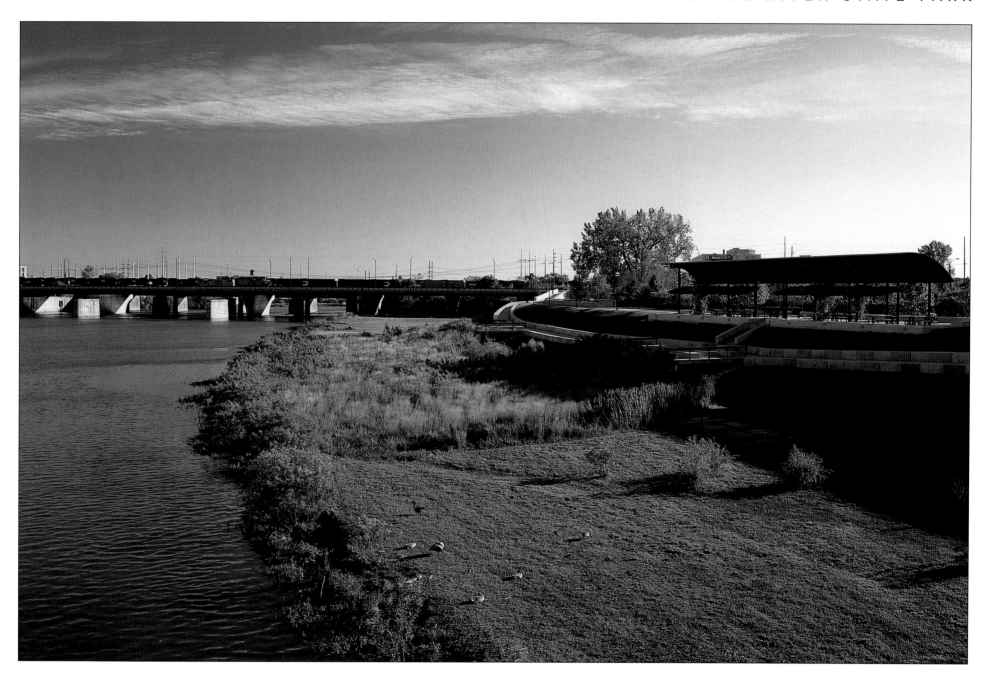

White River State Park today features urban walkways for Hoosiers. Just off to the extreme right of this photo is the pavilion of White River Gardens, which has a glass conservatory, outdoor design gardens, a water garden, and a wedding garden. Created with the intent of reclaiming White River, the state park consists of about 270 acres along the banks of the river just west of the Mile Square. The park's development kicked off in the 1980s, but it took years for local residents to appreciate the area's transformation. One of the first cultural gems in the area was a museum devoted to Old West and Native American art. The Eiteljorg Museum of American Indians and Western Art opened in 1989 at the main entrance to White River State Park.

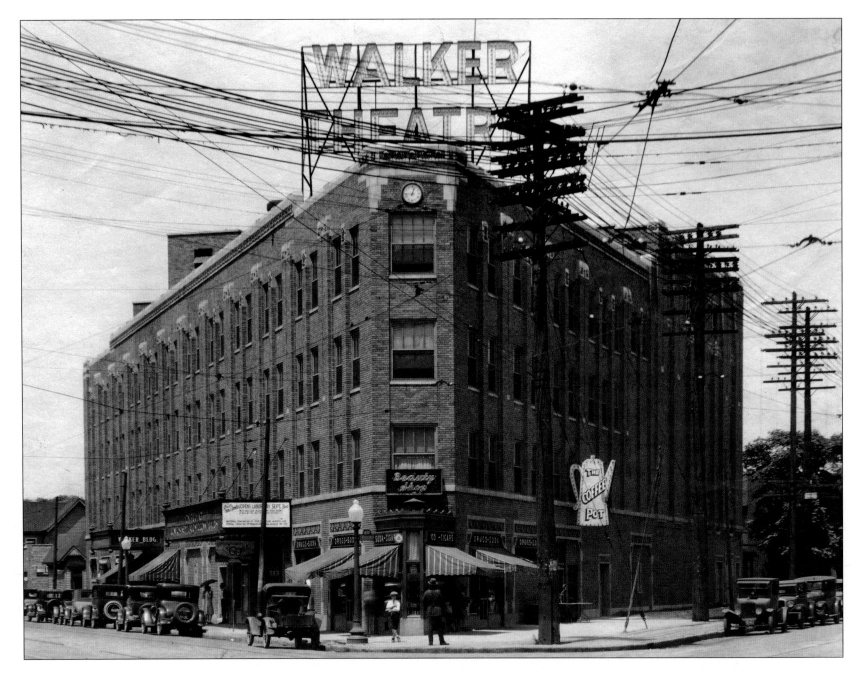

A magnificent, four-story building on Indiana Avenue was the vision of one of the most remarkable women in Indiana history. Madam C. J. Walker, whose parents were slaves, may have been the first African American woman to become a millionaire, but she didn't live to see the completion of the building complex that she envisioned. She amassed a fortune as an entrepreneur in the hair-care and cosmetics industry, but died eight years before the Walker Building opened in 1927. The building, shown here in 1928, served as the international headquarters for the Walker family's business. It also housed popular restaurants (including one called the Walker Coffee Pot), a beauty college, a ballroom, and a drugstore. During the 1940s and 1950s, the Walker Building was the hub of vibrant Indiana Avenue, the center of African American music and business life in Indianapolis.

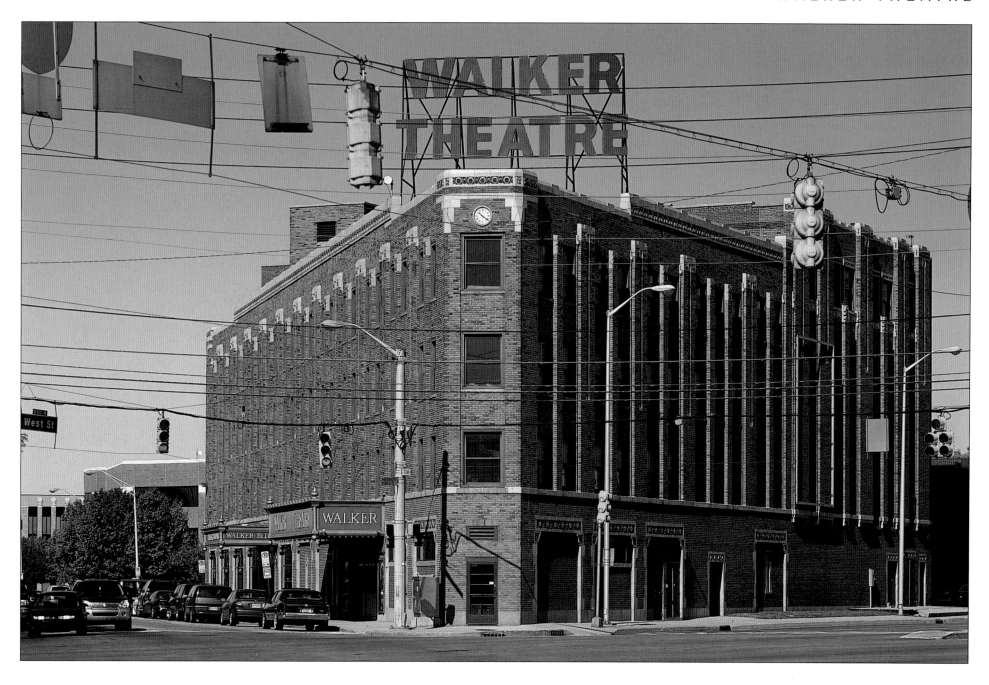

Just as in the heyday of the Indiana Avenue jazz scene, the building named in honor of Madam Walker is a symbol of ethnic pride today. The Madam Walker Urban Life Center includes the majestic Madam Walker Theatre Center, which seats about 950 people. The theater is decorated with elaborate carvings celebrating African folklore and culture. The center opened in 1988 after a massive restoration of the former Walker Building, which had deteriorated during the 1970s as businesses left Indiana Avenue. The trend has reversed, and the Walker Theatre is a popular setting for a range of civic events, including the Wes Fest, an annual tribute festival to the late jazz legend Wes Montgomery, the biggest star to emerge from the Indiana Avenue music scene.

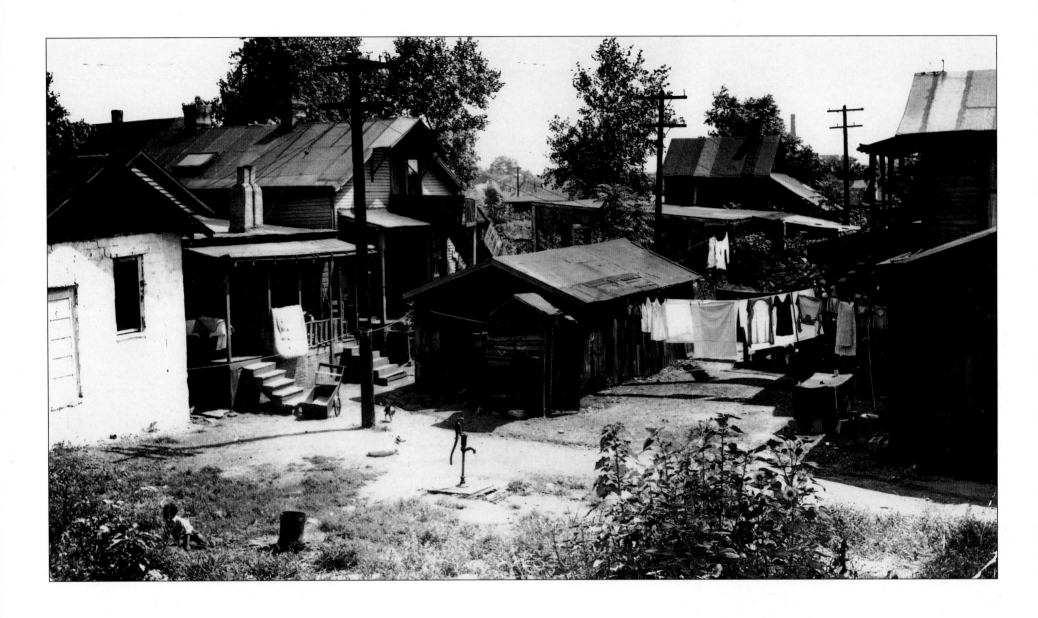

Future basketball star Oscar Robertson described his boyhood neighborhood of the 1930s as a "ghetto" in his autobiography. Federal officials used the phrase "slum clearance" during the 1930s, when this photo was taken, to refer to the work undertaken in the Westside to make way for Lockefield Gardens. Almost 400 houses near Indiana Avenue and Locke, North, and Blake streets, including the homes here, were removed to build Lockefield

Gardens, the first major public housing project in the city. Generally regarded as one of the most successful of such developments in the nation, Lockefield Gardens opened in 1938 and consisted of 748 living units, primarily low-density apartment groupings. The project was funded by the Public Works Administration as part of the New Deal during the depression.

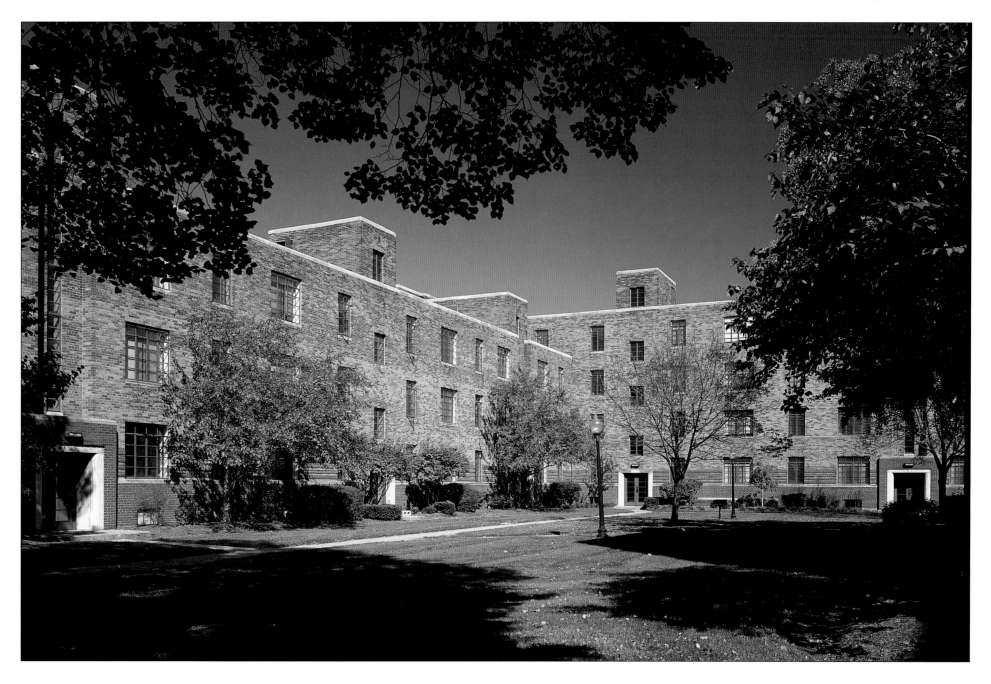

Lockefield Gardens is a mix of original buildings from the late 1930s that have been renovated and modern residences constructed in the 1980s and 1990s. Well landscaped and well maintained, the apartments in Lockefield Gardens have become popular among college students, particularly with the growth of nearby Indiana University–Purdue University Indianapolis (IUPUI). Many of Lockefield Gardens' older buildings, which were upgraded in a "soft rehab" technique, have their original casements. Before the revitalization of Lockefield, the housing units had fallen into disrepair as middle-income families moved farther north or west. Lockefield, though, never deteriorated to the "ghetto" of Robertson's youth.

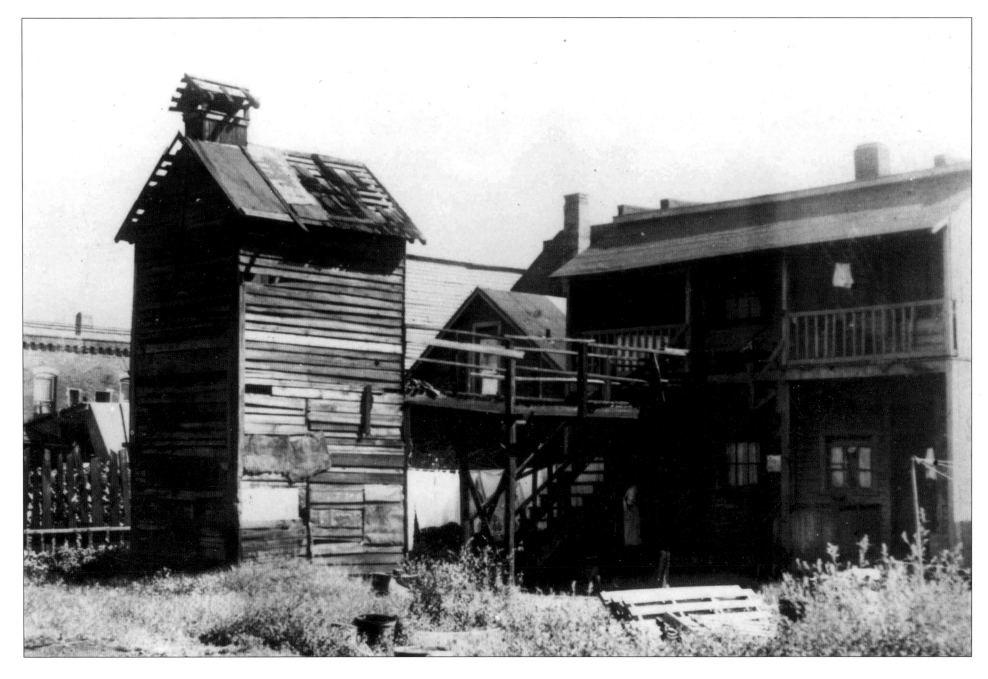

When this photo was taken in 1941, a time when most Indianapolis residents had been enjoying indoor plumbing for decades, this two-story outhouse, located at 458–460 North Agnes Street, still stood tall, if not proud, behind a four-story apartment building. This was in the Near Westside area, which comprised of several poverty-stricken neighborhoods. Much of the area that is now the site of IUPUI was described as "a shameful mile of shambles" by the *Indianapolis Star* in the early 1950s. The blighted neighborhoods, which also included an outhouse near a shallow well that provided drinking water for residents, were about a mile from the Soldiers' and Sailors' Monument. However, the apartment buildings and outhouses were tucked away on little-used dirt streets, so they were seldom seen by those who worked downtown.

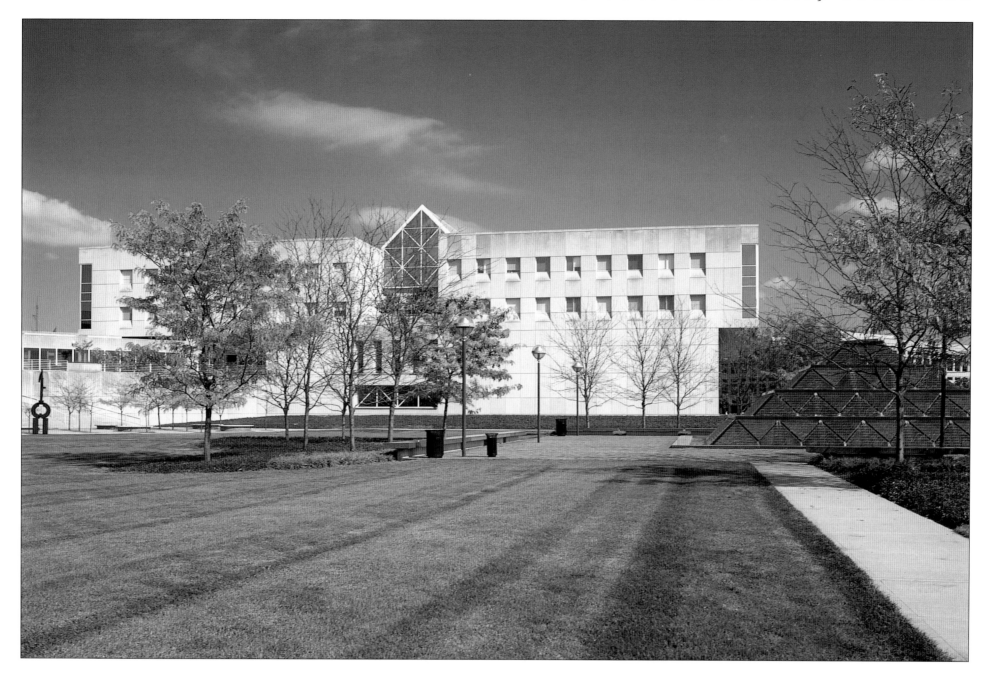

Out with outhouses, in with IUPUI, one of the nation's largest urban campuses. The site of the former outhouse was near the $32 million IUPUI library, which opened in 1993 on the 400 block of University Boulevard. (The name was changed from Agnes Street in the 1980s.) The five-story University Library, with its atrium and tiered exterior fountain, is among dozens of modern buildings on the commuter campus, which has grown

dramatically since its beginnings in 1969. Today IUPUI is attended by 29,000 students, making it the third-largest university in the state behind only its "parents," Indiana University and Purdue University, which are long-time rivals. By 1993, IUPUI was the fourth-largest employer in Indianapolis.

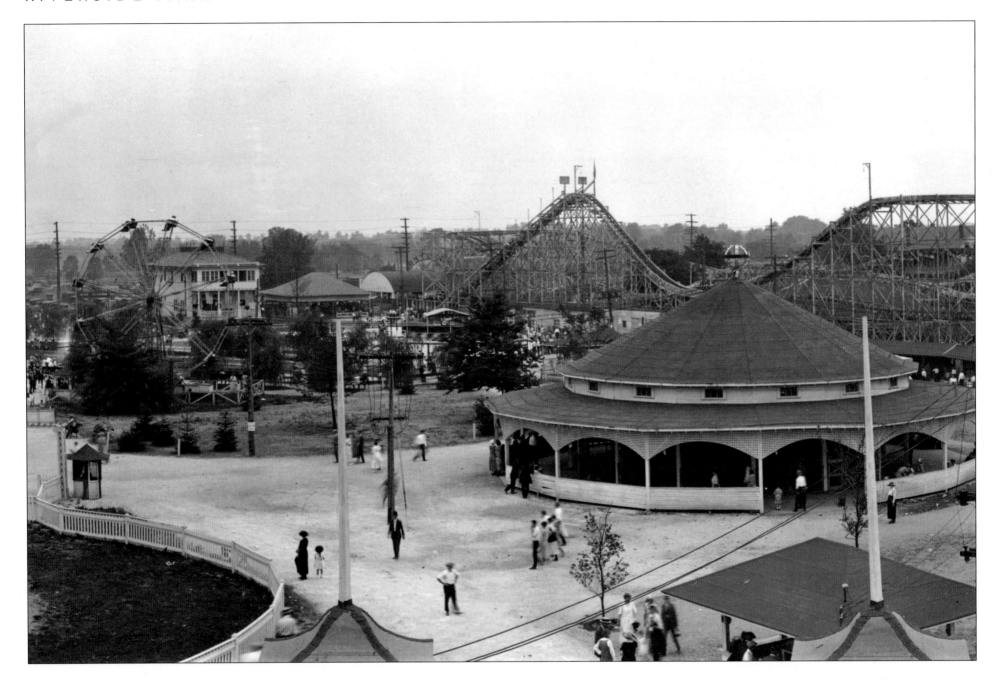

Generations of Hoosier children first experienced the thrill of riding a roller coaster, Ferris wheel, and a waterslide at Riverside Park, which flourished for more than sixty years along the White River at West Thirtieth Street. The amusement park opened in 1903 next to farmland that Mayor Thomas Taggart asked the city to purchase in the 1880s as part of a series of public parks. Riverside, shown here in the mid-1920s, initially offered only a handful of "fun house" rides, as well as a toboggan. Eventually, the amusement park captivated families with a miniature railroad and two roller coasters called the Flash and the Thriller. In 1952, Riverside was visited by more than a million patrons. It was not all fun and games though. Riverside generated outrage by clinging to a "whites-only" admission policy through the 1950s even as African American families moved into surrounding neighborhoods.

Several factors contributed to the demise of Riverside Amusement Park, which closed in 1970 after years of deterioration. Middle-class residents had abandoned Riverside and other neighborhoods in favor of new subdivisions farther north. In addition, the construction of Interstate 65 through the nearby area hurt property values, at least temporarily. Since 2000, several residential subdivisions, including River's Edge, have been built on or next to the site. Most of the new homes and town houses are on the north side of West Thirtieth Street near Riverside Parkway Drive. To the south, Riverside Park and Golf Course emerged in the 1980s after the city launched a rejuvenation effort. The Major Taylor Velodrome, a $2.5 million cycling track named for a famous African American cyclist from Indianapolis, is also located here. It seats 5,000 spectators.

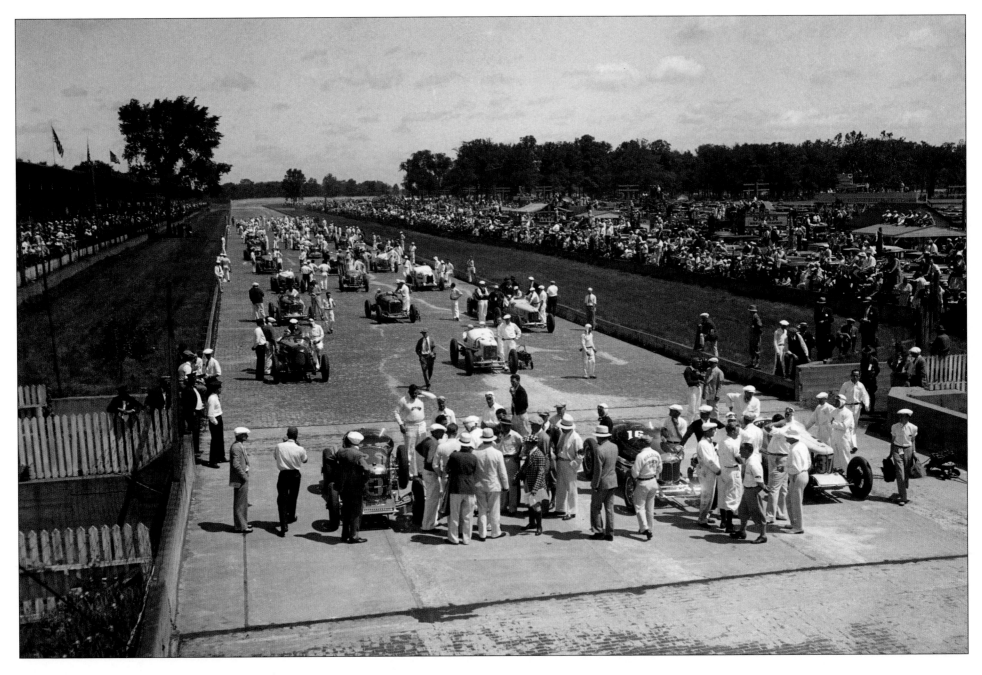

The Indianapolis Motor Speedway Corporation was formed on February 9, 1909, when 328 acres of farmland northwest of downtown was purchased by flamboyant entrepreneur Carl Fisher and his partners. A two-and-a-half-mile oval track was built and the first car race, a five-mile dash, was held in August 1909. It was a disaster. The track surface broke up, causing the deaths of two drivers, two mechanics, and two spectators. After several unsuccessful automobile and motorcycle races, Fisher decided a single extravaganza was needed. The Indianapolis 500 was born with great success on May 30, 1911. Ray Harroun beat the other thirty-nine drivers, winning the race with an average speed of 74 mph in six hours and forty-two minutes.

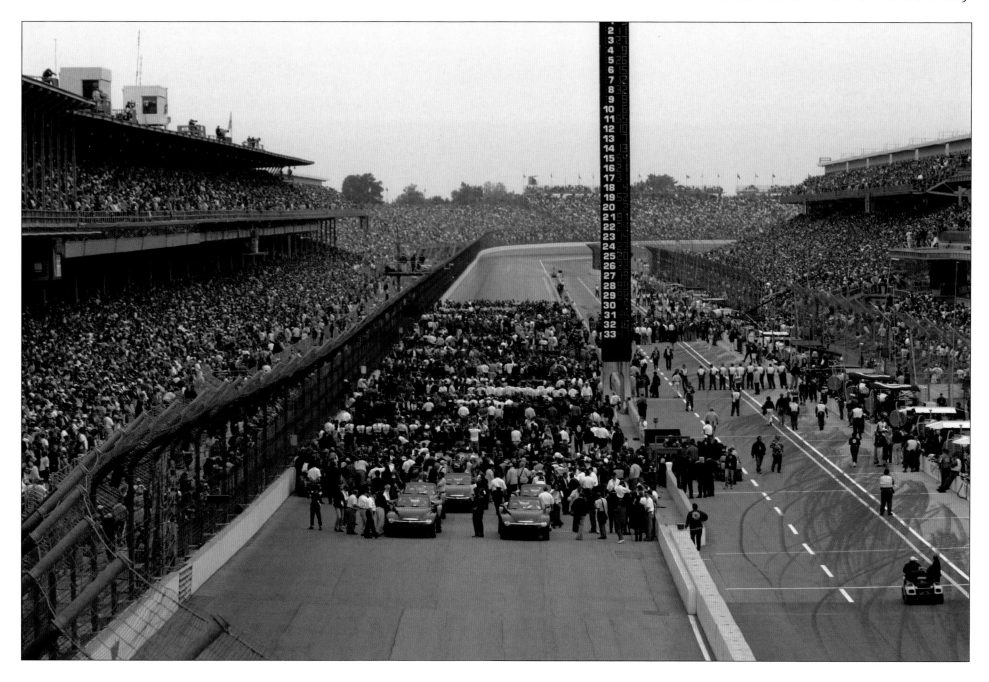

The Indianapolis Motor Speedway has been nicknamed "the Brickyard" since 1909, when the surface of the oval track consisted of 3.2 million bricks. A single strip, called the "yard of bricks," remains at the track's start/finish line. The Indianapolis 500, which today has a field of thirty-three cars, became and remains the largest single-day sporting event in the world, regularly drawing 300,000 spectators to the Speedway. Now the Speedway also hosts two of the world's other prestigious races: the Brickyard 400, featuring stock cars, and the United States Grand Prix, where Formula One cars run backward down the start/finish straight. NASCAR's inaugural Brickyard 400 in August 1994 was won by crowd favorite Jeff Gordon, who grew up less than fifteen miles west of the Speedway in the town of Pittsboro.

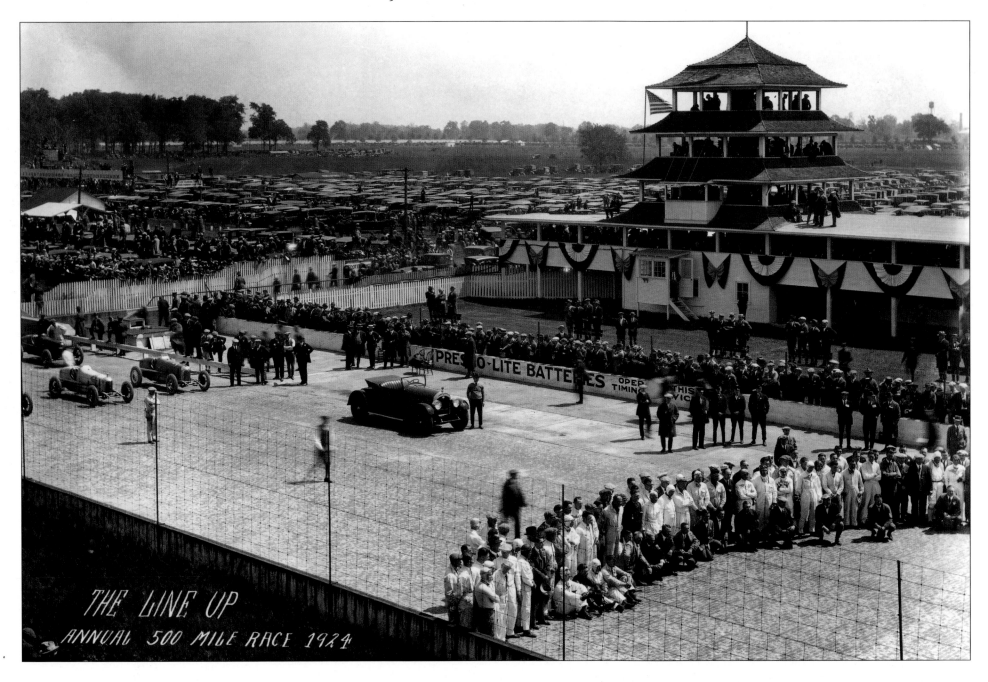

THE LINE UP
ANNUAL 500 MILE RACE 1924

An eye-catching pagoda housing racetrack officials was a landmark at the Speedway for decades, but fate was not kind to it. The wooden, Japanese-style pagoda, seen here in 1924, was painted green and white; it burned to the ground in 1925 the day after the Indianapolis 500. The pagoda had become such a landmark that a second one, also wooden, was erected immediately. By the mid-1950s, the Speedway began to take on a modern look as aluminum and steel seats supplanted aging wooden grandstands. The second pagoda was replaced by the modernistic Tower Terrace. Propelled to a new era of glory, the Speedway attracted the best drivers from around the world. Mario Andretti, Jim Clark, Graham Hill, Jacques Villeneuve, and Emerson Fittipaldi are among those who have won the world's premier car race and claimed the massive Borg-Warner Trophy that goes with the Indy 500 title.

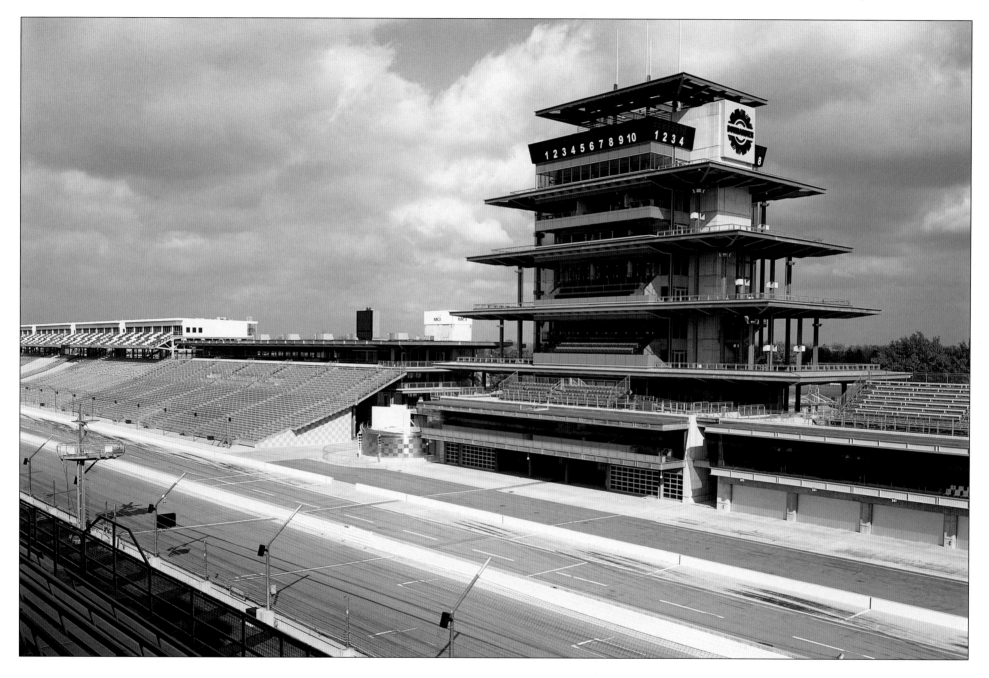

A towering new pagoda was completed in 2000 as part of a series of changes at the Speedway to accommodate the introduction of Formula One racing, in which the cars use a specially built infield circuit. The Tower Terrace built in 1955 was demolished to make way for the new pagoda, which is 153 feet tall; Speedway owner Tony George asked Indianapolis architect Jonathan Hess to create a pagoda as a tribute to the racetrack's heritage. In addition to bringing NASCAR and Formula One racing to the Speedway, other changes have been initiated by George. The infield at the racetrack had been the setting for rollicking party behavior from the 1950s through the 1980s, with the most notorious section known as the "snake pit." Beginning in the 1990s, George strived to restore a wholesome image to the Speedway, with increased security, more bleachers in the infield, and upgraded concessions.

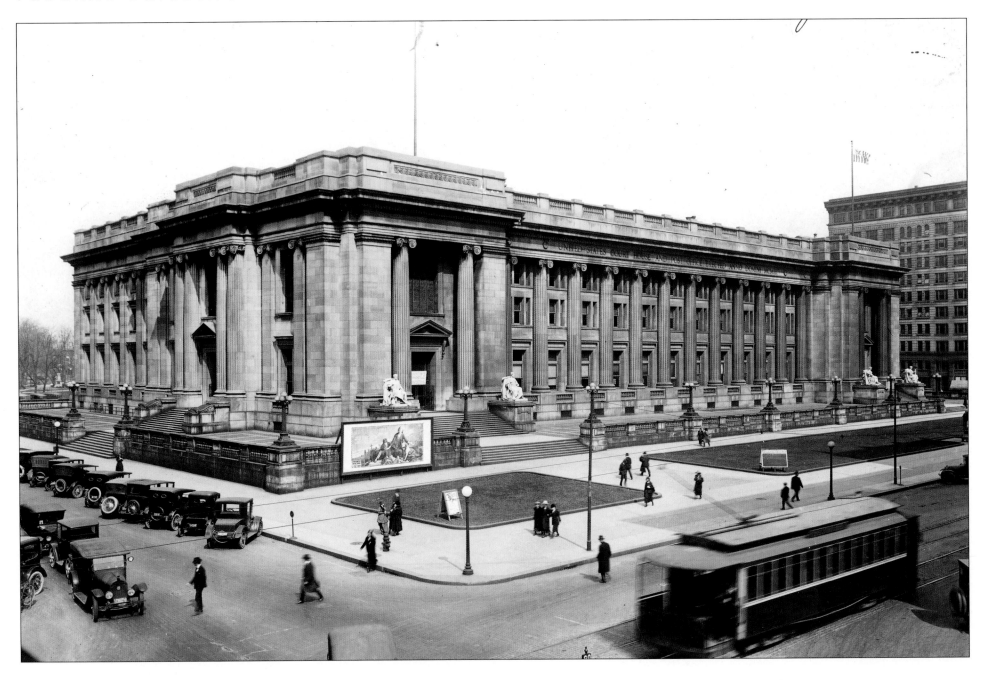

The structure that spans a city block of Ohio Street between Pennsylvania and Meridian streets became known as the Federal Building, although it was officially called the U.S. Courthouse and Post Office. The $12 million construction of the neoclassical structure began in 1903. Built of Indiana limestone, the Federal Building is lined on all sides by Doric columns. The grand architectural style, which combined Greek, Roman, and Renaissance classicism, started a trend in public architecture in Indianapolis. Massive structures influenced by the Federal Building include the Indianapolis–Marion County Public Library built in 1917. The south facade of the Federal Building, seen here in 1919, features several large sculptures. The interior has mosaics, murals, and stained-glass windows in the courtrooms. Until 1973, the Federal Building housed the city's main post office.

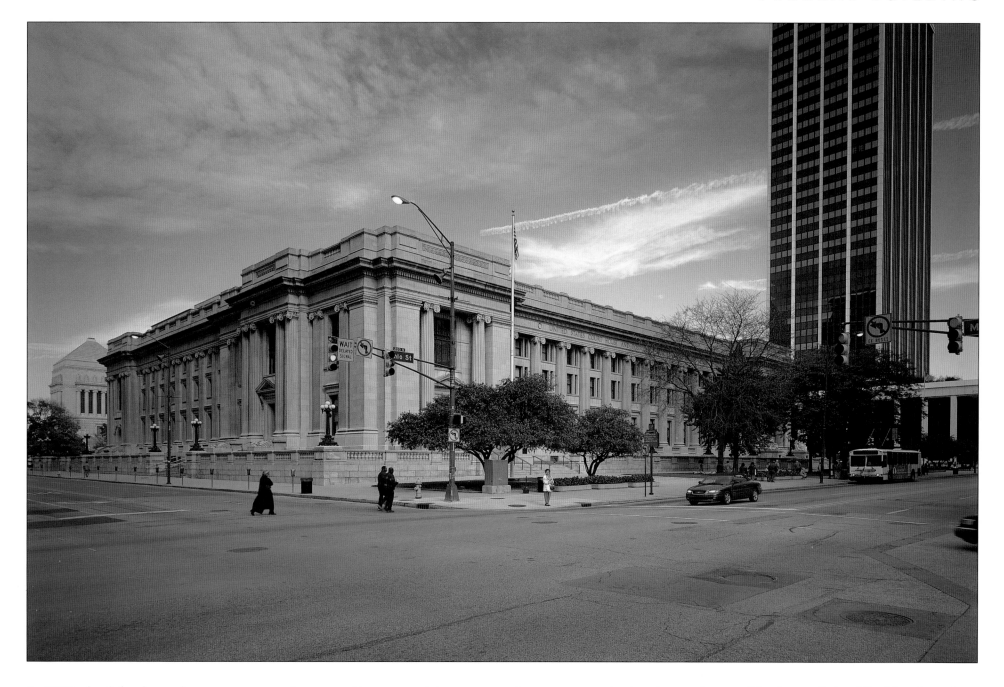

In 2003, the federal courthouse was renamed as part of its centennial anniversary celebration. The Birch Bayh Federal Building and U.S. Courthouse no longer houses the post office, but it remains the imposing home of the courtrooms for the U.S. District Court of Southern Indiana. A U.S. senator from 1963 to 1981, Birch Bayh was the author of some important constitutional amendments. The former Federal Building has often been confused with the Federal Office Building (also known as the Minton-Capehart Building) at 575 North Pennsylvania Street. Erected in 1975 in the modern architecture style, its structure is frequently derided for its wavy exterior bands of orange and other vivid colors.

By 1925, when this photo was taken, the Indiana School for the Blind had occupied prime real estate in the Mile Square for more than seventy years. Set far back from North Street and surrounded by iron fences, the school's five-story building with Corinthian cupolas opened in 1853 in the block bounded by North Meridian and Pennsylvania streets. Over the years, a barn, dormitory, laundry, and greenhouse were added to the grounds. During the 1920s, though, Hoosier politicians decided the downtown site was ideal for a war memorial plaza, meaning the school would have to close at this location. The current Indiana School for the Blind building opened in 1930 on sixty acres at North College Avenue and Seventy-seventh Street. The new school incorporated the iron fence and stone scrolls from the downtown structure.

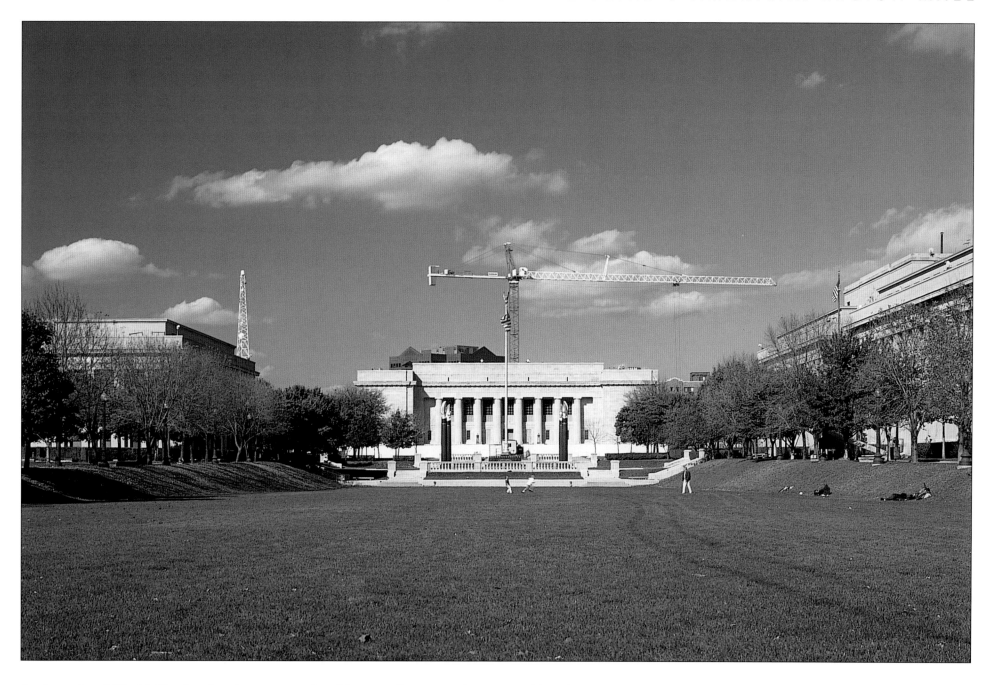

In the wake of World War I and with returning doughboys swelling its ranks, the American Legion was founded in 1919 and chose Indianapolis for its headquarters. The legion lobbied for the creation of a five-block war memorial that would include its headquarters building as well as various tributes to fallen soldiers. It took most of the 1920s to construct the memorial plaza and structures, which were primarily built of Indiana limestone and

marble. The American Legion State and National Headquarters, designed in a totalitarian classic style, opens onto the terraced mall shown here. The crown jewel of the plaza is the Indiana World War Memorial Building, which rises 210 feet above street level. At the center of a part of the grounds known as Veterans' Memorial Plaza is the Obelisk Fountain.

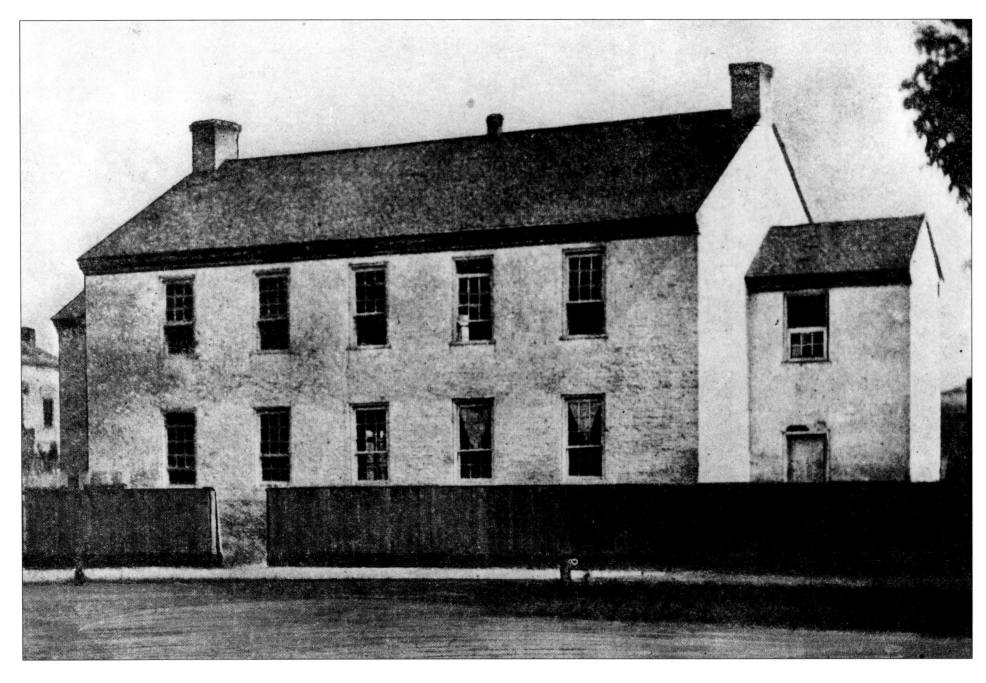

Marion County Seminary opened in the 1830s and chalked up a rather illustrious list of alumni. They included an indifferent student who was the son of David Wallace, Indiana's governor during the late 1830s. Lew Wallace later became the state's best-known Civil War leader, then reaped astonishing success as the author of *Ben-Hur* (1880), which historians believe was read by more people in its era than any book other than the Bible. As a student at Marion County Seminary, Lew Wallace indulged in a "habit of truancy," as he put it later. Known for its rigorous curriculum, Marion County Seminary was overseen by an elected board of trustees. Its building in University Square was demolished in 1860 as the public school system in Indianapolis began to flourish.

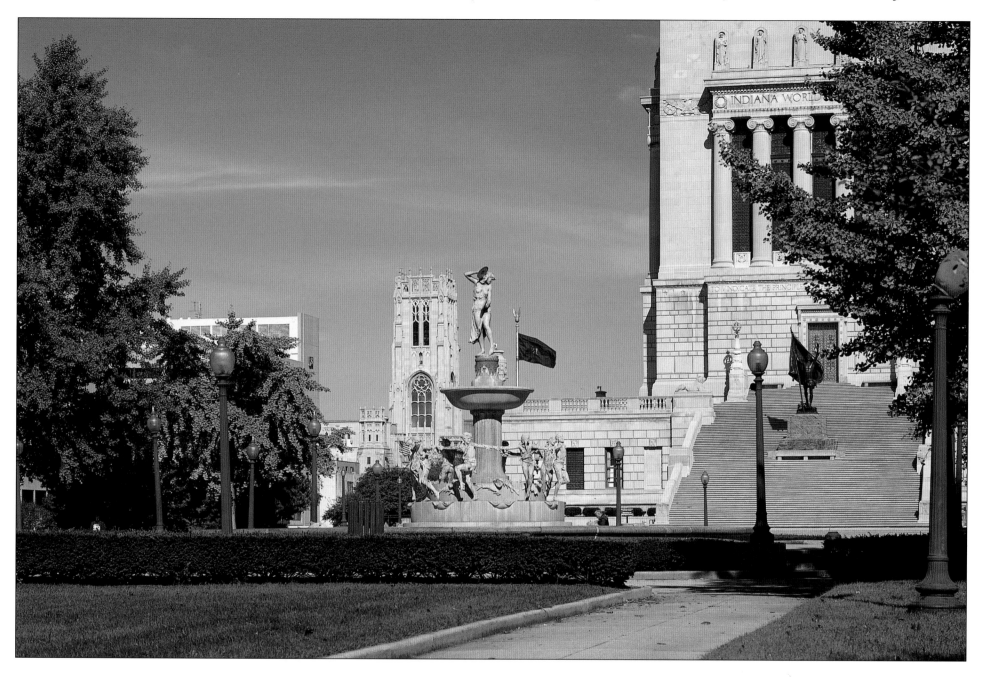

University Park was so named because civic leaders in 1821 expected a state university to develop on the site. It never happened and instead the park became the setting for several statues, as well as the five-level DePew Fountain at the park's epicenter. Among the statues in University Park, which was created after a community-wide fund-raising effort, are sculptures of Presidents Abraham Lincoln and Benjamin Harrison, the wood nymph Syrinx, the satyr Pan, and Vice President Schuyler Colfax, who hailed from South Bend and served under President Ulysses S. Grant. Colfax socialized with the Lincolns and is believed to have been the last public official to shake the president's hand.

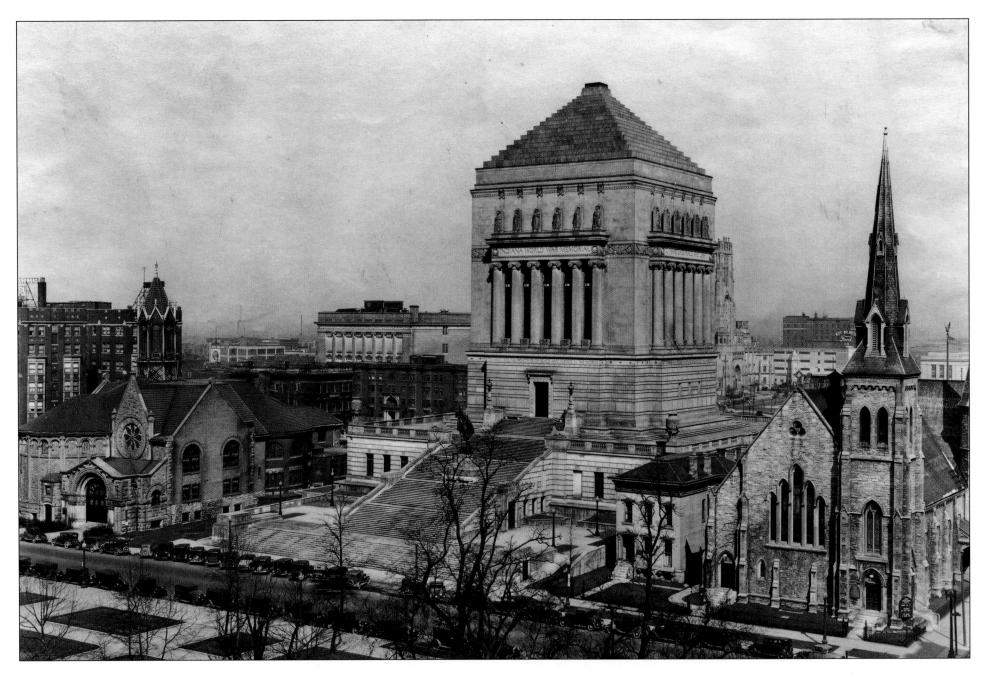

The Indiana World War Memorial Building, seen here in 1932, sits on a block raised above street level, meaning the shrine itself rises 210 feet above the ground. Constructed during the 1920s, the war memorial and surrounding plaza were initially designed to honor the sacrifices of Hoosiers who had fought in World War I. To create the memorial, several structures were removed from the two city blocks bounded by Vermont, Meridian, Pennsylvania, and North streets. The north and south sides of the shrine have majestic doors of double-leaf bronze. General John J. Pershing, a World War I commander, laid the cornerstone of the three-story memorial building on July 4, 1927, declaring it "a patriotic shrine." The memorial has a 500-seat auditorium, a grand staircase, and a Shrine Room that symbolizes peace and unity.

Today the Indiana War Memorial has come to symbolize the sacrifices of all Hoosiers who have fought in modern wars. Inside are listed the names of every Hoosier who participated in World War I, as well as all of those killed or missing in action in World War II, Korea, and Vietnam. Names are being added of Hoosiers killed in the 9/11 tragedy and the wars in Iraq and Afghanistan. Another majestic Indianapolis landmark is also clearly visible in the photo, the Scottish Rite Cathedral at 650 North Meridian Street. The world's largest Scottish Rite cathedral, the Tudor building with Gothic ornamentation was completed for $2.5 million in 1929. The cathedral is laid out in multiples of thirty-three feet to symbolize the thirty-three years of Jesus Christ's life. The cathedral's Gothic tower, which rises 212 feet above the street, has a carillon of fifty-four bells, making it one of the country's largest.

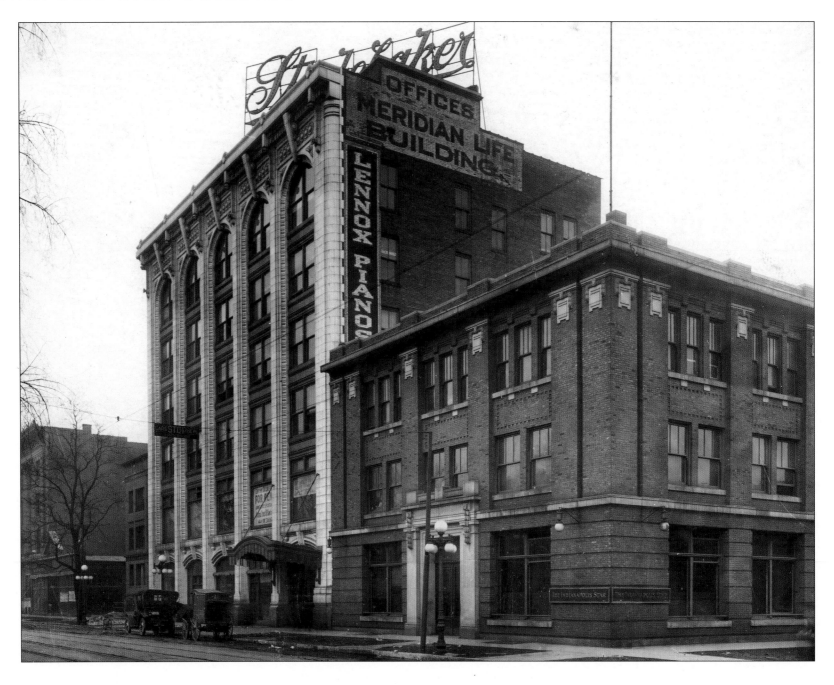

There were three daily newspapers in Indianapolis when this photo was taken in the 1920s. Self-made media titan Eugene C. Pulliam owned a string of newspapers and radio stations in Indiana and Arizona, eventually including his flagship, the *Indianapolis Star*, which had been founded in 1903. A morning newspaper, the *Star* competed with two afternoon dailies, the *Indianapolis News* and the *Indianapolis Times*, both of which were praised

(and, in the case of the *Times*, awarded a Pulitzer Prize) during the 1920s for their exposés of the Ku Klux Klan's stranglehold on Indiana politicians. In 1948, Pulliam purchased the *News* but decided to maintain competitive newsrooms. That meant more space was needed in the three-story Indianapolis Star Building, so the adjacent, five-story Meridian Life Building was "absorbed" to accommodate the combined *Star/News* operations.

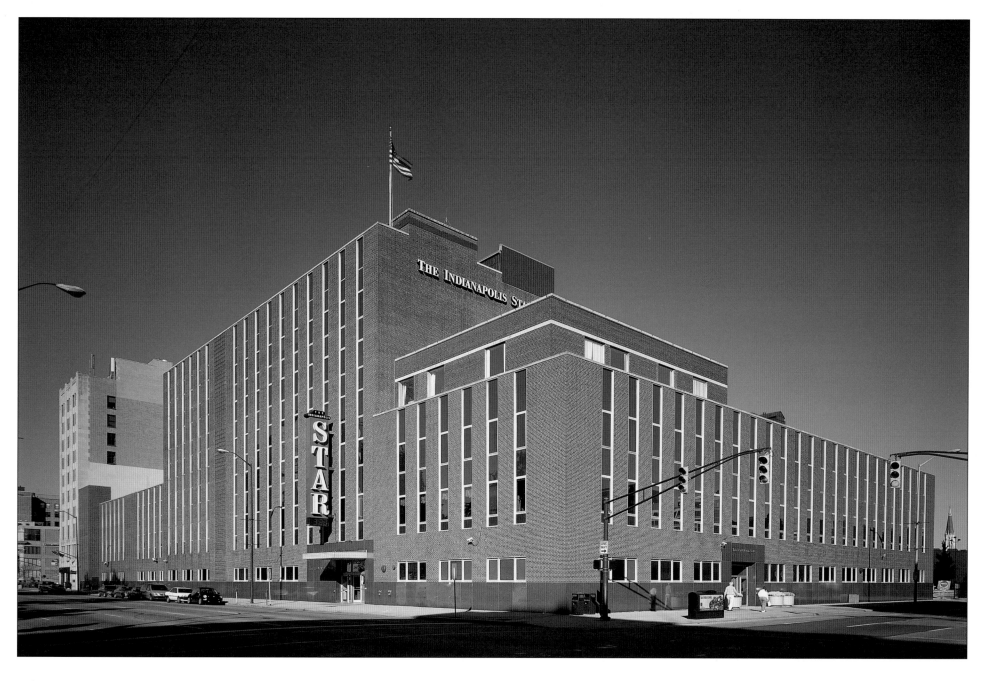

Like many major American cities today, Indianapolis now has just one daily newspaper. The *Star* has outlasted all of its competitors, although even it has undergone a significant ownership change. The first daily to throw in the towel was the *Indianapolis Times*, which shut down in 1965. During the next thirty years, the *Star* won two Pulitzer Prizes for investigations of police corruption and medical malpractice, but also endured criticism for its fiercely conservative editorial stance. In 1995, the staffs of the *Star* and the *News* merged. Four years later, the venerable *News*, once the state's most widely read newspaper and known as "the Great Hoosier Daily," printed its farewell issue. In 2000, nearly five decades of family ownership of the *Star* ended with its purchase by Gannett Co., the nation's largest newspaper company.

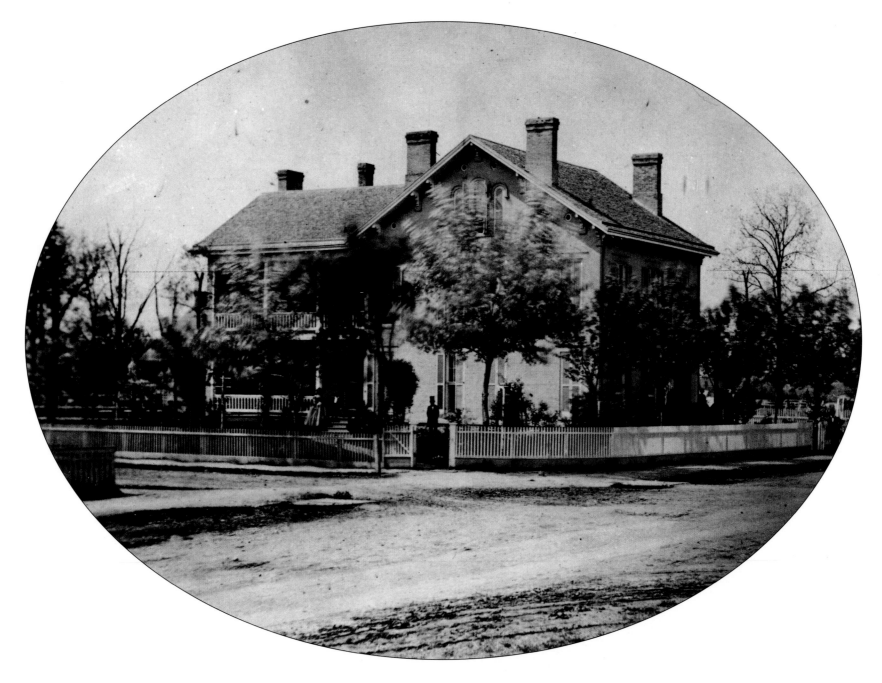

As befitting a mover and shaker, early Indianapolis civic leader William Sullivan (1803–86) lived in a stately and spacious home, seen here in a photo from 1862. A civil engineer and educator, Sullivan became a county surveyor. He oversaw street improvements, designed city maps, and helped get the local school system up and running. If all that wasn't enough to keep him busy, Sullivan also served as the city council president, became a justice of the peace, and was on the board of trustees for railroads. He couldn't have slept much, but when he did it was at this house on the northwest corner of North Meridian and St. Clair streets. Sullivan undertook all of these public and private endeavors after moving to the still-new city of Indianapolis in 1834.

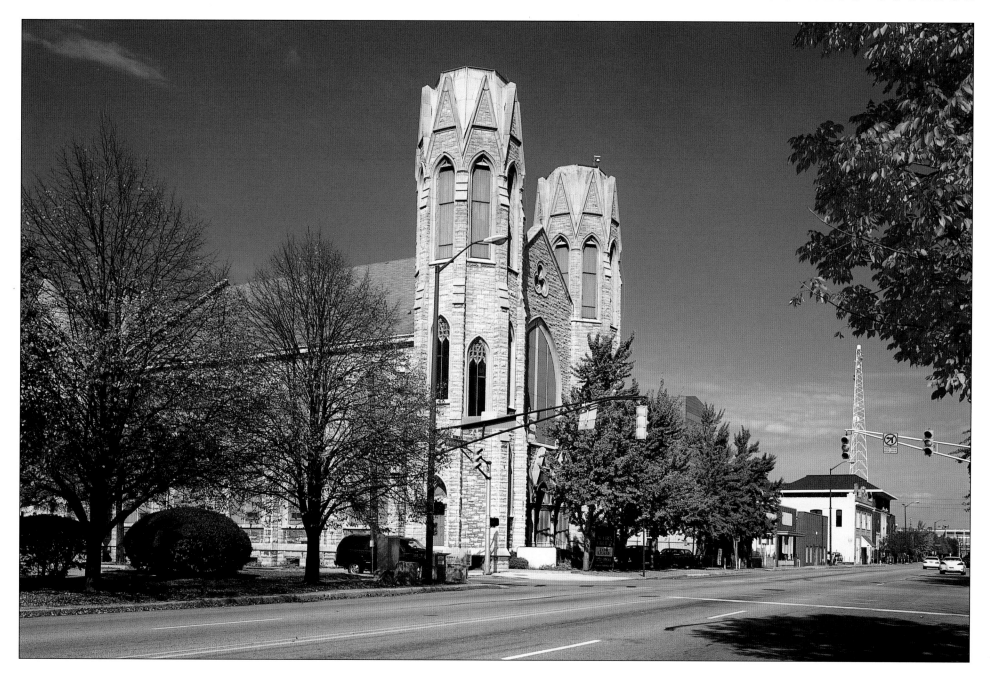

The limestone structure on the former site of William Sullivan's mansion was built as the Meridian Street Methodist Church in 1901. Most people today, however, associate it with the Indiana Business College, which has made the building its flagship since 1948. The business college bought it from the church, which had constructed an indoor gymnasium for the congregation's active youth program. The business college had been founded in 1902 by an Ohio educator who said that Indiana needed trained workers as the state developed from an agrarian economy. The business college remodeled the sanctuary for offices and created classrooms in the gym. With increased enrollment—the business college today has more than 900 students in Indianapolis and 3,500 statewide—it moved into a larger glass and steel structure on East Washington Street in 2003.

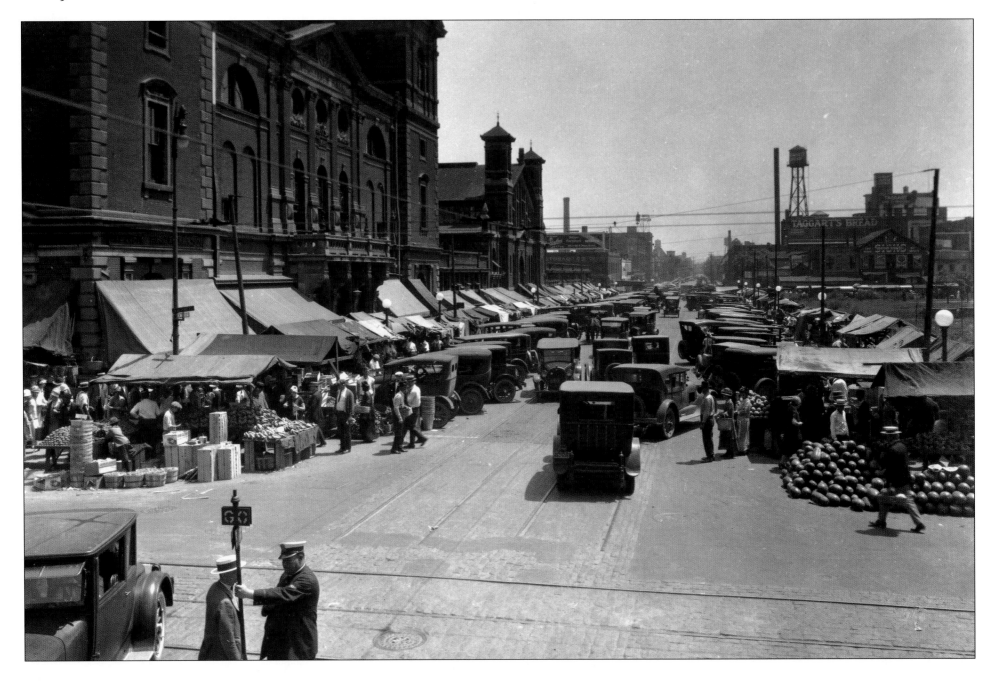

This street scene from 1925 depicts a bustling market day at City Market, which was built in 1886 and adjoined Tomlinson Hall (both on left of photo). An enormously popular marketplace for fresh fruit, vegetables, meat, bread, and poultry, City Market had produce stands run by generations of immigrant families. Just west of the market, Tomlinson Hall, also built in 1886, was a massive civic building at the corner of Market and Delaware streets. With a brick facade and detailing of limestone, Tomlinson Hall featured a stage and spacious performing hall. The auditorium hosted political conventions, balls, lectures, and patriotic band concerts. Tomlinson Hall's dedication ceremony was timed during the Grand Army of the Republic Music Festival to raise money for the Soldiers' and Sailors' Monument. Tomlinson Hall was destroyed by fire in 1958.

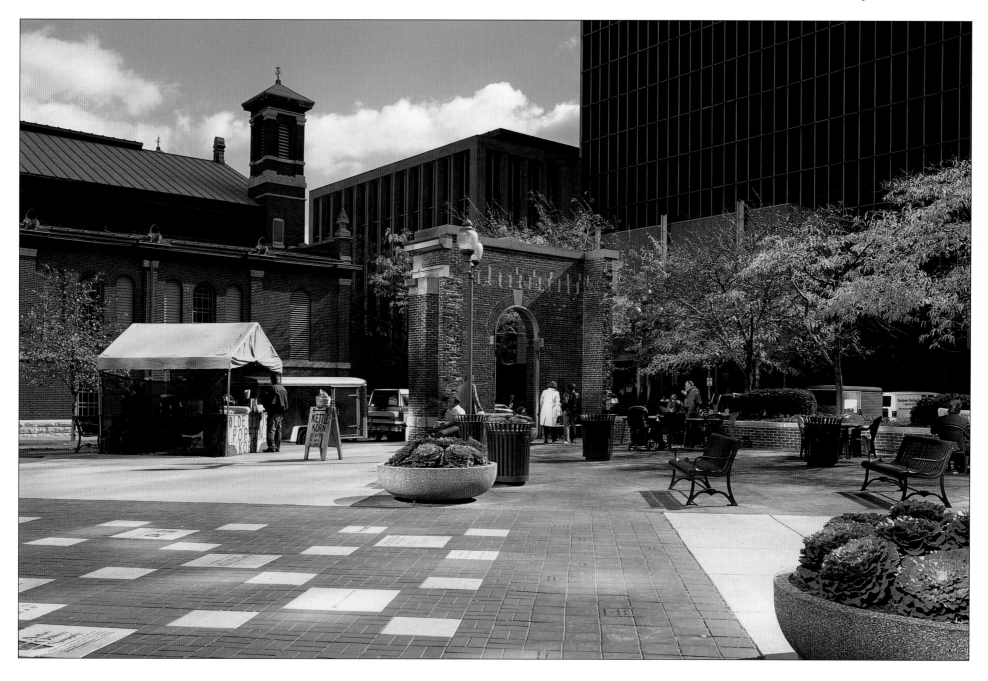

A doorway arch from Tomlinson Hall survived the fire and was erected in the courtyard of City Market in 1977 during one of several renovations of the historic marketplace for fresh vegetables and fruit. Built with twin towers flanking a central entrance, City Market is a popular lunchtime destination for downtown workers, who "people watch" in the courtyard during balmy weather. From May through mid-October, a farmers' market is held every Wednesday; the bricked Market Street is closed to traffic so vendors can sell fruit and a colorful array of other fare. The courtyard is a frequent setting for pep rallies for the Indianapolis Colts and Indiana Pacers, as well as noontime music concerts. Inside, City Market today has far more restaurants and deli counters than produce stands.

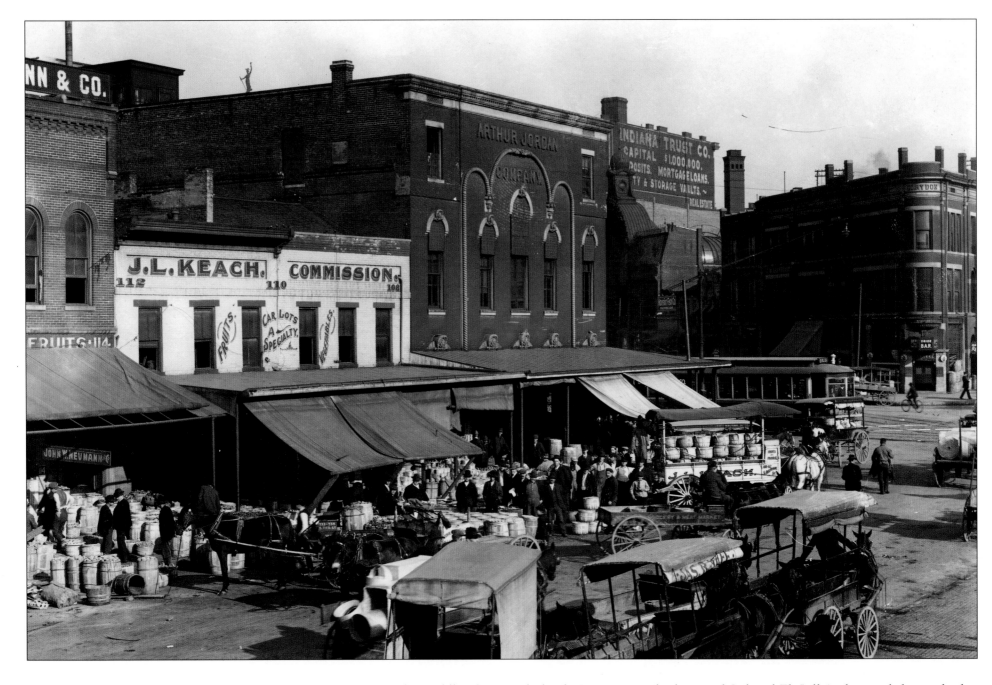

Keach Fruit and Vegetable Market enjoyed a plum location in the middle of the Wholesale District when this photo was taken in 1905. A family-owned wholesale business founded in 1859, Keach and its bounty were on South Delaware Street just south of Maryland and Virginia streets. The Wholesale District sprang up around Union Station after the Civil War so retailers would have easy access to railroads for their wares. For several years, the Wholesale District was the home of Colonel Eli Lilly's chemical shop, which the war hero opened in 1876. The small chemical business made medicinal syrups, sugar-coated pills, and fruit flavors. Other businesses in the Wholesale District included a millinery house, a grocery, and an electrical equipment company.

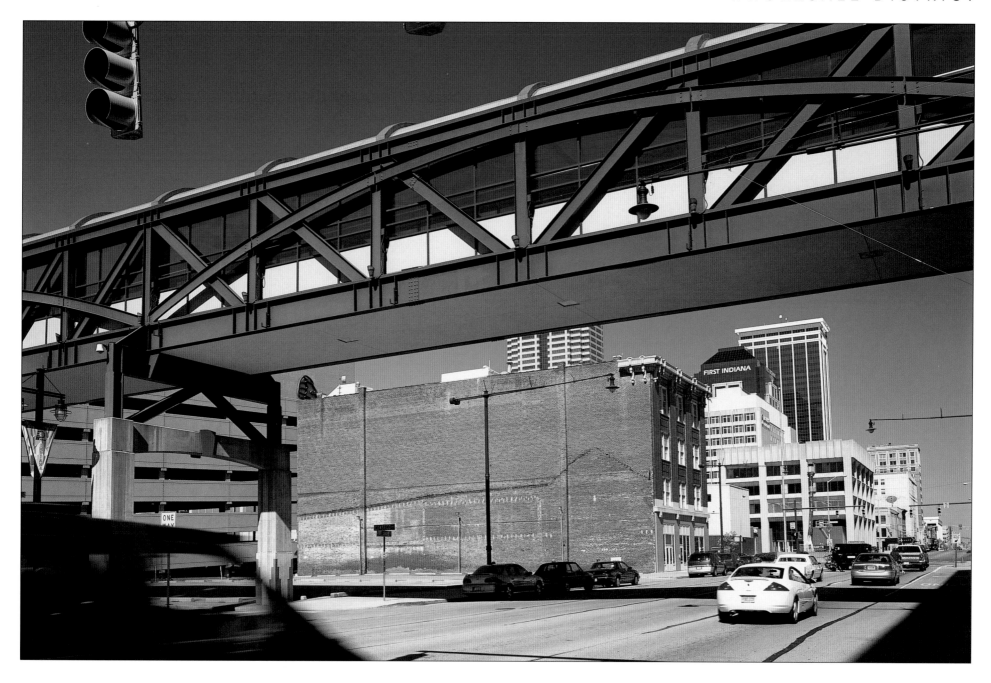

The most noticeable building today near the former Keach Fruit and Vegetable Market site houses people, not produce. Nonviolent prisoners on work-release programs are handled in the building that the Marion County Sheriff's Department calls "the Annex" to its jail. Stretching above the former Keach site is an enclosed walkway from a parking garage to Conseco Fieldhouse. The skybridge was designed with "retro architecture," just like the stadium for the Indiana Pacers. Elsewhere in today's Wholesale District are restaurants, nightclubs, delis, and coffee houses. Eli Lilly and Co., of course, became a $6 billion pharmaceutical giant that has manufactured Prozac and other drugs distributed around the world. Even today, its international headquarters are not far from the Wholesale District, where it has its roots.

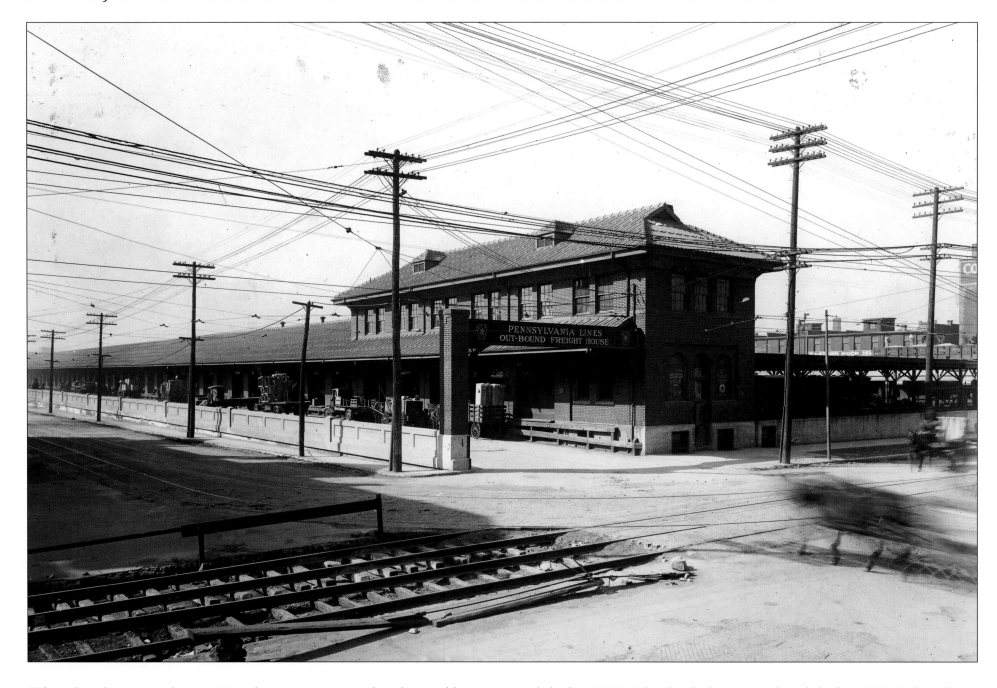

When this photo was taken in 1919, there were no signs that this would become the site of one of the city's top tourist attractions. The 100 block of South Pennsylvania Street, being near Union Station, was the location of a freight house for the Pennsylvania Railroad. One of four major Northeastern-based rail systems serving Indianapolis, its lines here—which connected to cities such as Terre Haute, Cincinnati, Frankfort, and Vincennes—operated until the late 1960s. This freight house was demolished in 1980. Before the 1980s, the Indiana Pacers played in Market Square Arena. The team, then a new member of the NBA after several years with the now-defunct American Basketball Association, was in danger of being purchased and relocated to another city. An exhausting sixteen-hour "Save the Pacers" telethon in 1977 is credited with rescuing the franchise.

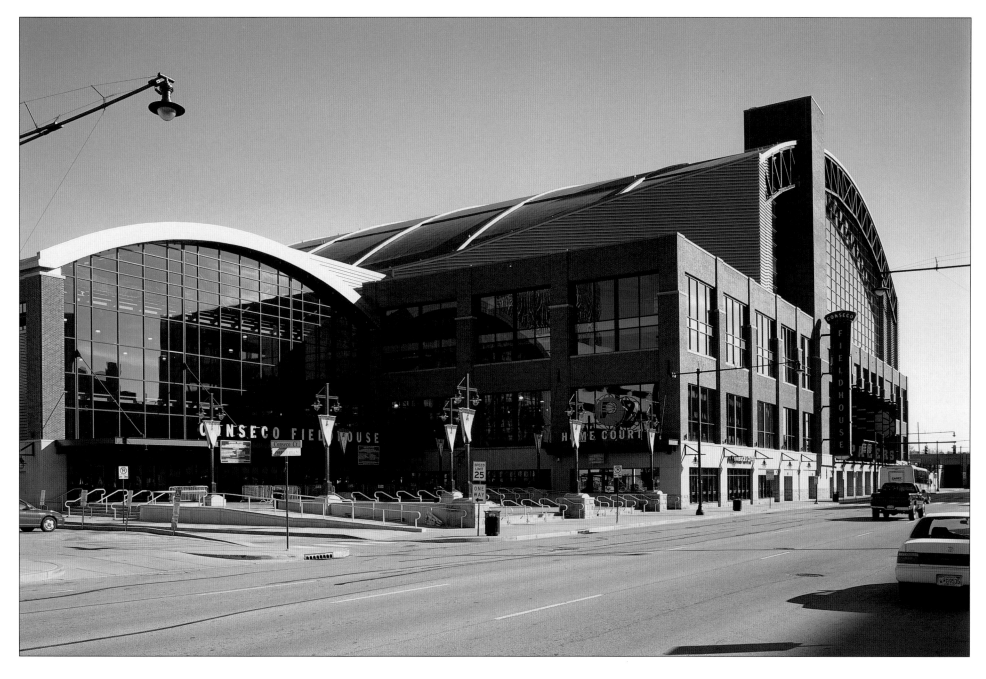

Conseco Fieldhouse is now immediately associated with pro basketball. The $183 million arena for the Indiana Pacers and Indiana Fever, which opened in November 1999, has a retro high school appearance. The world's largest crane was used to install tresses at 125 South Pennsylvania Street; the crane was so huge it had to be disassembled outside the stadium, then reassembled inside. With a seating capacity of 18,345, the fieldhouse doesn't just host pro basketball games—it's been used as a venue for concerts by Nine Inch Nails and opera star Luciano Pavarotti, as well as ice shows and pro wrestling tournaments. A victory by the Indiana Pacers over the Boston Celtics opened the arena. Conseco, which occupies 6.2 acres, replaced the rather soulless Market Square Arena as the Pacers' home.

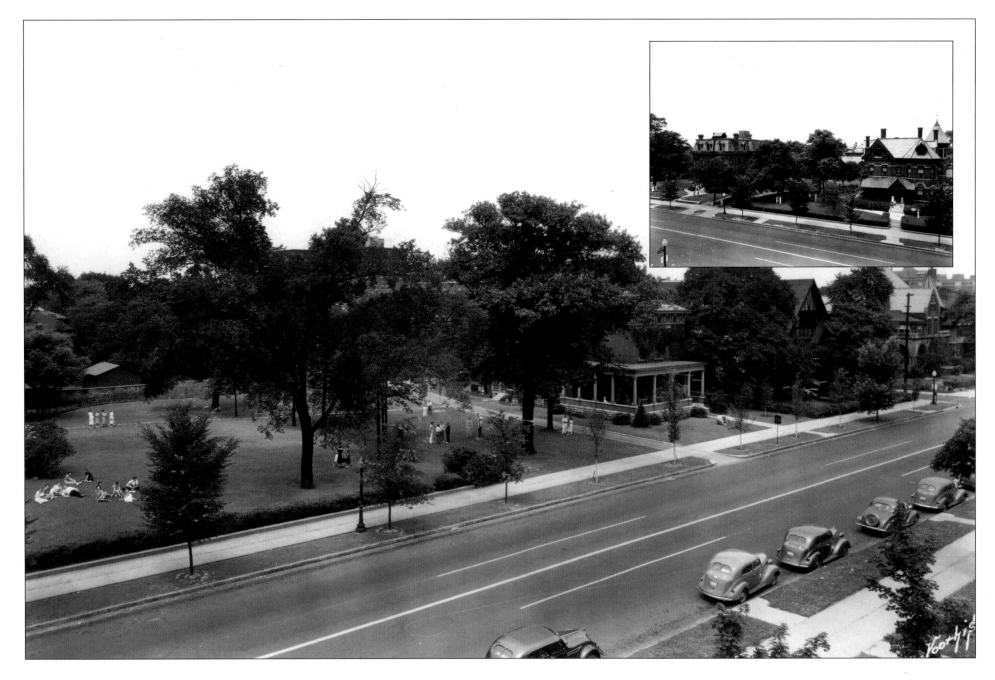

When this photo was taken, probably around 1938, the Benjamin Harrison Home at 1230 North Delaware Street had recently been sold by the widow of the nation's twenty-third president and his young daughter. Benjamin Harrison and his beloved first wife, Caroline, had the Italianate home built in 1874, fourteen years before Harrison, a Republican, became the only president elected from Indiana. After the devastating year of 1892—during a two-week period, Caroline Harrison died of tuberculosis in the White House and her husband lost his bid for reelection—Benjamin Harrison returned to his Indianapolis home and resumed his successful law practice. Just south of Harrison's home (inset) are the homes of Indianapolis merchants L. S. Ayres and Hiram Wasson, who lived here when they were overseeing the legendary department stores that bore their names.

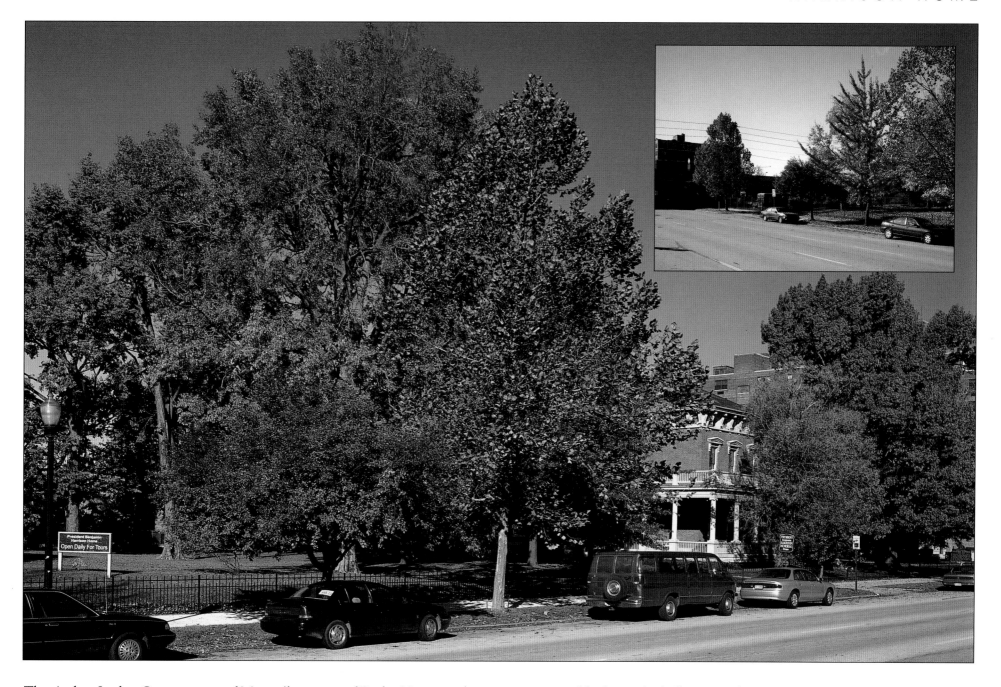

The Arthur Jordan Conservatory of Music (later part of Butler University) purchased the Harrison, Ayres, and Wasson homes during the 1930s; the conservatory used them for music and dance instruction as well as for student housing. In the early 1950s, public tours began of the Benjamin Harrison Home; after a renovation in 1974, it opened as a house museum where visitors could admire the ballroom, walnut staircase, and parquet floors. It still has many original furnishings in its sixteen rooms. The Ayres and Wasson houses, alas, had a different fate (inset). They were demolished in the 1960s, shortly before completion of Interstate 65, the expressway that cuts through the Old Northside neighborhood.

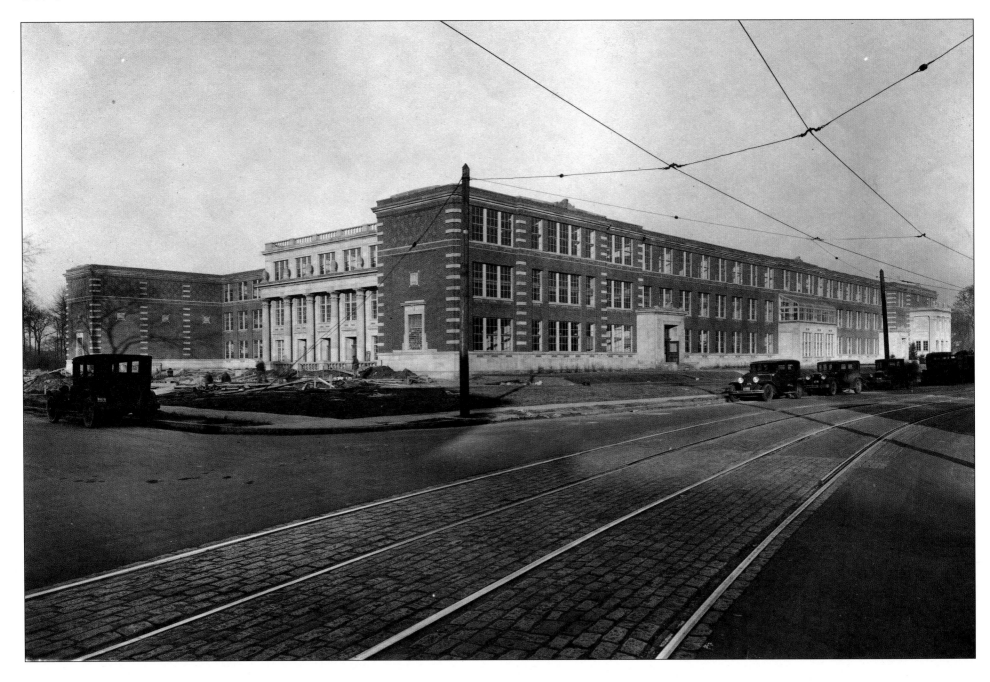

Has any high school meant more to a community than Shortridge High has to Indianapolis? The alma mater of novelist Kurt Vonnegut (class of 1940), U.S. Senator Richard Lugar, and author Dan Wakefield (both class of 1950) evolved from the first public high school in Indianapolis. Named after administrator Abram Shortridge, the high school conducted classes in downtown buildings before moving to Thirty-fourth and Meridian streets in

1928, the year this photo was taken. Emphasizing academic rigor, Shortridge enjoyed national renown as one of the country's best public high schools. Booth Tarkington played hooky from Shortridge so frequently in the 1880s that his frustrated parents withdrew him; they sent the future Pulitzer Prize–winning author to an East Coast boarding school.

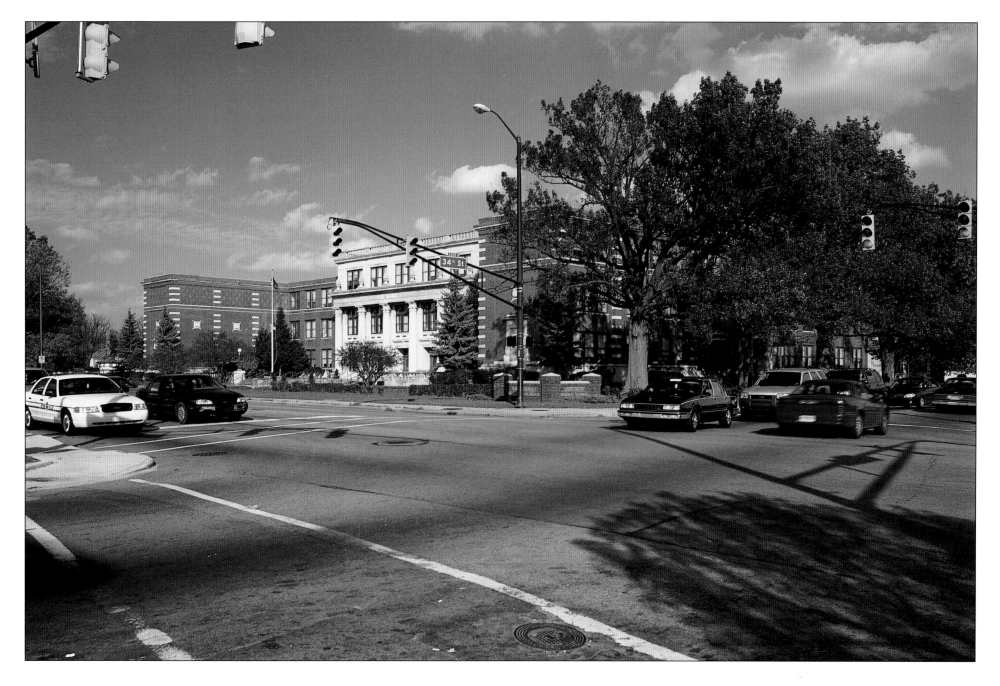

The magnificent exterior looks the same, but sadly, Shortridge High School is no more. In a move that sparked protests, Shortridge High School was converted into a middle school in 1981. Today it is Shortridge Middle School, attended by sixth through eighth graders in the Indianapolis Public Schools system. Later in the 1980s, Shortridge became a magnet school for students gifted in the arts, and foreign language instruction has also been expanded there. Wakefield used Shortridge as the model for the high school in his 1970 best seller, *Going All the Way*.

Crown Hill Cemetery has several claims to fame. It's the third-largest graveyard in the country, it's the burial site of more American vice presidents (three) than any other cemetery, and it's the final resting spot of poets, business tycoons, and the gangster John Dillinger. This is how Crown Hill's southern portion, the superintendent's property, looked in 1902. The cemetery is located on such a tranquil, hilly area that city residents of the late 1800s and early 1900s came here to picnic. In creating the graveyard during the 1860s, civic leaders chose the site three miles northwest of the Circle because of its stunning vistas with oak, maple, and other deciduous trees. A three-arched Gothic gateway was constructed at the entrance on Thirty-fourth Street and Boulevard Place.

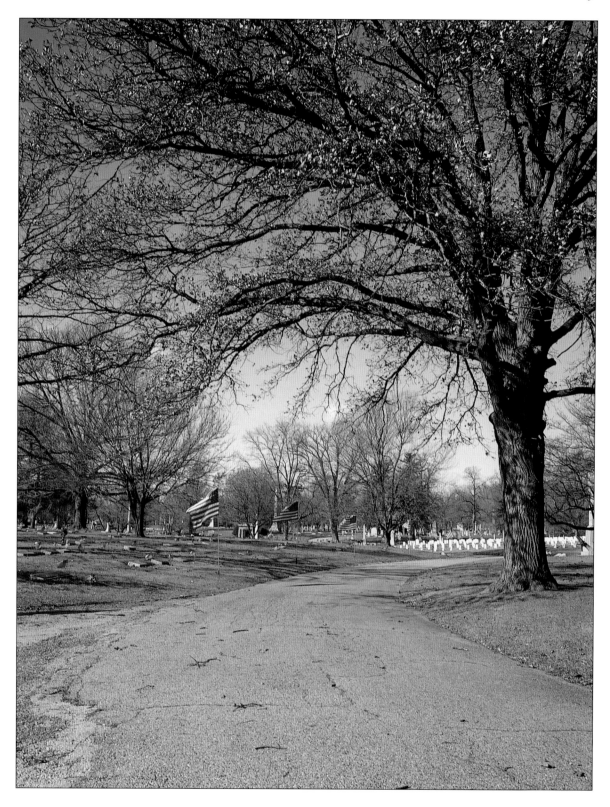

There is still plenty of burial space at Crown Hill Cemetery, which occupies 550 lush acres. Unusual or distinctive grave sites continue to be added more than 115 years after the nation's first lady, Caroline Scott Harrison, was brought here in a funeral procession following her death in the White House. The long-time owner of the Indianapolis Colts, Robert Irsay, is memorialized with a grave site that is unmistakable: a big horseshoe, the symbol of his football team. Ten governors of Indiana and one governor of Kentucky are buried at Crown Hill, which in the United States is exceeded in size only by cemeteries in Los Angeles and Cincinnati. In this photo of Crown Hill's southern portion, American flags decorate many graves in honor of Veteran's Day.

When the Tee Pee first opened in the 1930s, it was originally known as the Wigwam. Among all the local restaurants that thrived during the drive-in craze of the 1950s, the Tee Pee was one of the most popular. The Native American–themed eatery with the unforgettable design enjoyed a high-visibility site next to the Indiana State Fairgrounds, off busy Fall Creek Parkway and East Thirty-eighth Street. The Tee Pee's heyday came during the late 1940s and 1950s when teenagers and college students were drawn to the drive-in to socialize and to enjoy a burger and milk shake. The Tee Pee was such a hit as a Northside hangout that a Southside Tee Pee opened on Madison Avenue. During the 1960s, the Tee Pee evolved into a more family-oriented eatery, offering Chief Burgers and feathered headdresses for children.

Drive-in restaurants suffered due to the soaring popularity of fast food during the 1970s. Even the Tee Pee bit the dust and was torn down in 1988 despite loud protests and various "stays of execution." For several years, its site has been a barren asphalt lot, a silent testament to a vanished culture. Today, it's been fenced and is used as an overflow parking lot for the state fairgrounds.

Many other popular drive-in restaurants of the 1950s also closed or changed their formats. These included the Ron-D-Vu near the Butler University campus, the Pole at West Sixteenth Street and Lafayette Road, and several Knobby's Restaurants.

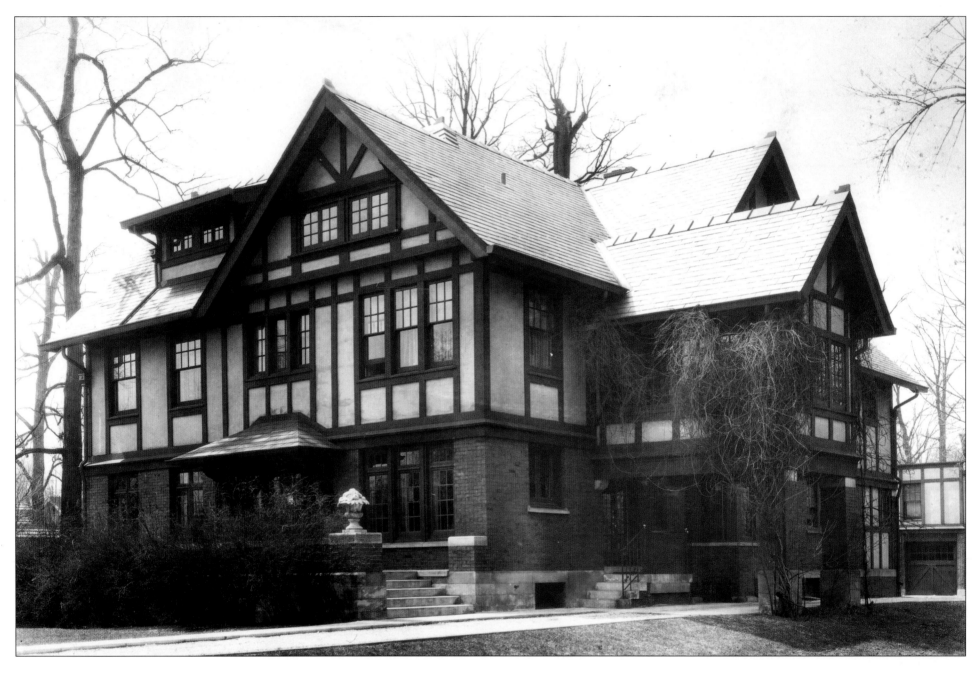

During the 1920s, the stately mansions along North Meridian Street became the showplaces of Indianapolis, not only for their grandeur but because many were the homes of literary notables and other celebrities. None were more famous than author-playwright Booth Tarkington (1868–1946), who lived in this Tudor-style home from 1923 until his death. His mansion at 4270 North Meridian (seen here in 1927) was older than many of his neighbors' homes;

it was built in 1911 for Maria Hare, a widow with six children. After Tarkington bought and remodeled it, the mansion became the talk of the town. He filled it with an art collection and hosted glittering dinner parties for visiting luminaries such as Helen Hayes and the four Marx brothers, who arrived in a convoy of chauffeured white Cadillacs.

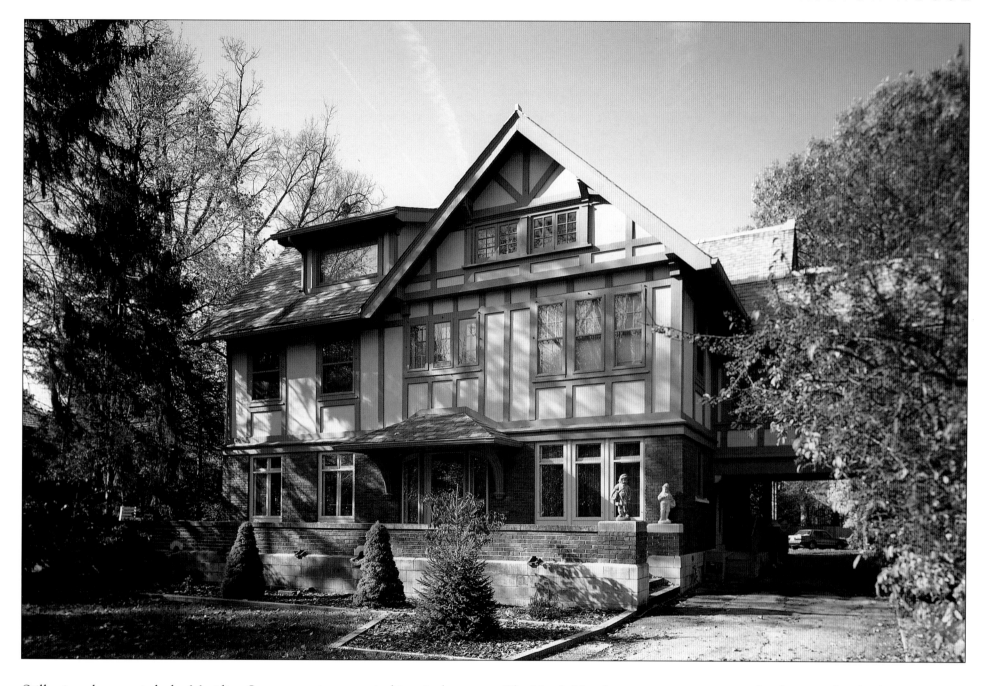

Still privately occupied, the Meridian Street mansions remain historical and architectural gems enjoyed by passing commuters and visitors. Thousands of commuters pass by daily because, unlike mansions in many cities that are tucked away on obscure streets or hidden behind gates, the North Meridian homes are on one of Indianapolis's busiest thoroughfares.

The North Meridian mansions are a mix of architectural styles from French Renaissance and Italian Renaissance revival to Southern Colonial, Colonial revival, and Renaissance revival. Almost all of them have elegant landscaping and towering trees. The Indianapolis Museum of Art uses the name of Tarkington's "Penrod" stories for its chic annual arts festival.

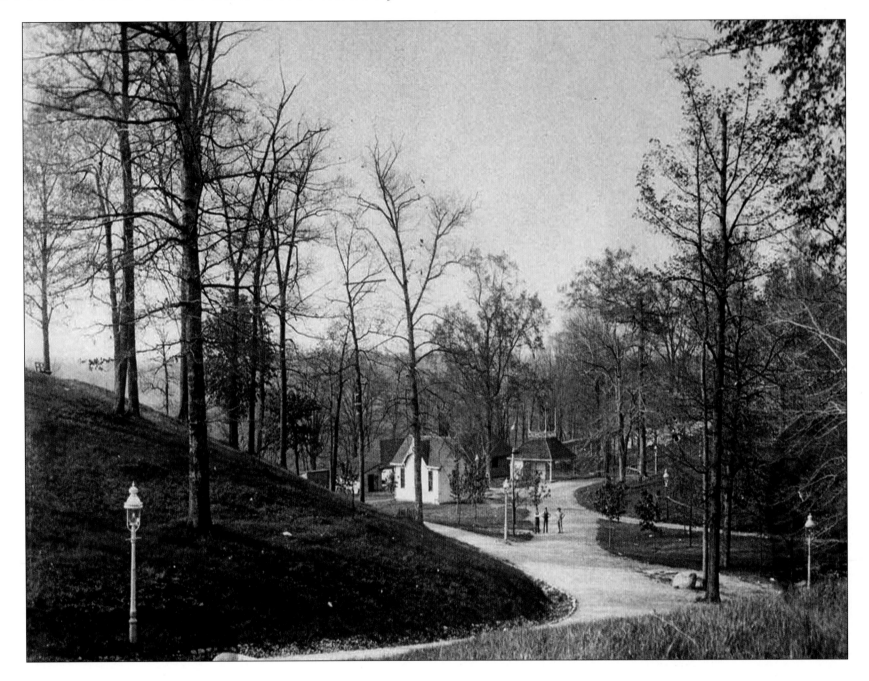

The Citizens Street Railway Company was the unlikely developer of the 246-acre Fairview Park in 1890. By the start of the new century, Fairview Park (as seen in this photo from about 1910) had become an amusement park with a boathouse, band shell, ponies, and, eventually, a merry-go-round, bowling alley, and refreshment stands. Band concerts were Sunday afternoon staples and plays were staged in the summer on the canal's west bank.

Fairview Park also served a role in health care during the early 1900s. Sick women and children, along with nursing mothers, were frequently brought to the park for fresh air and to enjoy the serenity of the flowers, trees, and ponds. During this era, Butler University was located in the Eastside suburb of Irvington, but the campus was rapidly outgrowing that site, which was hemmed in by upper-middle-class homes.

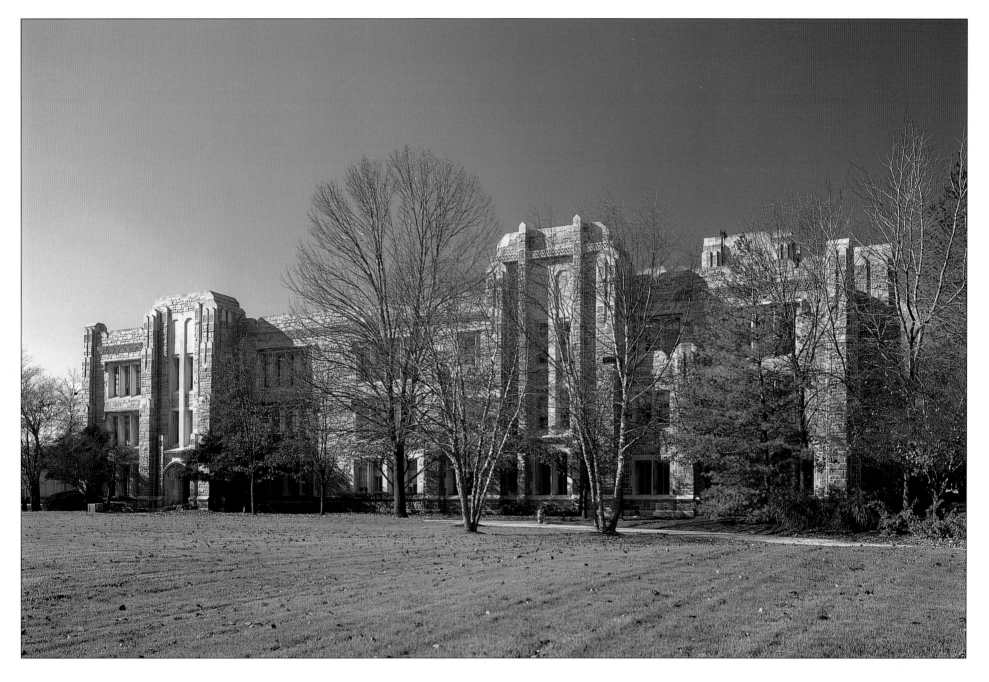

The campus of Butler University, a private university attended by about 3,500 students, has been on the former Fairview Park site since 1928. Campus landmarks include the massive Hinkle Fieldhouse—the largest basketball arena in the country when it was built in 1928 and the site of the high school boys' state basketball tournament for generations—and the fortresslike Irwin Library, Arthur Jordan Hall, and Clowes Hall. Opened in 1855 as North

Western Christian University, the college was founded by Ovid Butler, a prominent Indianapolis attorney and abolitionist. It was Indiana's first coeducational college and the second university in the nation to employ a woman as a full professor. Today Butler is known for its programs in music, pharmacy, education, and telecommunications.

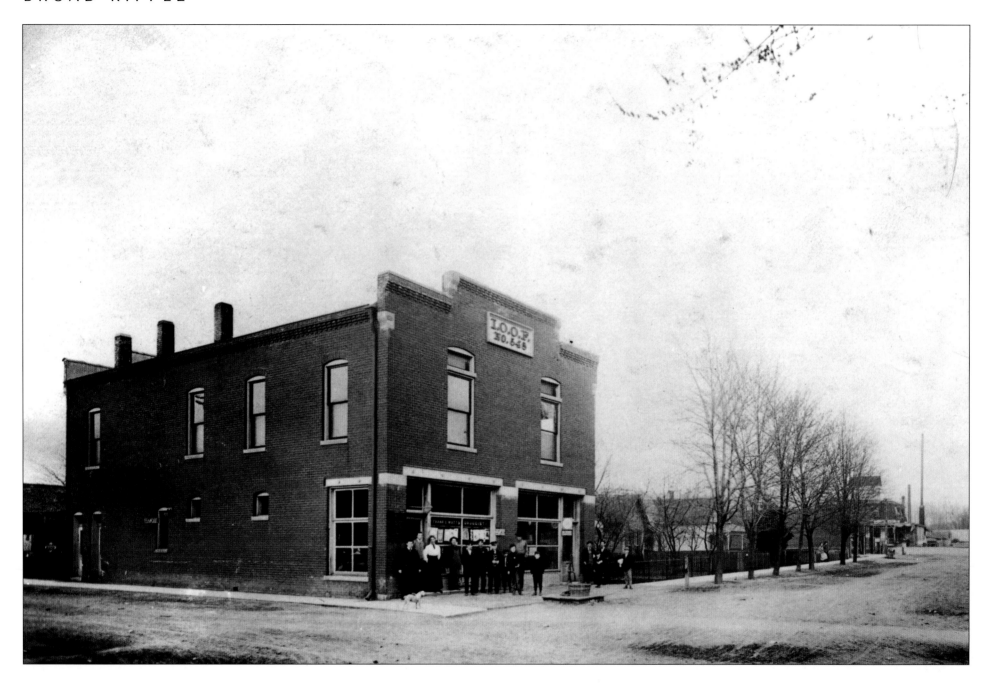

When this photo was taken in 1908, Broad Ripple was a self-governing town of several hundred residents along the Central Canal. During the summers, harried residents of Indianapolis traveled north by streetcars, and later interurbans, to tranquil Broad Ripple for relaxation and entertainment. With a park, shops, cruise boats that offered onboard dancing, and spots for fishing, Broad Ripple had the relaxed pace of a resort. Established as a town in 1836, Broad Ripple was annexed into the city of Indianapolis in 1922, by which point a housing boom of bungalows was underway. Watt's Drug Store, seen in this photo along with Lodge No. 548 of the International Order of Odd Fellows (which occupied the top floor), gave way in 1925 to the fondly recalled Lobraico's Drug Store.

With boutiques, nightclubs, ethnic restaurants, bars, antique shops, gourmet pet food stores, and pizza parlors, Broad Ripple is often described as "quaint" because of its many specialty shops and outdoor cafés. It became a trendy destination for nightlife seekers in the 1980s and has remained popular ever since, with continually escalating selling prices of the bungalows in the

former village. A parcel of sprawling Broad Ripple Park was converted in 1999 into the city's first "bark park," where dogs can romp off the leash. The Broad Ripple Village Association is one of the city's strongest advocacy groups of merchants and residents. Lobraico's closed in 1990 and Chelsea's, a card and gift shop, eventually opened in the building.

A landmark in Broad Ripple since it opened as a movie theater in 1938, the Vogue was developed by local cinema owner Carl Niesse. The name for the cream-colored, terra-cotta theater was suggested to Niesse by visiting movie stars Mary Pickford and Buddy Rogers. The first movie shown in the 800-seat theater at 6259 Broad Ripple Avenue was *College Swing* starring Bob Hope; admission was twenty-five cents for adults, fifteen cents for children. The Vogue was one of the first movie theaters in the Indianapolis area to be air-conditioned. The marquee in this photo from the late 1940s resulted from a remodeling; at this point, the Vogue was considered one of the premier movie houses in the Midwest.

Niesse sold the Vogue in 1954 and during the 1970s the theater showed adult movies. New owners pumped $500,000 into a restoration, paving the way for the Vogue's debut as a nightclub on New Year's Eve of 1977. As a nightclub, the Vogue is now one of the most popular venues in the Indianapolis area for dancing. Since a remodeling in 1993 that involved the installation of extensive lighting and sound systems, the Vogue has presented performances by the Red Hot Chili Peppers, the Dave Matthews Band, Little Feat, and Wynton Marsalis, as well as talent shows and regional band contests. With the remodeling in 1993, the size of the dance floor quadrupled. Long lines under the Vogue's marquee are a common sight as patrons wait to enter or buy concert tickets.

The Monon Railroad line began service to and from Indianapolis in the early 1880s, although its branch dated to 1865. The Indiana-based railroad ran between Louisville and Indianapolis as well as between Indianapolis and Chicago. When this photo of a train on the Monon tracks near Broad Ripple was taken, passenger service to Chicago included four round trips daily. Rumbling out of Union Station, the Monon line's service to Chicago was called the "Indianapolis Special" and sleeping cars were offered on an overnight train. Eventually, several railroad lines touted a service they called the "Indianapolis Special." With the decline in passenger rail service after World War II, the Monon shut down in 1959.

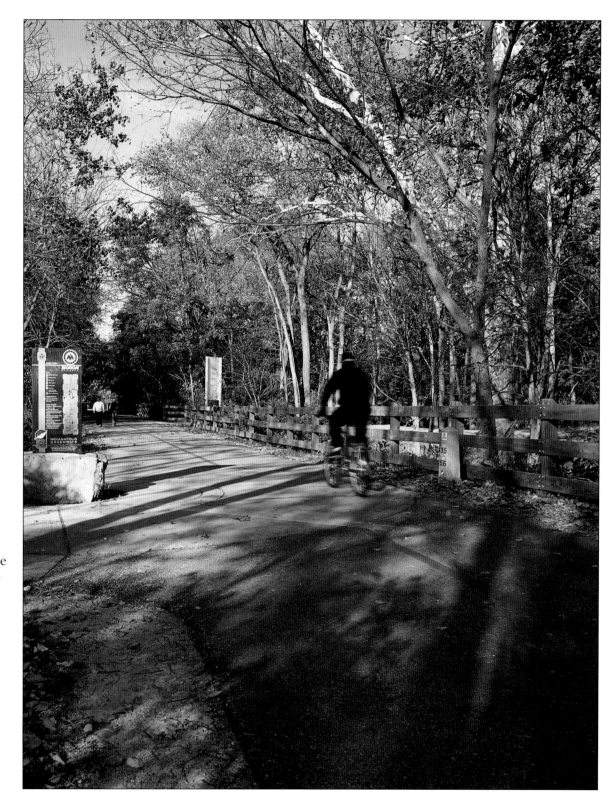

Today the Monon Trail is an enormously popular urban greenway for fitness and nature enthusiasts. The trail extends over fifteen miles from about Tenth Street near the Old Northside north to 146th Street in Carmel. Generally considered to be one of the busiest urban greenways in the country, the Monon Trail is often jammed with runners, cyclists, in-line skaters, and sightseers. According to some estimates, the Monon is used by more than 4,000 people daily. Grassroots citizens' campaigns helped initiate the development of the trail, which cost about $5.5 million to create. Funding came from several sources, including federal transportation grants and the Lilly Endowment. The Monon connects with other trails near the Central Canal, Fall Creek, and White River to form a major trail network through the Indianapolis metro area.

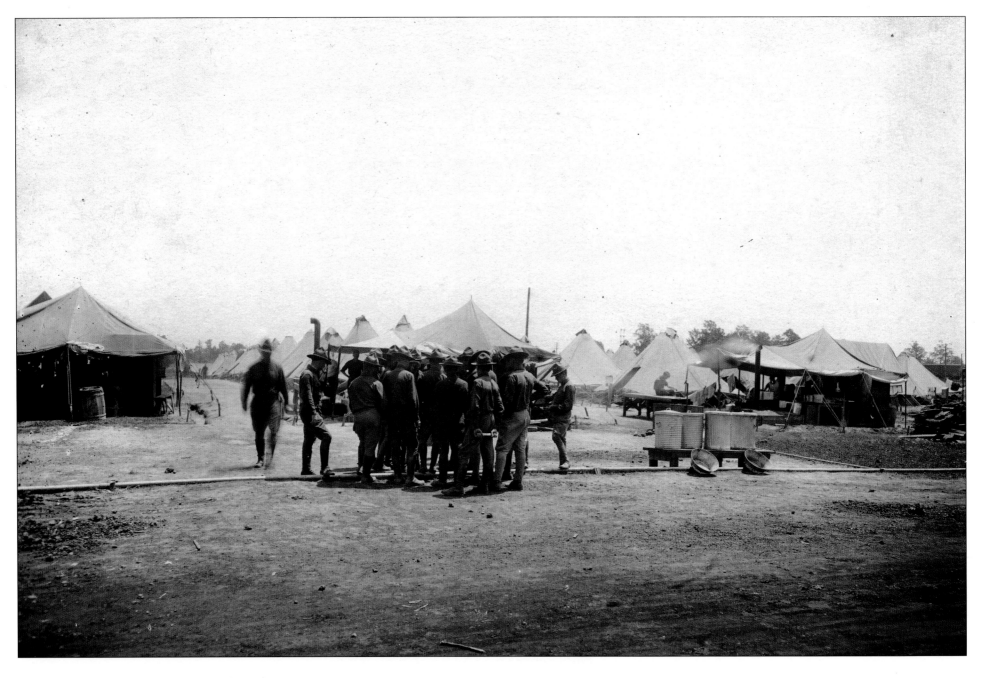

An active military facility for more than ninety years, Fort Benjamin Harrison was established in Lawrence Township in 1904, three years after the death of the president for whom it was named. The original site consisted of 1,994 acres. This photo from about 1918 or 1919 depicts soldiers who have returned from World War I, when the Indiana post became one of the country's biggest training and modernization sites. During World War II, thousands of Army troops were inducted at Fort Harrison, which trained finance specialists, cooks, chaplains, and medical technicians. Prisoners of war were housed at the fort's Camp Edwin Glenn. By the mid-1960s, Fort Harrison was the home of the Defense Information School and a huge Army finance center in a building that took up more than fourteen acres on East Fifty-sixth Street.

Fort Harrison State Park is 1,700 acres of woods, trails, picnic areas, a sledding hill, ponds, shelter houses, and a golf course. Visitors enjoy observing everything from wildflowers to woodpeckers in their natural habitats. The park also has coffee shops and restaurants, including the Garrison, which is in the former dining hall for military officers. The vast park was created after

Fort Harrison was phased out as a military facility over six years in the 1990s following the end of the Cold War. At the park's headquarters, visitors may tour the former prisons and military training camps. Some of the former military grounds were sold to private developers; they built suburban town houses and condominiums in 2000 and 2001.

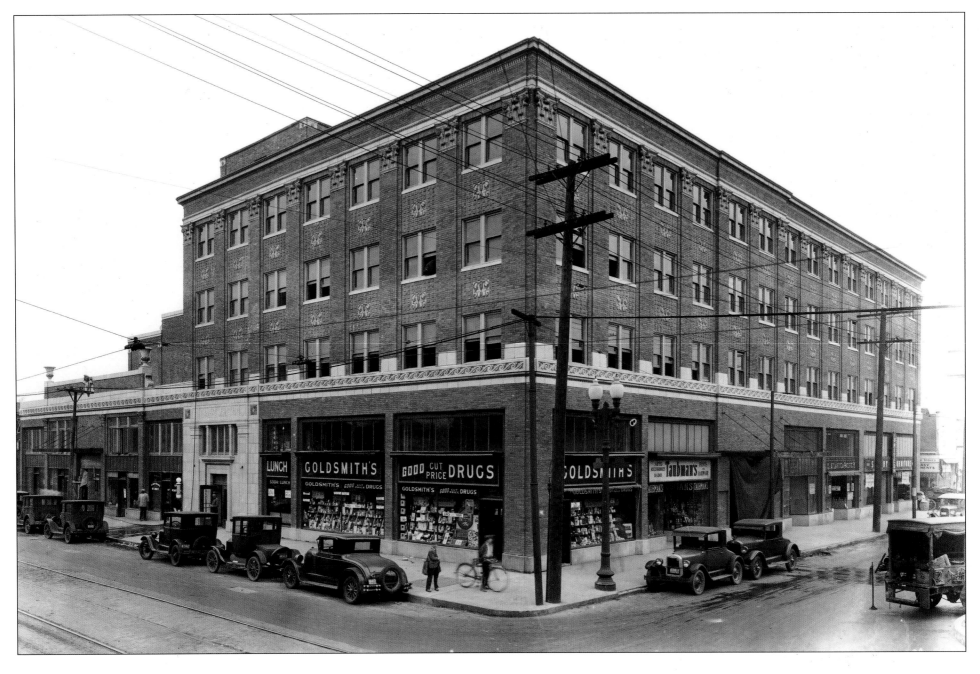

Fountain Square was a bustling retail and entertainment district when this photo was taken in 1928. That year saw the opening of the Fountain Square Theatre in the district southeast of downtown at the intersections of Virginia Avenue, Prospect Street, and Shelby Street. Although the theater showed movies and presented vaudeville acts, it earned a permanent niche in Indianapolis history by introducing a sporting pastime to Hoosiers: duckpin bowling. Duckpin bowling—which involves small pins and balls—became a fad during the 1920s, with a bowling alley in the theater building. Fountain Square was known for the German heritage of its groceries, taverns, diners, and bakeries. The area eventually attracted Irish and Italian immigrants, with downtown customers visiting by streetcars. After World War II, though, Fountain Square declined as suburban shopping centers lured patrons away.

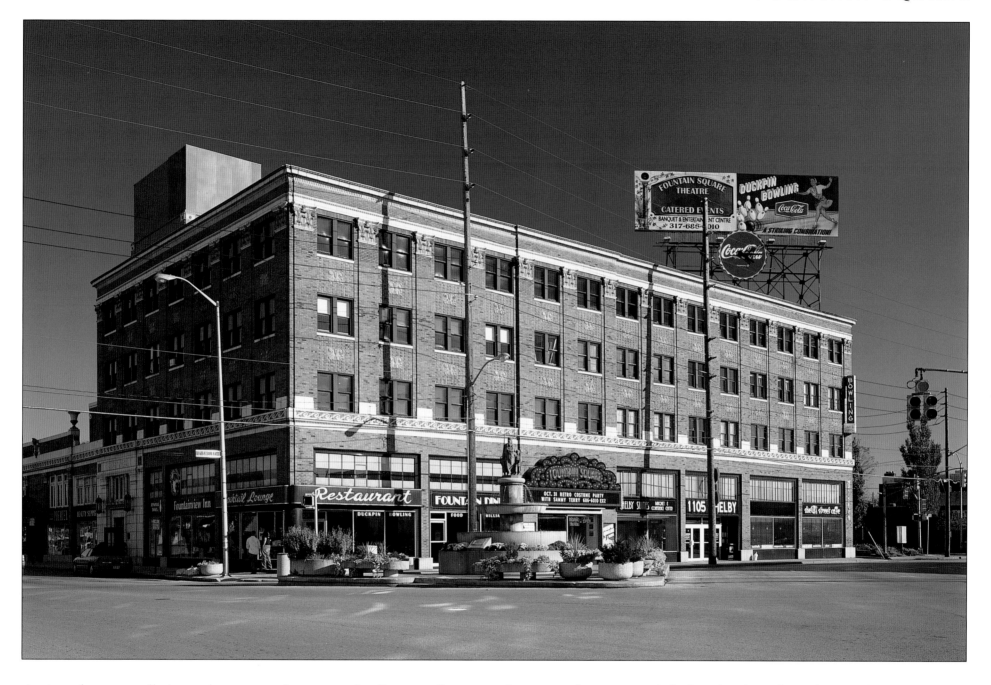

Antique shops, art galleries, and restaurants have opened in Fountain Square during a stunning revival that began in the 1990s. The Fountain Square Theatre Building, decorated with an Italian garden theme under a forty-foot dome ceiling with twinkling stars, was refurbished in 1998. Today the historic theater is used for a variety of events, including weddings, banquets, swing dancing, and receptions. A duckpin bowling alley—decorated with vintage bowling memorabilia and 1950s jukeboxes—is on the building's fourth floor. The rejuvenated Fountain Square area includes an inn, a diner that serves milk shakes and tenderloins, and a Greek restaurant. The old streetcar tracks have been paved over.

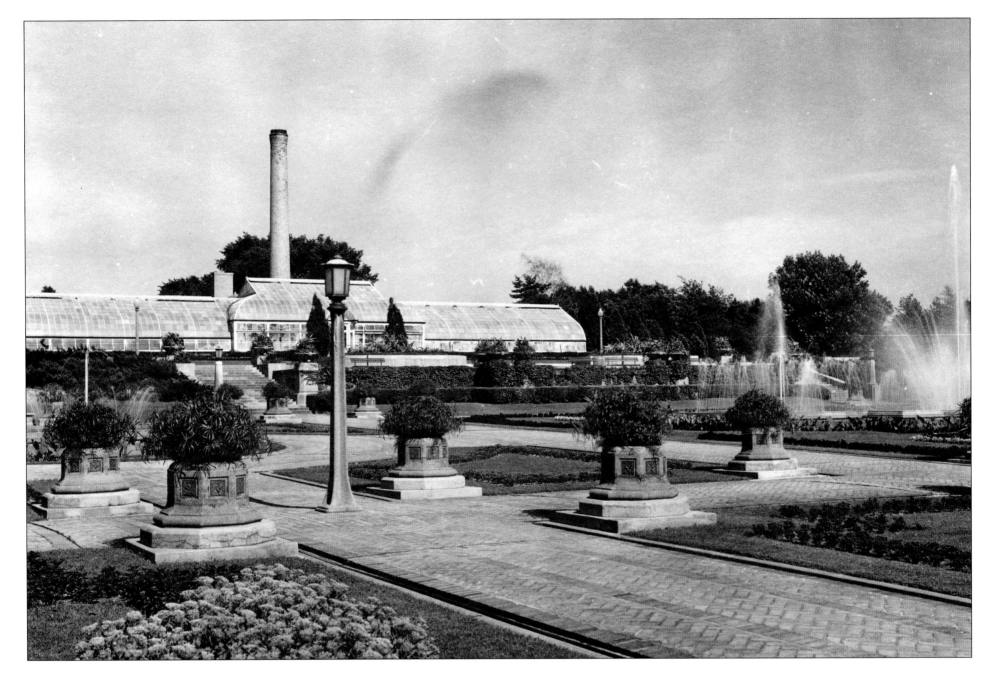

Garfield Park on the Southside is the oldest park in the Indianapolis park system. The park traces its beginnings to 1873, when the city purchased the land from civic leaders who had created a harness racetrack known as Southern Park on ninety-eight acres. After President James A. Garfield was assassinated in 1881, the park was renamed in tribute. The pagoda was built in 1903 and served as the focal point for dances and other social gatherings.

Southsiders also took pride in the original Garfield Park Conservatory, seen here in a photo from 1935. The greenhouse, which had been built twenty years earlier, lured visitors, as did the Sunken Gardens, which were dedicated in 1916, an amphitheater, and a swimming pool. The original conservatory was torn down in 1954 and rebuilt.

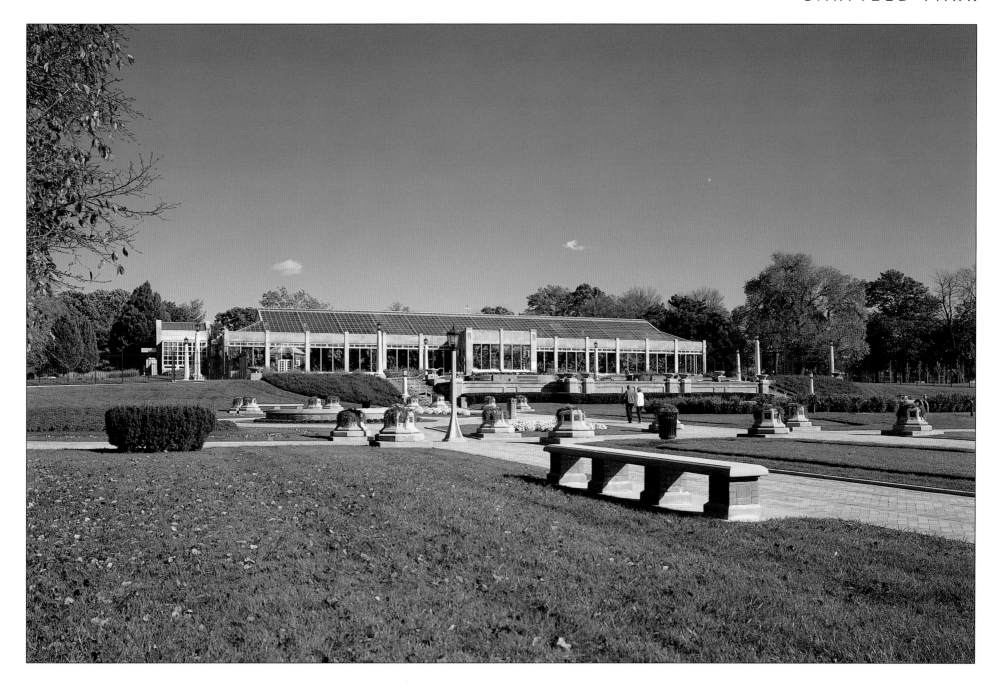

A popular site for weddings, receptions, and dinner parties, Garfield Park Conservatory was renovated in 1997. Under a glass roof, the conservatory features plants native to the Caribbean and other tropical climates. It has a waterfall and a rain-forest area that offer quite a contrast to the oaks, sycamores, and other trees native to Indiana that are found only yards away outside in the park. The Sunken Gardens were also restored in the 1990s, with a goal of returning them to their glory days of the 1920s. During the 1980s, the amphitheater was the setting for free performances of Shakespeare plays such as *The Taming of the Shrew*, but the Shakespeare Festival was discontinued by the mid-1990s. The main entrance to the park, which occupies about 122 acres, is at 2450 Shelby Street.

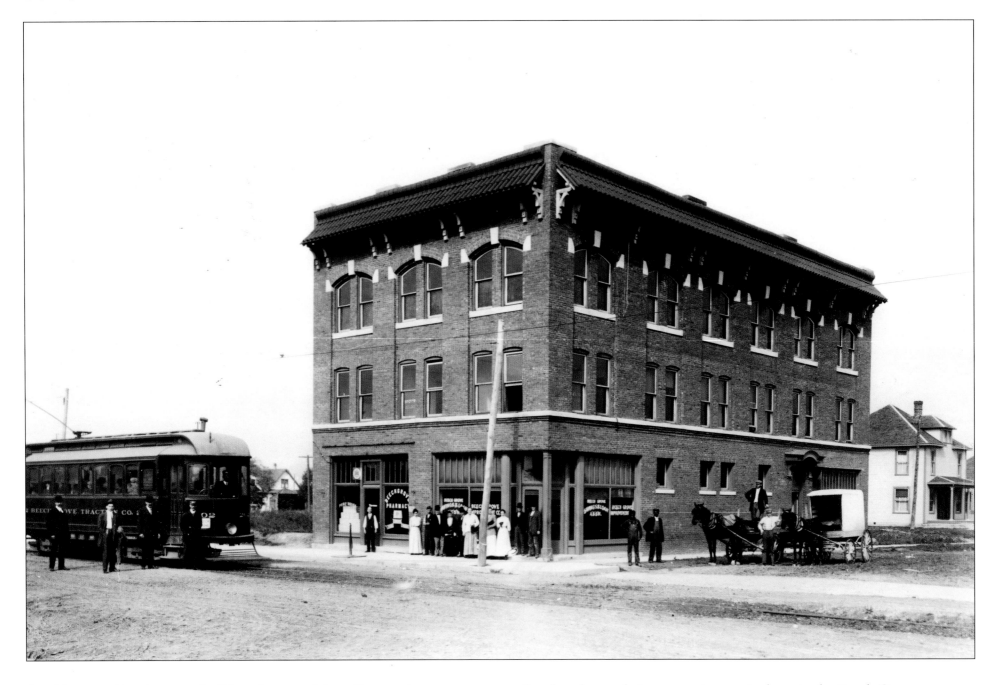

In addition to Speedway on the Westside, one of the self-governing communities within Marion County (incorporated Indianapolis) is Beech Grove on the Southeastside. The town had been incorporated for just five years when this photo, showing the Beech Grove Savings & Loan Building that dominated the 500 block of Main Street, was taken in 1911. Along with other businesses, the savings and loan opened because of the decision by

railroads to locate their automotive repair shops in the Beech Grove area, which had mostly been farms for cattle and various crops before 1905. Residents of Beech Grove elect a mayor and have their own school system and police and fire departments. After World War II, Beech Grove endured some economic setbacks as the train service declined nationally.

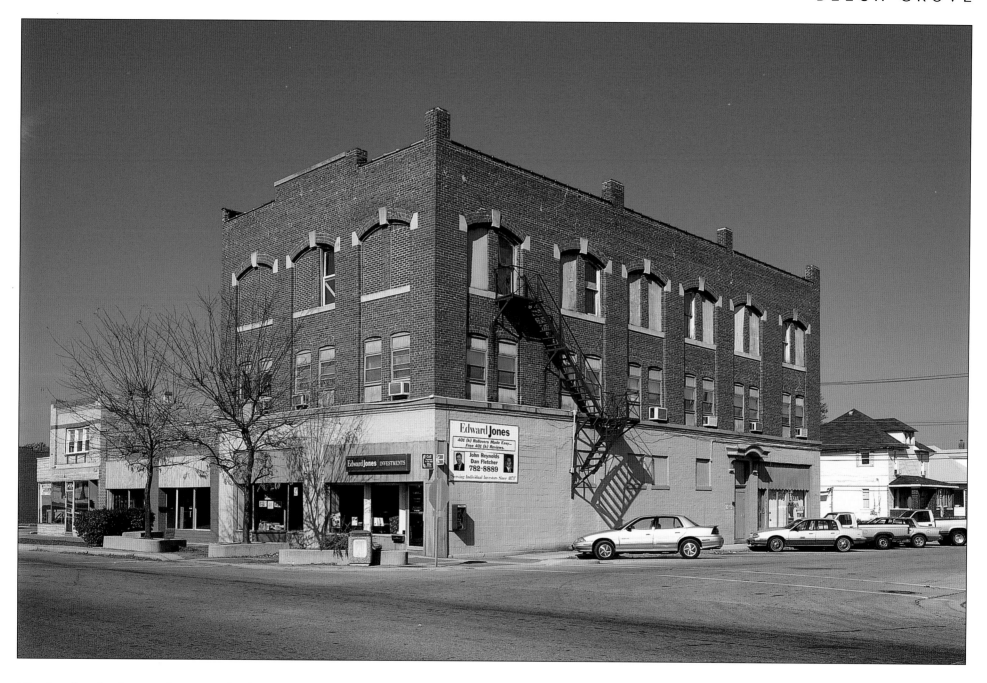

Nearly a hundred years after it was built—and long after trolley cars and horse-drawn buggies had vanished, except as novelties—the three-story office building on Beech Grove's Main Street remains largely unchanged. Today the former savings and loan building houses an investment firm, a barber shop, and other businesses. During the 1980s, the Indiana Department of Commerce helped fund a revitalization program for Main Street that included new streetlights and sidewalks, which now have an imprinted, bricklike look. According to the 2000 census, Beech Grove's population was 17,000. The area is famous for being the birthplace of actor Steve McQueen, who was born in Beech Grove in 1930.

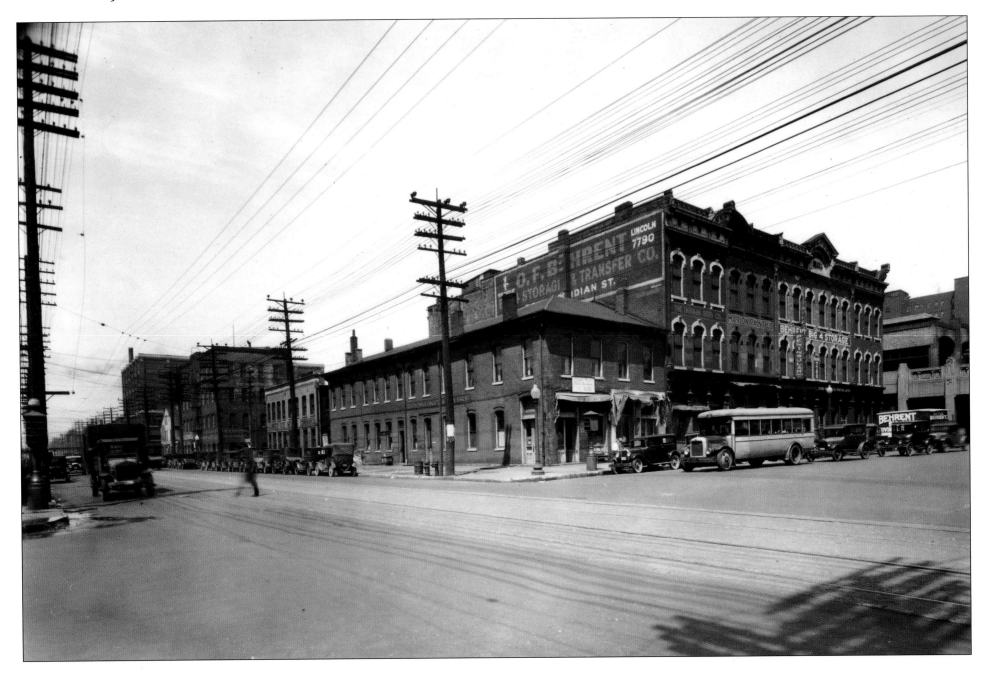

Founded in 1850, the Slippery Noodle Inn, seen here in a photo from the 1920s, is Indiana's oldest continuously operating bar on its original site. In its time, the inn has been through many name changes and scandals. Built as a roadhouse called the Tremont House, the tavern may have been a stop for escaped slaves on the Underground Railroad. In the 1860s, its name was changed to the Concordia House, then to the German House. With widespread anti-German sentiment during World War I, the German House became Beck's Saloon. It was known as Moore's Beer Tavern during the depression when John Dillinger, a local gangster, came to the bar with his cronies. Dillinger and his gang were indulging in target practice when they fired a shot, leaving a permanent bullet hole in the wall.

Today the Slippery Noodle Inn is a 500-seat bar and restaurant, nationally known as a venue for blues music. "The Noodle" was rechristened in 1963 after the Yeagy family purchased the inn. They preserved its historic character but spruced up the place, both in appearance and reputation. About a decade before the Yeagys bought the tavern, a bordello had been operating upstairs. It closed after two patrons quarreled over a woman—one of the patrons pulled a knife and stabbed the other to death. With the Noodle's current renown for "hot blues" and its flamboyant past, it's a popular watering hole for visiting celebrities ranging from movie stars to race car drivers and NFL players. The Slippery Noodle is generally considered to be the oldest commercial building still standing in the Indianapolis metro area.

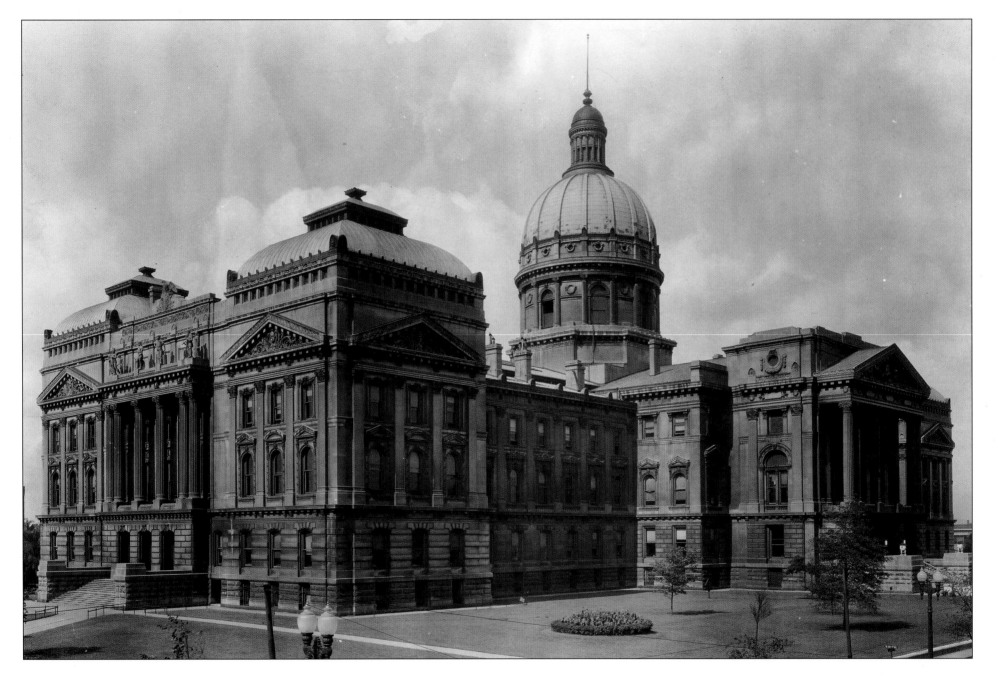

Limestone from the Hoosier State, naturally, was chosen to build the Indiana Statehouse for $2 million in 1888. The cupola atop the glorious dome reaches 234 feet above the four-story Statehouse, also known as the Indiana State Capitol Building, seen here in a photo from 1925. With a design similar to the United States Capitol Building in Washington, D.C., the Statehouse dominates westward views from the Soldiers' and Sailors' Monument and

Market Street. An eye-catching statue at the east entrance to the Statehouse depicts Oliver P. Morton, Indiana's charismatic governor during the Civil War. The interior of the Statehouse includes a central rotunda, regal columns, and marble galore. In addition to the governor's office and the chambers of the State Senate and State House of Representatives, the State Capitol Building houses the Indiana Supreme Court.

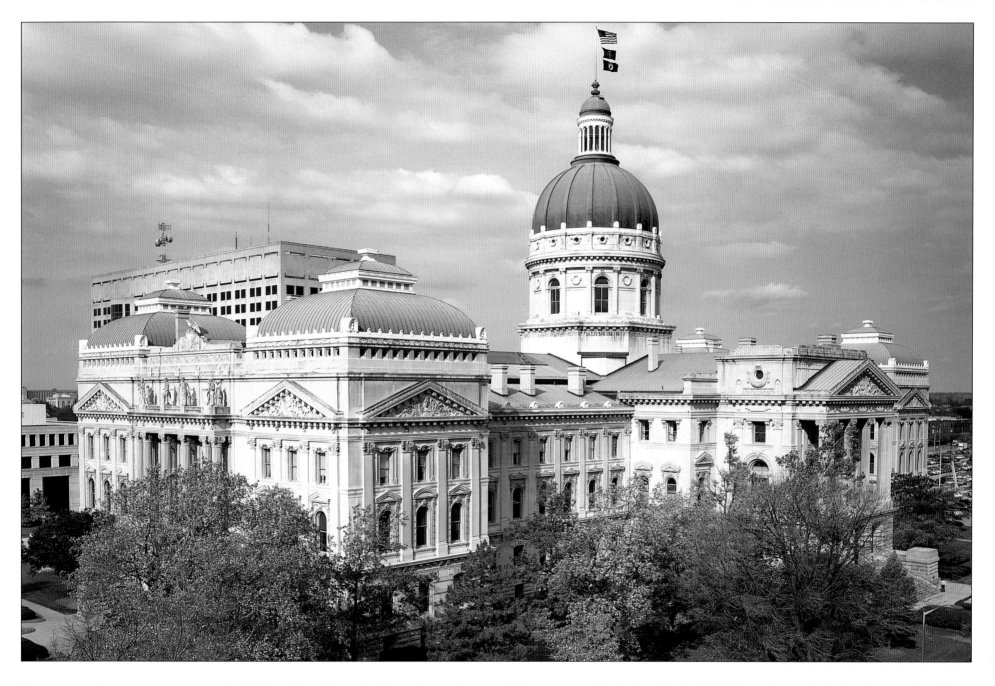

Imposing and impressive as ever, the Indiana Statehouse looks unchanged from a hundred years ago. Actually, there have been several renovations of the Indiana State Capitol Building, including an $11 million project in 1988, but most of the upgrades and alterations have been to the interior. Rejuvenation of the surrounding downtown, however, has been very visible.

The city once derided as "India-NO-Place" has exploded with growth and vitality. The population of Indianapolis (over 790,000 in 2004) makes it larger than Seattle, Baltimore, and even San Francisco. Its heartland location puts more than half the population of the United States within a one-day drive of the city.

INDEX